PUEBLO and NAVAJO

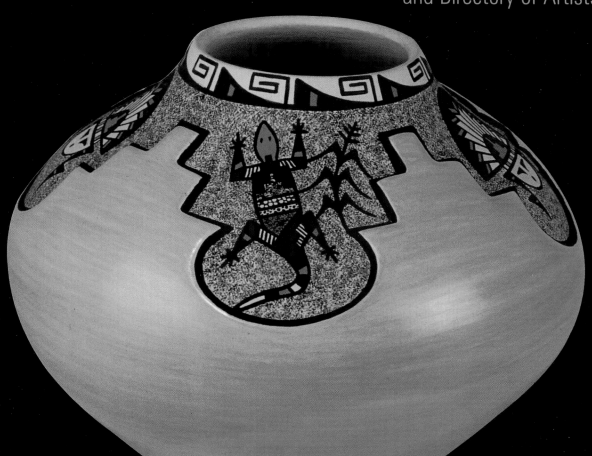

CONTEMPORARY POTTERY
and Directory of Artists

Guy Berger and
Nancy Schiffer

Schiffer Publishing Ltd

4880 Lower Valley Road, Atglen, PA 19310 USA

Published by Schiffer Publishing Ltd.
4880 Lower Valley Road
Atglen, PA 19310
Phone: (610) 593-1777; Fax: (610) 593-2002
E-mail: Schifferbk@aol.com
Please visit our web site catalog at
www.schifferbooks.com
Please write for a free catalog.
This book may be purchased from the publisher.
Please include $3.95 for shipping.

In Europe, Schiffer books are distributed by
Bushwood Books
6 Marksbury Ave.
Kew Gardens
Surrey TW9 4JF England
Phone: 44 (0)208-392-8585
Fax: 44 (0)208-392-9876
E-mail: Bushwd@aol.com
Free postage in the UK. Europe: air mail at cost.
Please try your bookstore first.
We are interested in hearing from authors
with book ideas on new & related subjects.

Library of Congress Cataloging-in-Publication Data
Berger, Guy 1959-
 Pueblo and Navajo contemporary pottery and
 directory of artists / Guy Berger and Nancy Schiffer.
 p. cm.
 Includes index.
 ISBN: 0-7643-1024-0 (paperback)
 1. Navajo pottery--Directories. 2. Navajo artists--
Directories. 3. Pueblo pottery--Directories. 4. Pueblo
artists--Directories. 5. Potters--Southwest, New--
Directories. I. Title: Pueblo and Navajo contemporary
pottery and directory of artists. II. Schiffer, Nancy. III Title.
E99. N3 B498 2000
738.3'089'97--dc21 99-088913

Cover design by Bruce Waters
Book design by Blair Loughrey
Type set in Zurich/Korinna
ISBN: 0-7643-1024-0
Printed in China

CONTENTS

ACKNOWLEDGMENTS

We appreciate the assistance of the following people who provided essential tasks toward the completion of this work:

The Palms Trading Company staff: Enso Medici, Tammy Saavedra, Frank Serino, Tony Weber, Sergio Vigna, Vince Medici, Roger Smith, and Billy Archuleta.

Molly Higgins of Schiffer Publishing

All of our proofreaders and typists: Daniela Berger, Diana Berger, Daiana Bourquet, and Monique Mora.

People who assisted in collecting biographies: Gary Zens, Frank Lente and Mark Del Frate. Jo-Anne Weber for doing a great job on the biography software.

A special thanks to my family for their help and encouragement: My wife Daniela, my daughter Diana, and my son Peter.

And finally to Charles and Keta Berger (Mom & Dad) – Thanks for a lifetime of love.

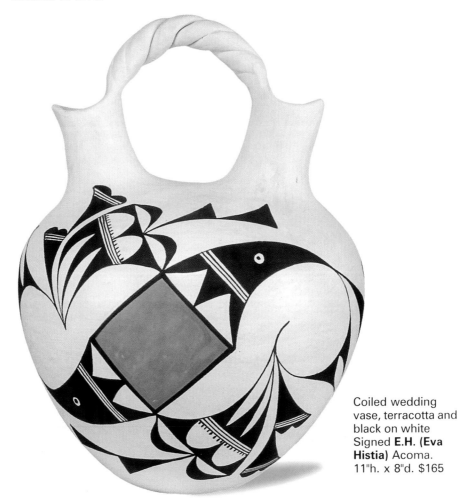

Coiled wedding vase, terracotta and black on white Signed **E.H. (Eva Histia)** Acoma. 11"h. x 8"d. $165

FROM THE GROUND UP

This book came about more out of necessity than design. As the pottery buyer for Palms Trading Company in Albuquerque, one of the services I provide our customers is to give as much information as we can find about each of the artists. After a piece of pottery, or any other item for that matter, was purchased, I would hand-write, usually from memory, information about the artist, his or her family, how long I could remember them doing that type of work, etc. This process became quite laborious, especially during the peak hours at our store. There was the problem of time, of course, but the real problem was my memory. Being forgetful, I felt I was not giving our customers all the information they needed and desired. In light of this, I came up with a biographical worksheet to gather information from each artist, including information customers seemed most interested in knowing.

The Directory of Artists, in the third section of this book, is extensive. Over a period of five years, we have gathered information from over seven hundred artists (there are potters, kachina carvers, jewelers and sculptors), most of whom filled out our worksheets themselves, thereby furnishing authenticity as well as

Coiled seed pot, white with ripple design and sterling silver. 3.5"h. x 8.5"d. Signed **Preston Duwyenie**.

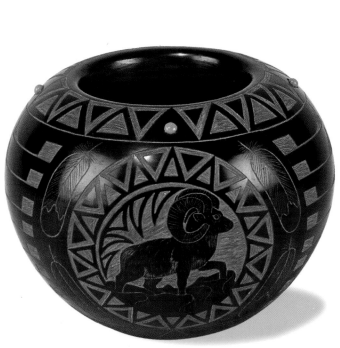

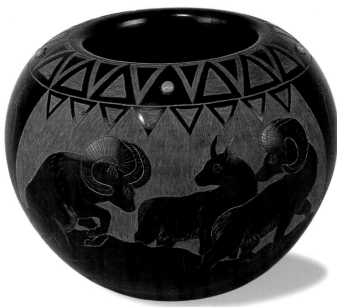

Coiled bowl, black etched design with rams and feathers. Turquoise stones set around top. 3.5"h x 4.5"d. Signed **Red Starr**, Sioux, 96. $585

individual personalities to each entry. In the Directory you will find many artists who are quite familiar to you, but what I think sets this book apart are the hundreds of contemporary artists included who previously have been obscure and not received the recognition they deserve.

Each biography presents a wealth of information about each artist, including their birth date, who their parents are, what type of work they do, who taught them, how long they have been doing this work, awards each artist has won in juried competitions, what their favorite part of the work is, and, finally, how each signs their work. This is information other publications do not have.

In order to give the reader insight to the lives of these people, I have written of personal experiences at several of the pueblos that have touched me in special ways. I share these stories so that readers can learn more about the artists and where they get inspiration to create their wonderful art. Following these personal stories are photographs of each group's pottery, from the traditional to the contemporary.

As you read the chapters, then view the photographs, keep in mind that each piece of pottery is a creation that originated in the artist's mind and combines all the life experiences and training particular to that artist. Also, keep in mind the countless hours spent thinking, designing, polishing, painting, firing, and searching for a buyer for their work. The next time you look at a piece of pueblo or Navajo pottery, consider all these factors before you look at the price. Whether the pottery is poured in a mold and hand painted, or hand coiled from earthen clay, the heart and soul of the artist is contained within.

The process of pottery making has been well documented for decades, and we will not repeat it here. While exploring the pages of this book, I would like you to read each story and put yourself into the moment of seeing, smelling, and experiencing pueblo life. Once you get in touch with that, and look at each photograph with those thoughts in mind, you may notice how much your appreciation for the pottery has grown.

Guy Berger, Albuquerque
Summer, 1999

THE VESSELS

THE FUNERAL

Sometimes in life, things happen to us that we never in a million years thought would happen. The following experience is very dear to my heart and, while sharing it with the readers, I would like to express my sincere appreciation and respect to the family that considered me important enough to have this experience with them.

I was first informed of the death of one of our dearest potters from Acoma Pueblo on a beautiful spring day in the early 1990s. One of the potter's grandsons had let us know the previous day that she had passed away, and we were quite saddened because she had been a friend of Palms Trading for quite a long time.

This lady created beautiful, traditional (coiled) Acoma pottery for most of her life. She worked with the clay gathered from the community clay pit, located near Acoma Pueblo. Her designs were simple, as taught to her by her mother many years before. Each piece of her pottery was created not only to bring a few dollars into the household, but also as an extension of her to share with the rest of Creation.

I was invited to this wonderful lady's funeral by her grandson. Being outside the Acoma culture, I would not normally have been welcome at such an event; therefore, his invitation meant a great deal to me. He took the time to drive to Albuquerque, a distance of more than fifty miles, and personally ask that I attend. I told him that I would be honored to do so, and that he and his family could expect me at the old church in Acoma the following day.

When I drove to Acoma, I really did not know what to expect. Was I dressed properly? How would the other members of the family react to my being there? What was the appropriate protocol for this situation? What I did know was that this was an opportunity not many people from my Anglo culture had the privilege to witness.

I had a little trouble finding the old adobe Catholic church where the funeral was to be held, but after stopping and asking a person walking down the road, I was directed to it. I was about thirty minutes early, so I looked around a bit and wondered about what was about to take place.

The Church was very old, made from adobe bricks, with walls at least eight feet thick. There were very few windows, but the church was well lit nonetheless. There were, at most, ten rows of old wooden pews placed on an old wooden floor that creaked each time a step was taken. The ceiling was constructed of wooden beams called "vigas." The altar was fitting for a simple place like this, it seemed to me, consisting of plain wood and a few pictures and statues of saints.

I saw a small, blue, mini-pickup truck approach the church from the East. Behind the truck were several other cars and trucks, not more than five; there were no motorcycle escorts, no long black limousines, and none had their lights on. If I hadn't known better, I might have thought these people were here for morning mass, and nothing more.

The vehicles following the pickup parked in the lot while the truck backed up to the sidewalk that led to the church. People in the pickup got out and waited for others to gather at the tailgate. Once everyone was there, the tailgate was lifted. What I saw was quite different from any other funeral I had ever attended. Wrapped in blankets and a fiberglass tarp, the body of the potter of Acoma rested in the bed of the truck. When everyone was ready, nephews and grandsons lifted the body and proceeded to carry it into the Church for the funeral mass.

The mourners all followed the pallbearers into the foyer of the church where, in the aisle just in front of the altar, the body was laid on the floor, wrapped just as it had been in the truck. We filed in and took places in the pews. The priest said opening prayers and proceeded with the mass. This part of the funeral I was quite familiar with. What was to come has made me realize how fortunate I was to be there.

When the mass was concluded, the body was carried by the grandsons and nephews back to the pickup and a small procession followed it to the cemetery where internment was to take place.

The Acoma cemetery stands in the foothills of Acoma Pueblo land. There is nothing fancy about the place; no grass adorns the ground and no trees give it shade. The graveyard is barren except for crosses and stones that mark the places where people are buried.

Our friend was to be buried in the lower part of the site. We approached a great mound of earth piled near a hole in the ground. To the south of the grave site

there was an old backhoe that had done the major part of the digging. (I was later told that the backhoe was used only to remove the major part of the dirt and that the male members of the family finished digging the grave to the proper depth and dimensions.)

Several male relatives of the deceased then removed the wrapped body from the truck and laid it beside the grave, opposite the pile of dirt. It was now time for the funeral ritual to begin.

A medicine man from Acoma Pueblo was present to perform the traditional Indian ritual of burial, and a Catholic priest was present to recite the Christian rite of burial. The Catholic priest conducted his part of the service first by saying the proper prayers, according to the laws of his Church. When he finished, the body was lowered into the grave by the male family members. In addition to the blanketed body, a bag with some of the deceased's possessions was laid beside her. I do not know what was in the bag, but I believe those personal possessions are thought to be beneficial to the person in the afterlife.

As soon as this part of the ceremony was complete, the male members of the family took shovels that were stuck in the mound of dirt and began to fill the hole. This was a very emotional moment for both the family and myself. The men worked feverishly, creating a great cloud of dust with their activity. When one man tired, he passed his shovel to another who dug as fast as he could. The entire hole was filled within a matter of minutes, culminating in a mound of earth that protruded about three feet over ground level. At the head of the grave, a large flat stone was placed.

The medicine man now took his place just behind the stone. In his hands he held a traditional pottery bowl that had been made by the deceased potter. The bowl was of medium size and decorated with the polychrome geometric designs for which she was well known. Inside the bowl was sacred water which the medicine man had prayed over for the last day and a half in the family's home, insuring that it was properly purified for this purpose. Now he took the bowl in his hands and began to pray, first in regular speech, then working into a chant, and finally into a song. All of the words were in his native tongue, so I could not tell you what he was saying. Although I did not understand his

words, there was such a powerful feeling present at this time, that I was sure supernatural forces were there.

I was becoming lost in the chants and songs when, suddenly, the medicine man raised the pot up over his head and violently slammed it onto the flat rock marking the grave, breaking the pot into hundreds of pieces, and scattering the sacred water as well. I came to find out this was done to release the spirit of the lady from this world into the next. The following silence was stunning, as everyone's attention was focused on the smashed pot.

After a few more moments, the silence was broken by the medicine man thanking all who had attended, even mentioning that the family appreciated the presence of their friends from Albuquerque. This concluded the ceremony. Those in attendance were asked to have a meal with the family at their home in the pueblo. It was there that many of the meanings of the funeral were explained to me.

I will hold the experiences of that day in my heart forever. As I reflect on the funeral, I remember being moved by its simplicity, yet transformed by its power. From the common wrappings of the body, the desolation of the gravesite, the male family members participating in each step of the ceremony, and the pot being broken so suddenly and violently, all is as crystal clear in my mind today as the day it all took place.

Most interesting to me is how the pottery itself became a symbol of the potter's entire life. Constructed of clay from Mother Earth, as people are, the pot was molded in the potter's mind and hands as parents mold their children. The pot served its purpose in the world, whether it was made for utilitarian use or to sell for money to buy other things. Finally, the pot was used at the final hour to carry sacred water to the grave and to release the spirit to the afterlife. In this sense, her pottery is a reflection of the potter's life and will be used as a symbol at the time of the potter's death.

When looking at the photographs of pots which follow here, I hope this story will be remembered as you appreciate what each piece means to each particular artist. This pottery is not merely clay thrown together to make a few bucks, it symbolizes a great deal to the maker, and hopefully will have abundant meaning to you.

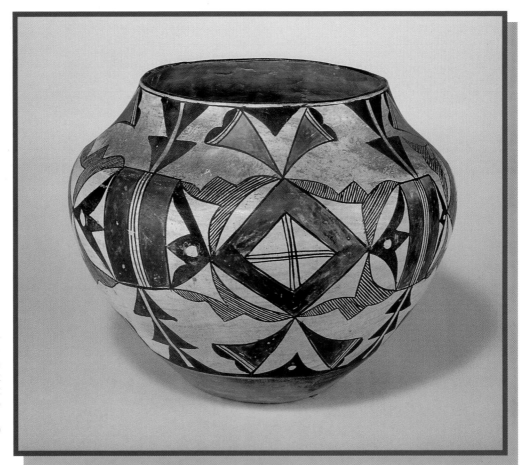

Old coiled
Acoma olla,
circa 1930s.
Off-white
background
with terracotta
and black
design. 8.5"h. x
10.5"d. No
signature.
$2000

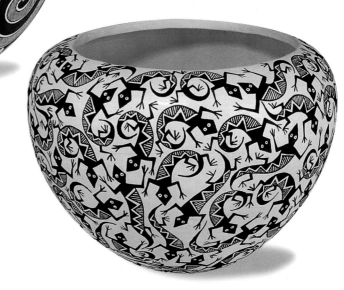

Lower left: Coiled small bowl,
white, terracotta and black design,
corrugated rim. 5.5"h. x 5.5"w.
Signed **E. (Earlene)Antonio**. $69

Left: Coiled bowl, 9.5"h. x 9.5"d.
White background with black
tularosa spiral design. Signed
Florence Aragon. $690

Below: Coiled bowl, white back-
ground with black lizard design. 6.
5"h. x 9"d. Acoma. Signed **John F.
Aragon** . Dated 11/98. $1,200

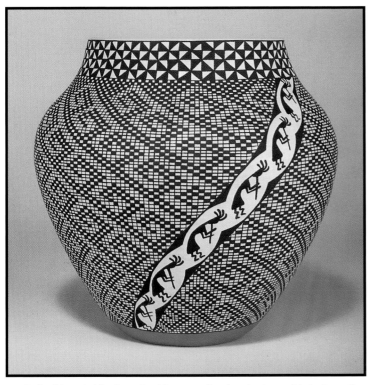

Coiled bowl, black and white eye dazzler design with kokopeli. Signed **M (Melissa) C. Antonio**. 7.75"h. x 7/5"d. $795

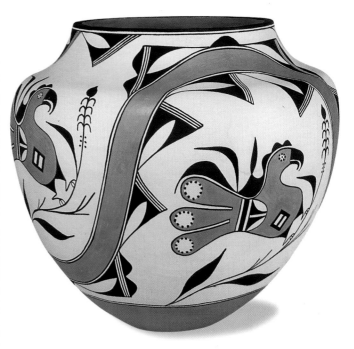

Bowl, white background with terracotta and black bird design. 10.5"h. x 11.5"w. Signed **Rachel Aragon**, Acoma, N.M. $750

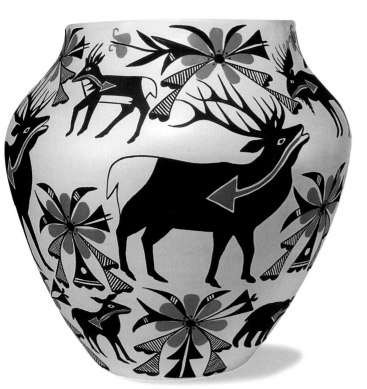

Coiled large olla, white with wildlife design. 12"h. x 12.5"d. Signed **M. (Mildred) Antonio**. $390

Molded bowl, red clay with etched bear and pawprint patterns and yellow shading. 7"h. x 8"d. Signed **Jr. (Wilbert)/Diane Aragon**, Acoma-Laguna, 1998. $165

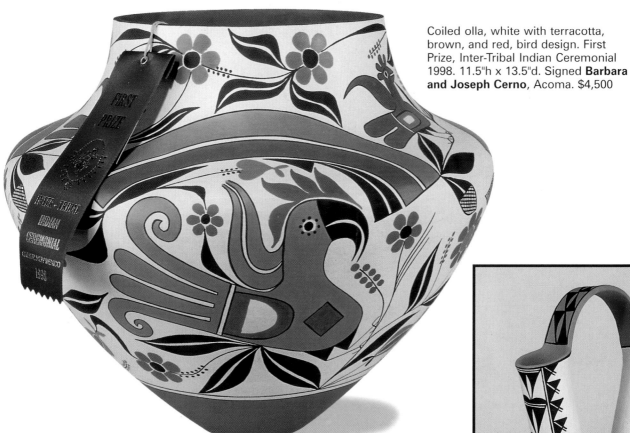

Coiled olla, white with terracotta, brown, and red, bird design. First Prize, Inter-Tribal Indian Ceremonial 1998. 11.5"h x 13.5"d. Signed **Barbara and Joseph Cerno**, Acoma. $4,500

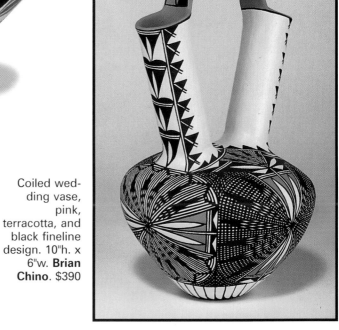

Coiled wedding vase, pink, terracotta, and black fineline design. 10"h. x 6"w. **Brian Chino**. $390

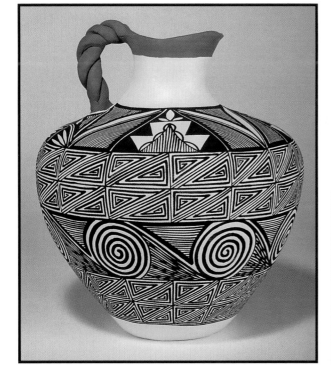

Coiled pitcher, cream with black fineline design, trimmed with terracotta. 9"h. x 8.5"d. Signed **I. (Iona) Chino**. $150

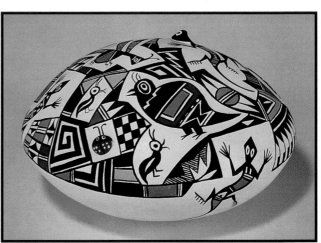

Coiled seed bowl, white with multicolored animal, bird, insect, fish, and geometric designs. 3"h. x 5"d. Signed **C. (Carolyn) Concho**. $375

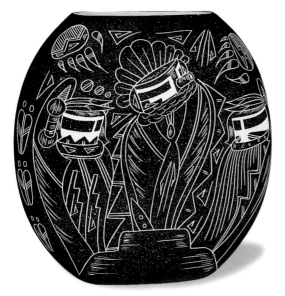

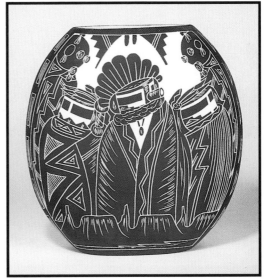

Molded pillow vase, black and white longhair and mudhead kachina design. Reverse side has black and white with blue speckles. 12"h. Signed **AC** **(Anthony Concho)**. $225

Coiled small bowl, black and white lightning design. 5"h x 5.25"d. Signed **J. (Jennifer) Estevan**. $195

Above: Coiled bowl, terracotta and black design on white. Signed **B. (Beverly Victorino) Garcia**. 10"h. x 10.5"d. $195

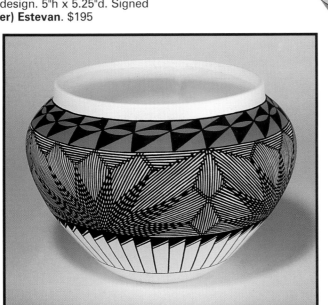

Left: Molded bowl, white with fineline design, trimmed with blue. 6"h x 8.5"w. Signed **Bea. (Beatrice) Garcia**. $99

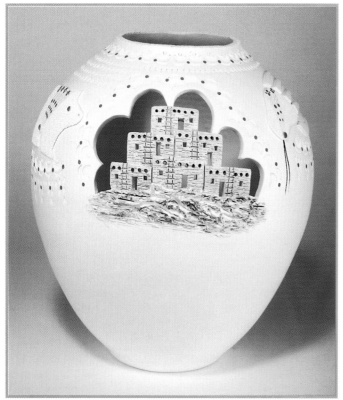

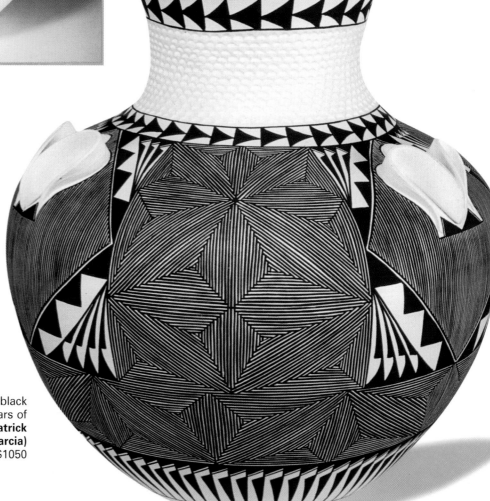

Coiled bowl, terracotta background with black lizard fineline design. 5.5"h. x 5.5"d. Signed **V. (Virginia [Virgie]) Garcia**. $135

Molded vase, white with raised bear, pueblo, and textured designs. 11.5"h x 10"d. Signed with a **Sunrise (Elliott Garcia)**. $285

Coiled bowl, white and black design with attached ears of corn. Signed **P. Garcia (Patrick Rustin and Shana Garcia)** 10.25"h. x 9"d. $1050

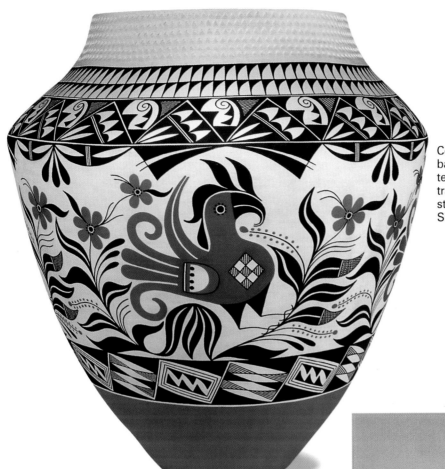

Coiled large olla, white background with black and terracotta parrot design. All traditional hand coil construction. 24"h. x 23"d. Signed **Goldie Hayah**. $4800

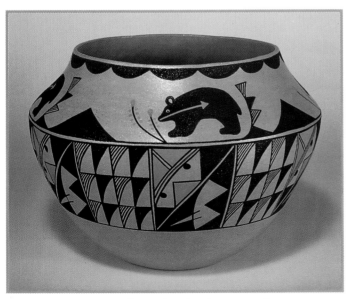

Above: Coiled bowl, micaceous clay, terracotta with black bear design. 8 1/2"h x 12"d. Signed **Juliet Hayah**. $225

Right: Coiled long-necked vase, white with pueblos and kiva ladder, Mesa Verde design. 14"h. x 9.5"w. Signed **W. (Wilfred) Garcia**. $780

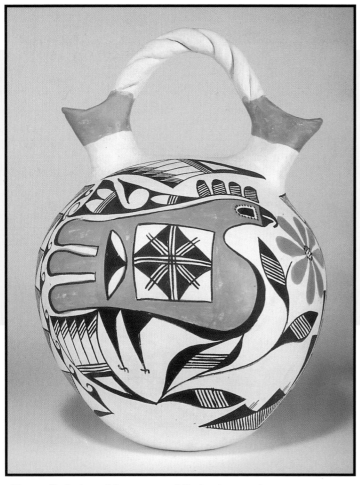

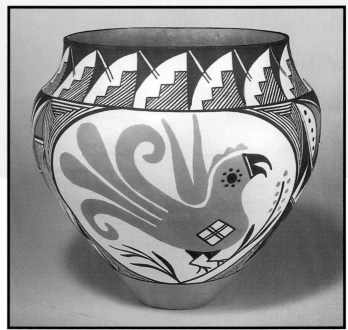

Above: Coiled wedding vase, white background with black and terracotta parrot design. 12.5"h. x 7.5"w. Signed **E. (Eva) Histia**. $285

Above: Coiled olla, white with terracotta and brown parrot design. 9"h. x 9.5"d. Signed **Joe L. (Loretta Joe)**. $225

Below: Coiled bowl, white background with brown and terracotta bird design. 8.75"h. x 9 1/2"d. Signed **M. (Miranda) Leno**. $240

Below: Coiled small seed bowl, white with multicolored bird, fish, and geometric designs. 2.25"h x 3.5"d. Signed **Sharon Lewis**. $195

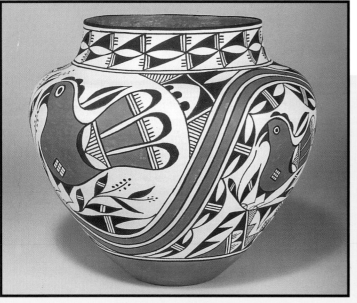

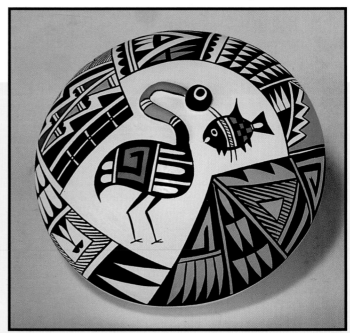

Coiled plate, black and white spiral design with lizards in center. 18"d. Signed **R. (Rebecca) Lucario**, Acoma. $9,000

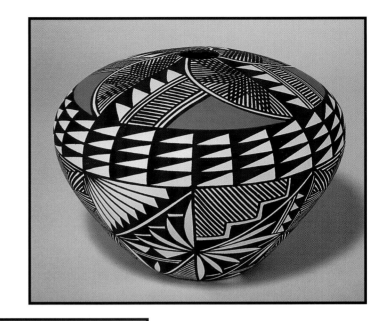

Above: Molded bowl, burned horsehair design with etched friendship figures. 8.5"h. x 11"w. Signed **Gary "yellow corn" Louis**. $285

Right: Bowl, white with fineline design. 6"h. x 6.25"d. Signed **D & R (Rita) Malie**, Acoma. $84

Below: Molded olla, black and white fineline star design. 13"h. x 14.5"d. Signed **M.M. (Ramona and Manuel Martinez)** $225

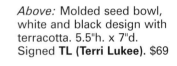

Above: Molded seed bowl, white and black design with terracotta. 5.5"h. x 7"d. Signed **TL (Terri Lukee)**. $69

Below: Coiled wedding vase, cream with black three dimensional lizard design. 10"h. x 6.5"w. Signed **Louis and Nadine Mansfield**. $165

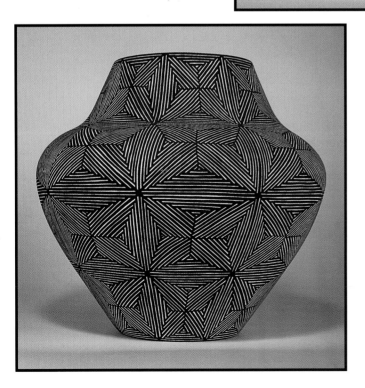

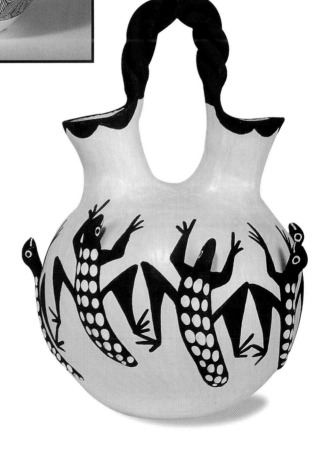

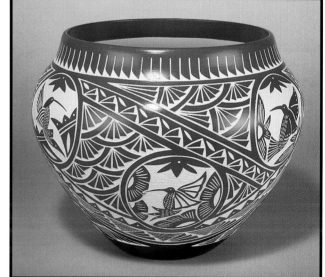

Above & right: Molded olla, white with brown bear designs and terracotta hummingbird etched designs. 8.75"h. x 12"d. Signed **D. M. (Darrin and Michelle) Pasquale**, Laguna-Acoma. $330

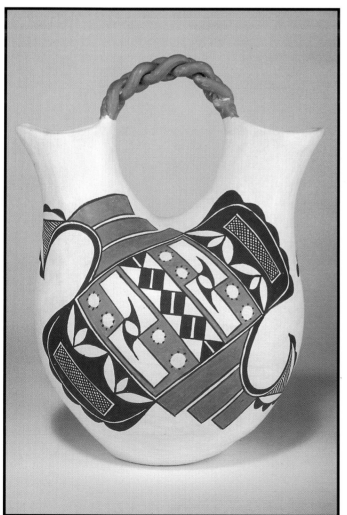

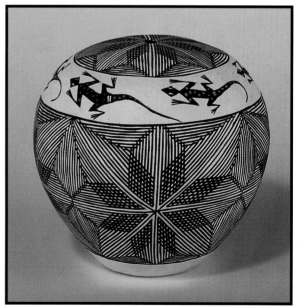

Above: Coiled seed pot, fine line design with lizards.4.5"h x 4.5"d. Signed **S. (Santana) Phillips**, Acoma. $84

Left: Coiled wedding vase, terracotta and brown design. 10.5"h. x 8"w. Signed **Monica Poma**. $345

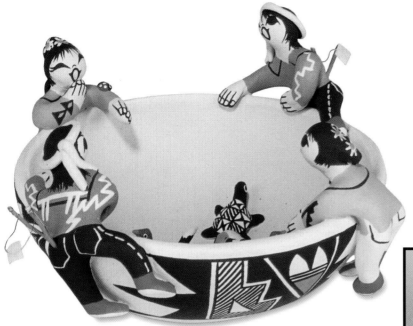

Coiled bowl, children climbing in with dog, birds, and lady bug inside. 2"h. x 5.5"d. Signed **Marilyn Ray**. $1,200

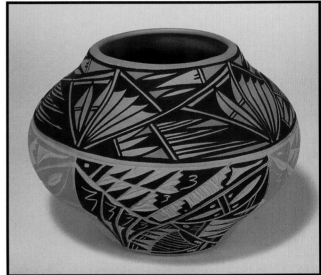

Molded olla, red clay, terracotta with black designs. 5.5"h. x 8"d. Signed **G.R.(Gregory Romero)**. $49.50

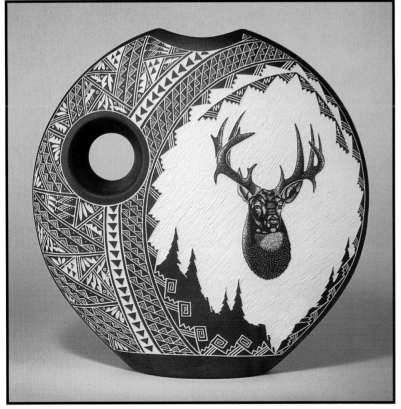

Molded pillow vase, white with deer and black etched linear design. 14.5"h. Signed **R.M.R. (Robyn and Mike Romero)** $345

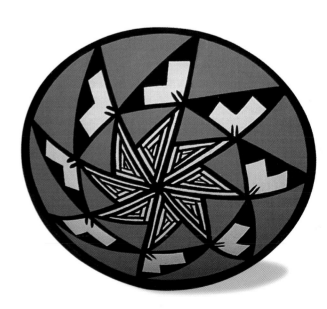

Coiled, very small plate, white, black, and terracotta design. 5"h x 2.5"d. Signed **D. (Dean & Divine) Reano**. $39

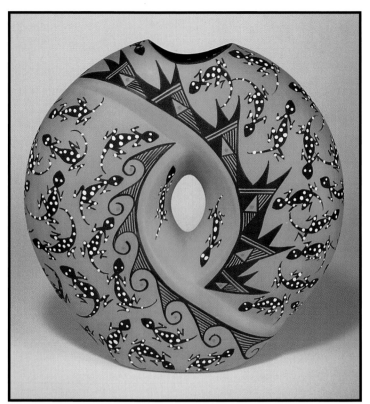

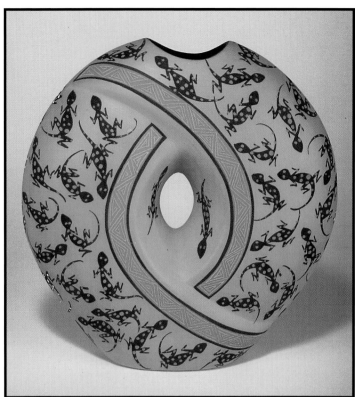

Molded pillow vase, terracotta with black, white, and blue lizard design. 11.5"h. Signed **Kuutimaits'a (Clara Santiago)**. $114

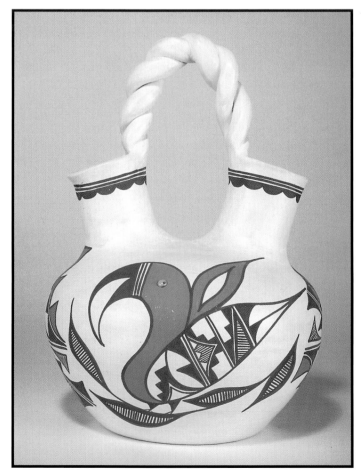

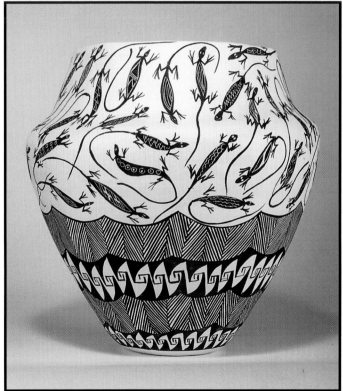

Coiled olla, white with black lizards and fine line design. 12"h. x 12"d. Signed **SS (Sharon Stevens)**. $390

Coiled wedding vase, white with brown and terracotta parrot design. Turquoise stones used for parrot's eyes. 10.5"h. x 7"w. Signed **M.S. (Michelle Shields)**. $180

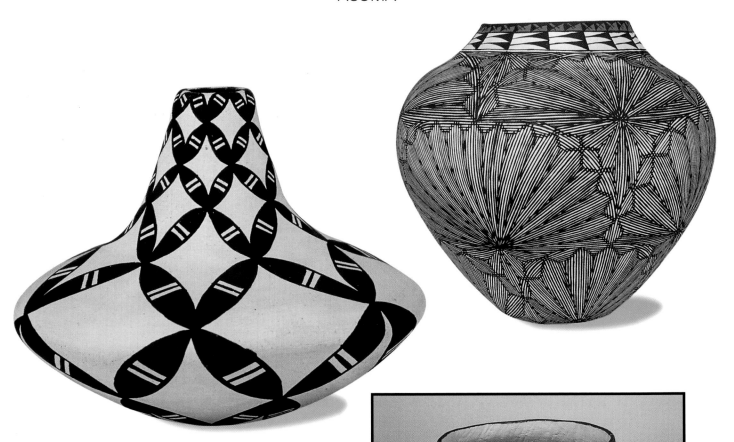

Above left: : Coiled small seed pot, white with black floral design. 2"h. x 2.5"d. Signed **Dorothy Torivio**. $450

Abovr right: Coiled olla with black and white fineline star design. 9.5"h. x 11"d. Signed **Delma Vallo**. $600

Right: Coiled bowl, white with heartline deer design. 6.25"h. x 8"h. Signed **A. (Adrian) Vallo**. $345

Below: Coiled three-part vessel, cream, terracotta, and black design with animals. 2.75"h. x 8"l. Signed **Yolanda Trujillo**. $84

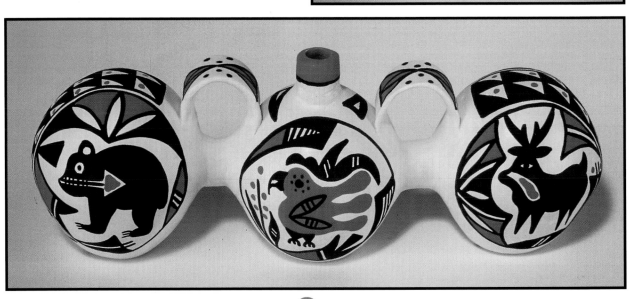

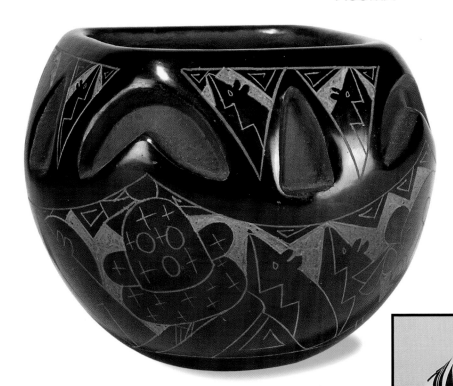

Left: Coiled bowl, black with multicolored etchings. Scraffito on Santa Clara pottery with pollen and mineral coloring by **Ergil Vallo** of Acoma. Signed **Dalawepi**. $495

Below: Coiled bowl, white with black and terracotta design. 8"h. x 9.5"d. Signed **Vallo (Simon Vallo)**. $225

Bottom right: Coiled bowl, black and cream tularosa design. 8.5"h. x 7.5"d. Signed **L. (Leland) Vallo**. $270

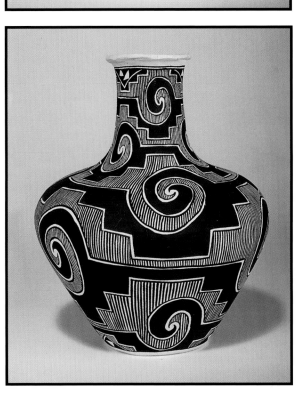

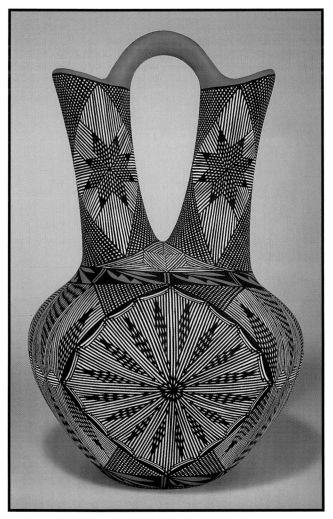

Molded wedding vase, black and white fineline design trimmed with terracotta. 14.5"h. x 8"w. Signed **Jay Vallo**. $285

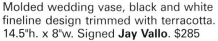

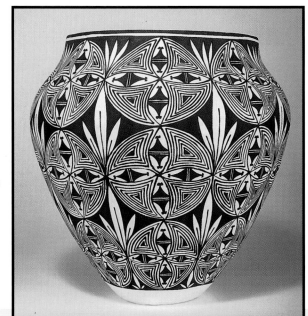

Right: Coiled olla, white with black fineline design. 11.5"h. x 12"d. Signed **Dylene Victorino**. $225

Below: Coiled olla, fine line designs with terracotta and black spiral with three distinct designs. First Place, New Mexico State Fair. 8.25"h. x 9"d. Signed **Sandra Victorino**. $990

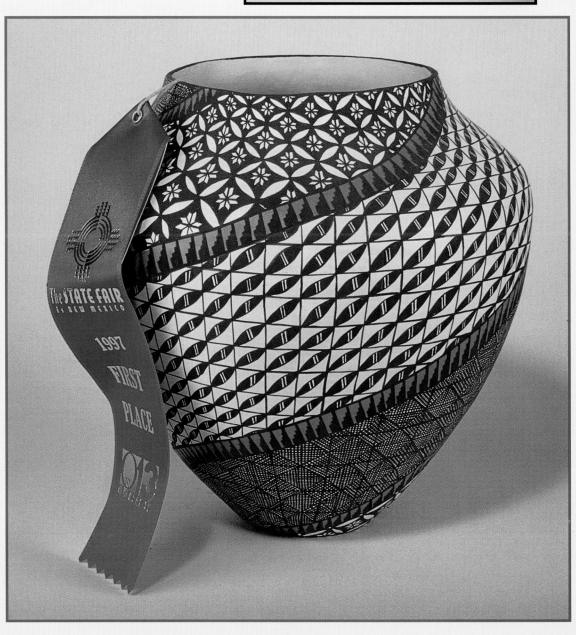

THE DANCE

One extremely hot summer, I was invited to attend the home dance at Hopi. I had never been to a kachina dance before, but the family that invited me appreciated me buying their goods at our store. I was honored to be invited to such an occasion and agreed to meet them at Hopi on the day of the dance.

My expectation of this event had only to do with what I had read and seen in photographs, so I felt very excited to be able to witness such a ceremony in person. I knew kachina dances had specific meanings to achieve specific results, such as increasing game herds, healing, thanks giving, producing bountiful crops, and bringing rain. I didn't really believe that the dances and chants would do any good, but for the sake of curiosity I wanted to see for myself.

I drove to Hopi from Albuquerque and met the people and their family, who had invited me, at the base of the Hopi village. These people were gracious hosts, and I thanked them for inviting me to such a special occasion. They made sure I wasn't carrying a camera or recording equipment, for these are forbidden at such a sacred occasion. Being assured that I wouldn't embarrass them, we began the walk up the steep slope to the center of the village and found a large rock to sit on together and watch the dance.

As we sat there in the sun, I tried to take in the atmosphere. I sensed the anticipation of the other people waiting for the dance to begin, and I noticed the structures that housed some of the members of this community and the rest of the setting. This Hopi village is set on top of a tall, shear, rock. From our vantage point, I could see for hundreds of miles in all directions. To get a feel for this place, imagine yourself sitting on a flagpole with a little more room to sit. The housing for the residents of this village are carved and constructed toward the center of the flat area of the rock. On the edge of the cliff, a place that couldn't have been more than thirty feet wide, was the open space where the dancing was to take place. On my left was the kiva with its roof below the level where I was sitting. The kiva is where the kachina dancers ready themselves, spiritually as well as physically, for the ritual they will perform.

I sat in eager anticipation, as time seemed to stand still, before the dancing began. The sun was high in the sky and the temperature climbed steadily. It must have been close to one-hundred degrees when the crowd quieted and figures started to appear from the kiva.

If you have never been to a pueblo dance, you cannot know the sounds of the singing. Many men with baritone voices change notes in sequence, half singing and half chanting.

There must have been thirty adult male dancers, each wearing a large wooden "tableta" on his head. A tableta is a large, thin piece of wood, painted mostly in turquoise with colorful symbols, and the crowns had feathers tied to their tops. Each man's body also was painted from head to toe, and each wore a loin cloth as well as a fox tail that hung behind him tied to his belt. These "hemis" kachinas danced, at first in a long line, and then organized themselves in rows facing the houses. Accompanying the hemis kachinas were smaller ones called "fire-gods." They must have been boys, for they were half the size of the hemis dancers. The fire-gods were painted black and covered with different colored dots. Each fire-god carried a large wooden dish and a stick with a serrated edge on one side. As the hemis kachinas began to chant and sing, the fire-gods rubbed the serrated edge of the stick against the dish to make an eerie, grating sound with each pass. Even though it seemed crude, the sounds, made in unison, were unbelievably serene.

The dancing, chanting, singing, and scraping went on for twenty to thirty minutes. I asked the people I had come with what the kachinas were dancing for. The response cemented my belief that this stuff was all for show. As the temperature soared, sweat poured from my brow and my skin began to turn red. My friend told me the kachinas were dancing for rain! "Fat chance on this day," I said to myself. I could see for miles around me and there was not a hint of a cloud, much less rain! The dancing paused for a moment and then started up again. I'm not sure if I was mesmerized by the constant chanting and scraping, or delirious because of the heat, but a few moments later, a slight breeze began to blow. Chanting continued, seeming louder and more forceful with every passing minute. Off in the distance, small clouds began to form and the dancing progressed. Larger clouds followed the smaller ones toward us. The fire-gods kept right on scraping. To my utter amazement, we became surrounded in cloud cover.

While no rain fell while I was there that day, I nevertheless had become a believer in these people and their connection to the spirit world. The experience was profound and unique in my life to that point. I returned home with a new respect for the Hopi people.

This ceremony was, to me, not only a connection to the kachinas and rain, but also to all of the Hopi arts. Kachina carvers, potters, and jewelry makers all reflect their lives and their beliefs in their art works. Whenever I see a kiva step on a Hopi pot, I remember the kachinas coming out of the kiva. When I see eagle wing designs on the clay, I can visualize the eagle taking the prayer from mortal beings to the gods and bringing the request back to earth. Each symbol, whether we recognize it or not, has a specific meaning to the artist.

Whenever you look at Hopi pottery, remember this story and let the power of the symbols create meanings and memories for you.

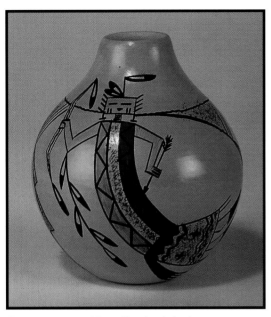

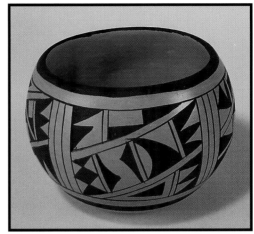

Coiled bowl, terracotta with black geometric design. 4"h. x 5.25"d. Signed **A.C.C. (Antonita Collateta)**, Hopi, Tewa. $84

Seed pot, tan with stylized yei design. 3.5"h. x 3"d. Signed **R. Claw**, Navajo. $255

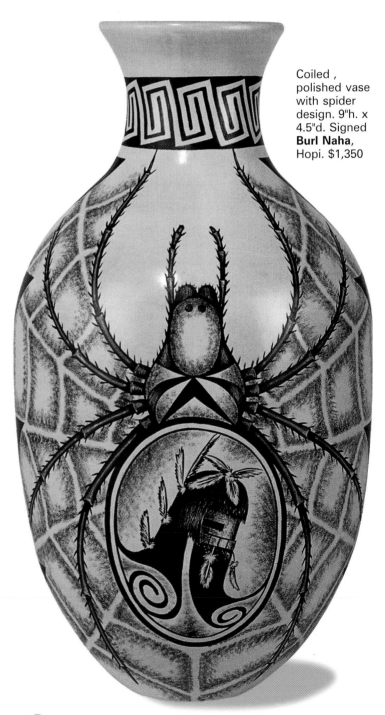

Coiled , polished vase with spider design. 9"h. x 4.5"d. Signed **Burl Naha**, Hopi. $1,350

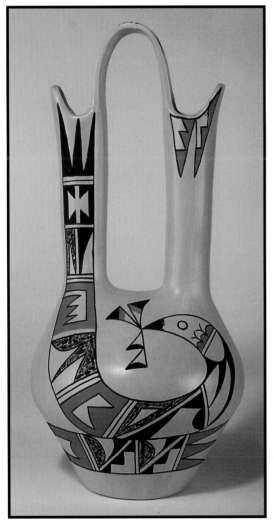

Coiled, stone polished wedding vase, bird with geometric design. 12.5"h. x 6"w. Signed **E. C. (Erna Chosa)**, Jemez, Hopi, Tewa. $450

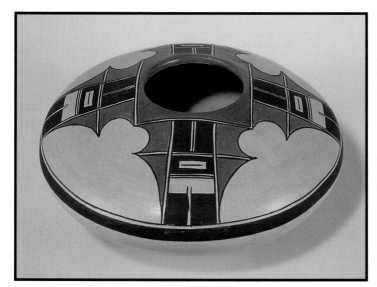

Coiled seed pot, tan with brown and terracotta designs. 3"h x 6.5"d. **Rachael Namingha**. $600

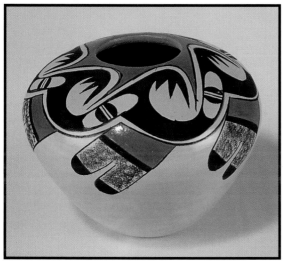

Coiled seed pot, tan with terracotta, brown, and black geometric design. 3.75"h. x 5"d. Signed **Adelle Nampeyo**. $285

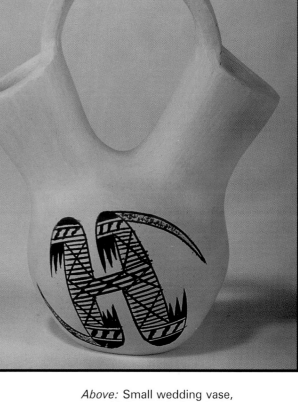

Above: Small wedding vase, tan with brown "migration" design. 5"h. x 4"d. Signed **Chastity Nampeyo**. $135

Left: Coiled, stone polished seed pot, tan with ear of corn. 3.5" x 5.25"d. Signed **Iris Nampeyo**. $2,400

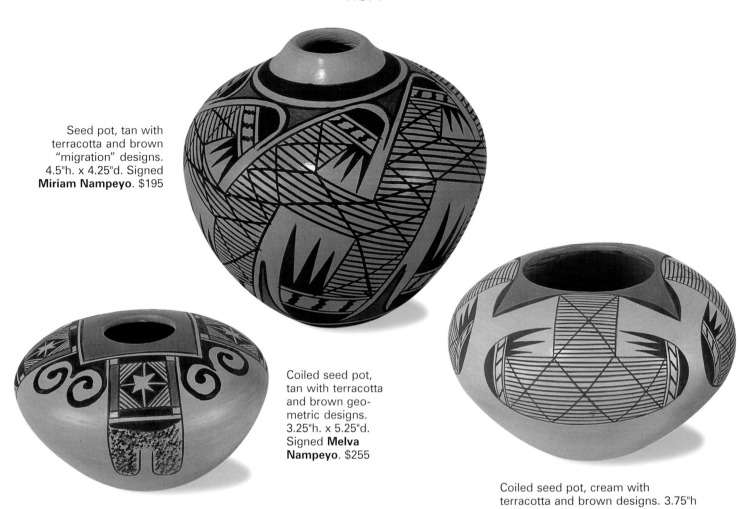

Seed pot, tan with terracotta and brown "migration" designs. 4.5"h. x 4.25"d. Signed **Miriam Nampeyo**. $195

Coiled seed pot, tan with terracotta and brown geometric designs. 3.25"h. x 5.25"d. Signed **Melva Nampeyo**. $255

Coiled seed pot, cream with terracotta and brown designs. 3.75"h x 6"d. Signed **Neva P. Nampeyo**.$450

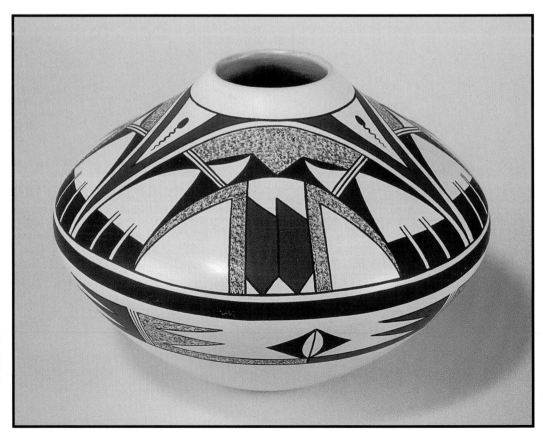

Coiled seed pot, white with brown and red geometric designs. 5"h. x 6.25"d. **Charles Navasie**. $990

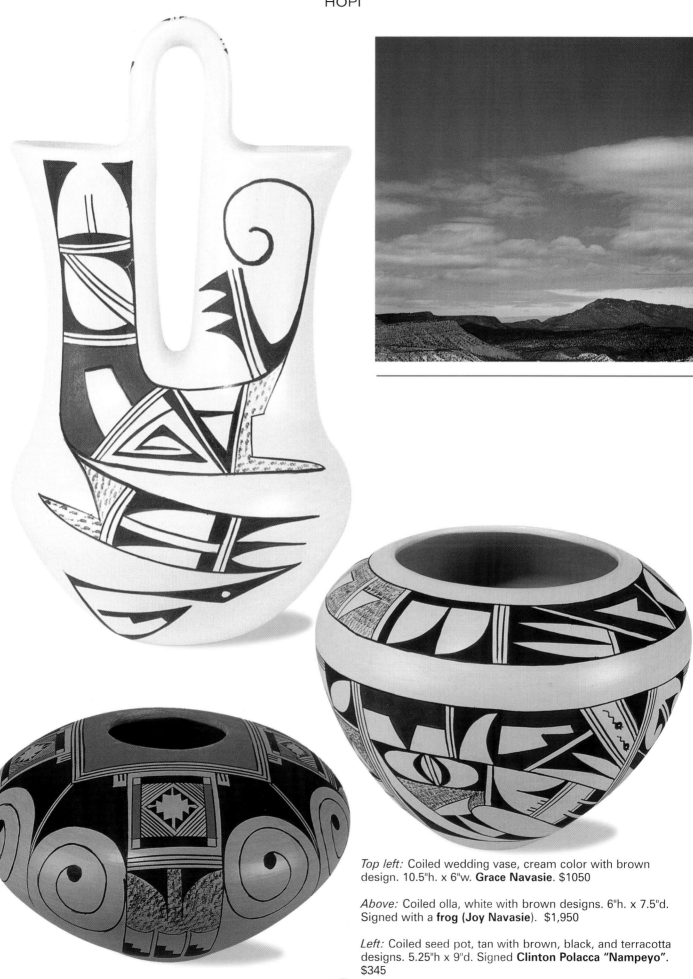

Top left: Coiled wedding vase, cream color with brown design. 10.5"h. x 6"w. **Grace Navasie**. $1050

Above: Coiled olla, white with brown designs. 6"h. x 7.5"d. Signed with a **frog (Joy Navasie)**. $1,950

Left: Coiled seed pot, tan with brown, black, and terracotta designs. 5.25"h x 9"d. Signed **Clinton Polacca "Nampeyo"**. $345

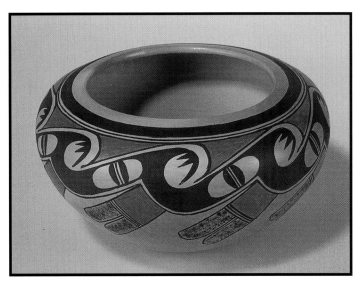

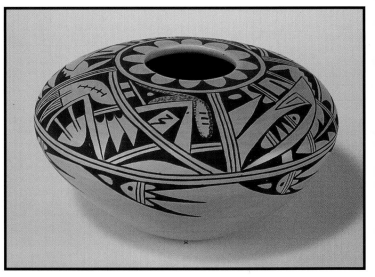

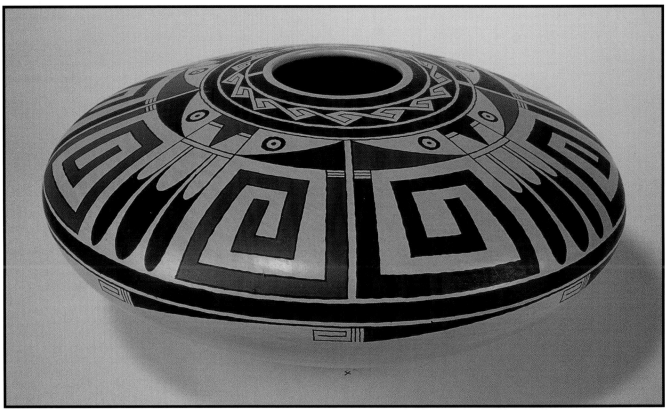

Top left: Coiled bowl, terracotta and brown design of waves and eagle tail feathers. 3.75"h. x 6.75"d. Signed **J. (Jean)Sahmie**. $585

Top right: Coiled seed pot, tan with brown geometric design. 4"h x 7"d. Signed **Jeanette Sahu**. $390

Above: Coiled seed pot, tan with brown and black feather and geometric designs. 4.5"h. x 9"d. Signed **S. (Stetson) Setalla**. $900

Right: Coiled, stone polished olla, tan color with terracotta and brown designs. 7"h x 7"d. Signed **Venora Silas**. Hopi. $345

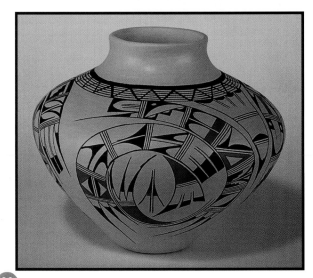

THE FAMILY

An ancient village fifty miles northwest of Albuquerque, Jemez Pueblo is a special place constructed, like the other pueblos, with adobe buildings surrounding a large courtyard where the dancing for feasts takes place. I was invited to attend the November 2 feast day in 1998 by Judy Toya and her family. She told me to come to their house, have a meal with them, and stay to watch the dances. The date happened to fall on a Thursday, when I was off from work, so I was pleased to accept the invitation.

The day was overcast and cool. I wondered if it would rain or even snow and what effect that would have on the dances. As I approached the pueblo, I could see many visitors' cars lining the highway near the pueblo. Vehicles are not allowed onto the inner courtyard. I parked about five blocks away from the entrance to the pueblo and walked down into the village, smelling the wood smoke from so many fires kindled inside homes both to keep the families warm and to bake bread. It is a wonderful smell really, reminding me, each time I notice it, what it must have been like every day, long ago.

As I got closer to where the feast day dancing was to take place, I began to hear the sound of drums. Drums at a pueblo dance are quite unmistakable. Five or six men from the community stand and hold a drum that is five to six feet in diameter. Each has a drum beater and strikes the drum in unison as they sing their songs, traditional tunes handed down from their elders.

There are several clans within the pueblo, and each clan has responsibility for a portion of the feast day dances. Clan members, including men, women, and children, practice for many weeks prior to the feast day so they all can dance in unison. Dancers are dressed in traditional clothing and the women wear a tableta signifying their clan. The dancers all enter the spacious dancing area from the east, making long rows from one end of the pueblo to the other. The youngest members, some no older than four, are accompanied by an older dancer, to show them the proper movements which they master quickly. There are four hundred to six hundred dancers at one time occupying the square.

Reasons for Jemez feast days are much the same as at the other pueblos and include thanks giving and prayers for rain, healthy and beautiful crops, health, and longevity.

I sat for over an hour next to one of the better-known storyteller makers, enjoying the sights and sounds of the festival. She told me that, come rain or snow, the dancing would proceed. This celebration started at dawn and continued until sundown.

At the west end of the pueblo was a shed built from cottonwood branches and covered with evergreens. A door in the shed faced East. Inside was a religious statue that was being honored this day. One family was responsible for setting up and taking care of the shed. Everyone in the pueblo took their turn showing respect to the statue inside. After I watched for several minutes, I went to visit my friends, the Toyas.

Inside their very modest adobe home, a long table was set for visitors. The table was at least twelve feet long, extending from one end of the room to the other, and was covered with many kinds of food: plates of ham, turkey, chicken, and beef; dishes of vegetables, fruit, and several types of dessert: cookies, jello, pies, and cake. This food gave credence to the term "feast."

The Toyas seemed very happy to see me. They placed me at the head of the table and proceeded to serve me from each plate and dish. I ate and ate and then ate more! When I was finished, the girls wondered why I didn't eat more. I couldn't have put one more bite in my mouth and said so, so they fixed a plate for me to take home, along with a loaf of bread. As Judy invited me into the kitchen to put these things together for me, I noticed more than one hundred loaves of bread and a fifty-gallon cauldron of chili stew, warmed by a burner. The quantity of food was tremendous.

These fine and generous people fed not only friends and family but also complete strangers. I wondered how many of my family would invite strangers to dine with us for any reason?

I was told that these religious and spiritual people invite everyone in because they never know who that person might be! The person could be Jesus himself; and what would happen if they refused to feed him? What a lesson this is to the rest of us. The gentleness, generosity, and sense of humor found among the Jemez Pueblo Indians is unparalleled.

The pottery made by these people reflects their gentleness of spirit. Jemez pots are, for the most part, simple in form and decoration. Some of the younger artists are taking the art to another level, but the vast majority of Jemez potters cling to the methods done years ago. Jemez pottery has always held a special place in my heart.

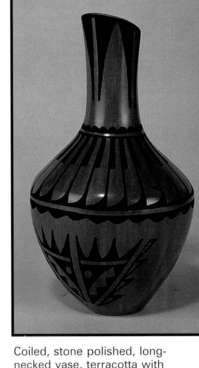

Coiled, stone polished, long-necked vase, terracotta with black design. 7.5"h. x 4"w. Signed **Jennifer Andrew**. **Walatowa**. $99

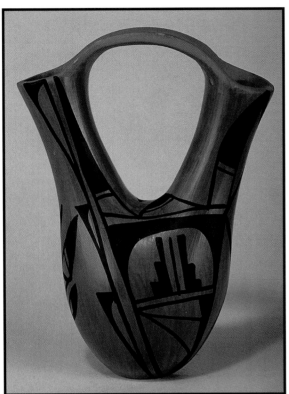

Coiled wedding vase, terracotta with black geometric design. 8.5"h. x 6.25"w. Signed **Chinana (Georgia)**. $39

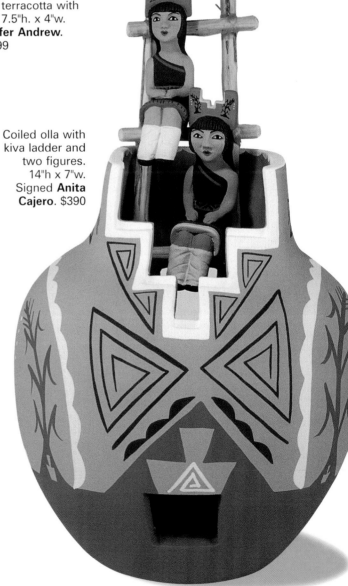

Coiled olla with kiva ladder and two figures. 14"h x 7"w. Signed **Anita Cajero**. $390

Coiled olla with multicolored design. 8"h. x 7"d. Signed **C. (Celina) Chavez**. $69

Coiled seed bowl, gray with carved pattern of eagle feathers and geometric design. 3.5"h. x 3"d. Signed **Angela Chinana**. $49.50

Coiled stone polished wedding vase, terracotta with black design. 7.35"h. x 6.5"w. Signed **Donald Chinana**. $45

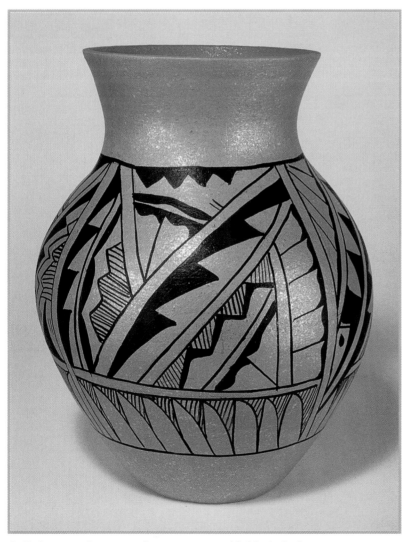

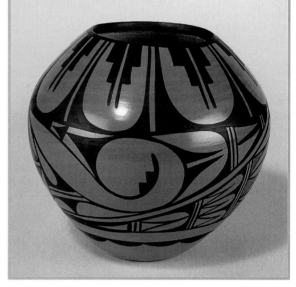

Stone polished bowl, terracotta with black design. 7.25"h x 8"d. Signed **Donald Chinana**, Jemez. $135

Coiled vase, micaceous clay, terracotta with black design. 11"h. x 8.5"d. Signed **(George) Chinana**. $165

Coiled seed bowl with etched petal design. 3"h. x 3.75"d. Signed **Lorraine Chinana**. $180

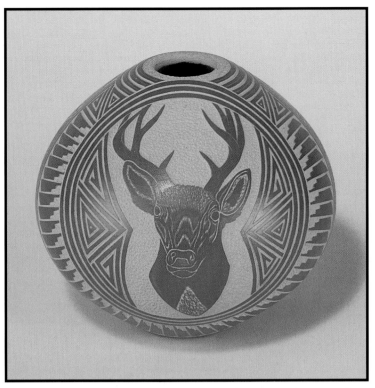

Coiled, stone polished seed bowl with scraffitto deer design and geometric patterns. 3.75"h x 4.25" Signed **Dennis Daubs**. $390

Coiled wedding vase, multicolor design. 9"h. x 4.25"w. Signed **(Percy) Chinana**. $30

Coiled, stone polished seed bowl with finial, etched sunface designs. 6.25"h. x 4.5"d. Signed **Glendora Daubs**. $1,350

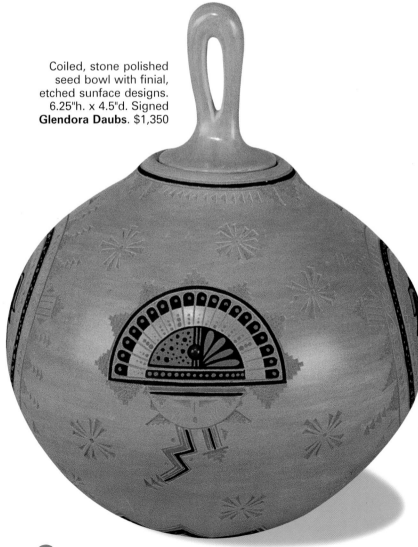

Coiled small bowl, floral design with acrylic paint. 2.5"h. x 2.75"d. **Fragua**. $12

Left: Coiled friendship bowl with children around rim. 4.75"h. x 6"d. Signed **Fragua**. $99

Below: Coiled, stone polished olla with etched and painted designs of lizards and Kachinas. 6"h. x 6"w. Signed **B.J. (Betty Jean) Fragua**, Jemez. $585

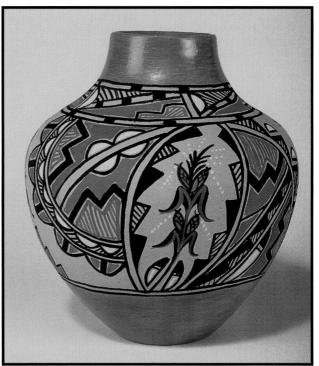

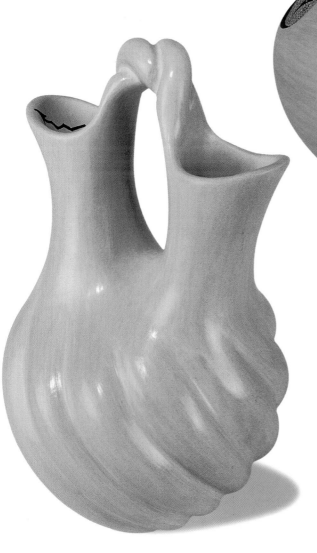

Above: Stone polished wedding vase, white swirl design with brown arrow painted in one spout. 8.75"h. x 5.5"w. Signed **Juanita Fragua**, Jemez. $540

Right: Coiled olla with terracotta, black, and white geometric pattern including cornstalks. 7"h. x 6.25"d. Signed **Lenora F. (Fragua)** 98. $135

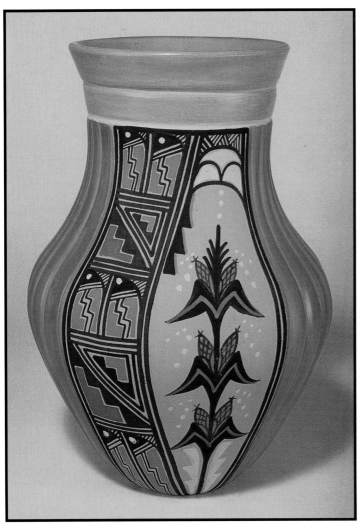

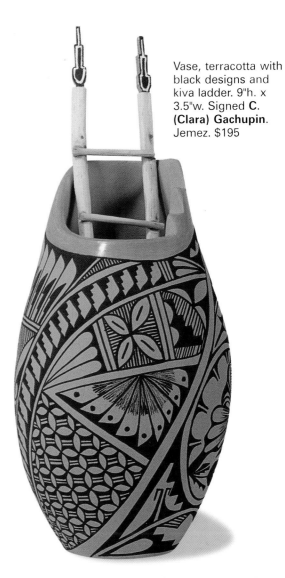

Vase, terracotta with black designs and kiva ladder. 9"h. x 3.5"w. Signed **C. (Clara) Gachupin**. Jemez. $195

Coiled vase, terracotta, black, and white with stone polished melon and corn design. 11"h. x 9.5"d. Signed **V.P. (Virginia [Ponca] Fragua)**. $285

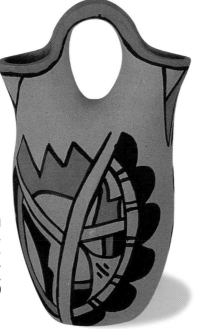

Coiled small wedding vase, 4.75h." x 3"w. Signed **M.F.G. (Gachupin)**. $8.50

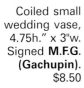

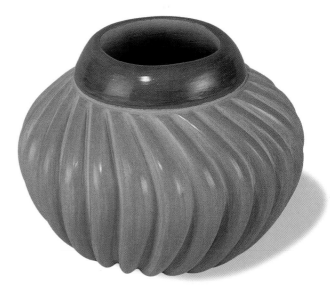

Small coiled olla, cream with melon design and terracotta rim. 2.5"h. x 3.25" w. Signed **Laura Gachupin**, Jemez. $300

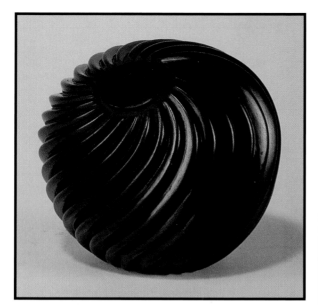

Coiled, stone polished seed pot, black with ridged design. 4"h x 4.5"d. Signed **Gabriel Gonzales**, Jemez. $750

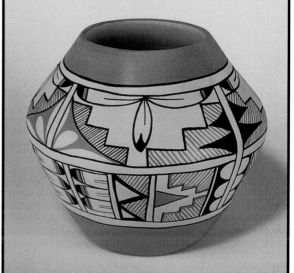

Coiled olla with terracotta and black design. 7.25"h. x 9"d. Signed **B.L. (Barbara Loretto)** $99

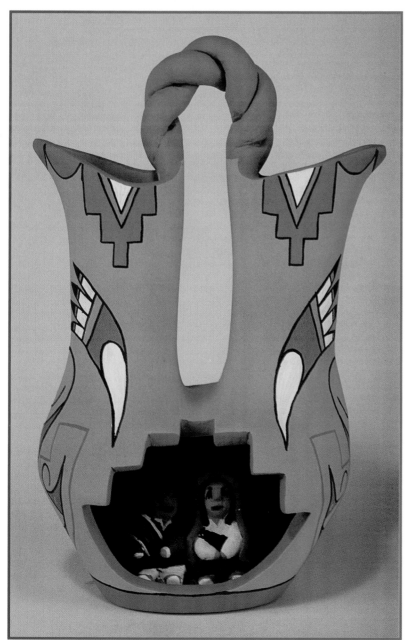

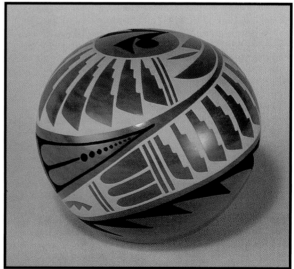

Above: Coiled, stone polished seed bowl with spiral design including wing pattern. 3.25"d. Signed **Mary H. Loretto**. $69

Left: Coiled wedding vase, cutaway with two figures and multicolored designs. 9.5"h. x 6.25"w. Signed **D.L. (Loretto)** $135

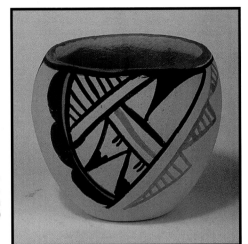

Coiled small bowl, 2.75"h. x 3"d. Signed **D.O. (Donna Ortiz)** $9

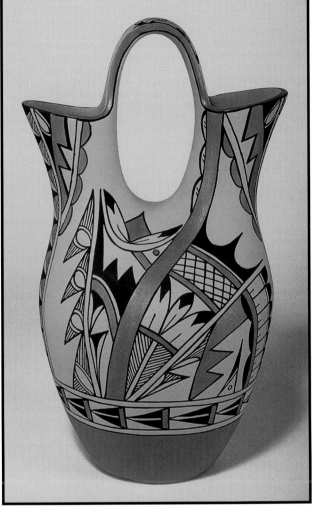

Coiled wedding vase, brown clay with terracotta and black design. 12"h. x 7"w. Signed **G.M. (Genevive Madalena).** $165

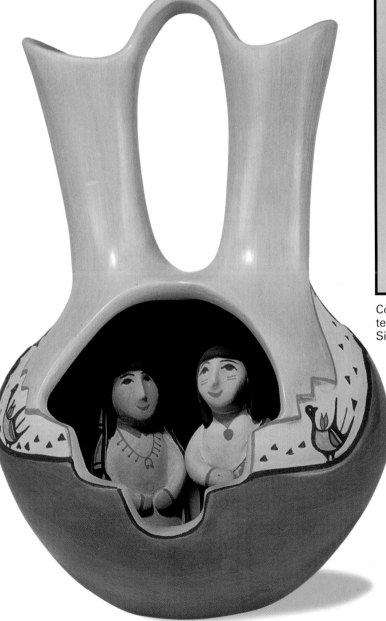

Coiled, stone polished wedding vase, cutaway with two figures inside. 12"h. x 9"w. Signed **Marie G. Romero**, Jemez, Walatowa. $450

Coiled, stone polished melon bowl. 4.25"h. x 5.25"d. Signed **Pauline Romero**. $345

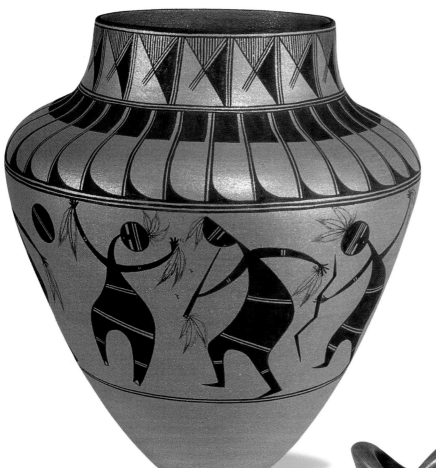

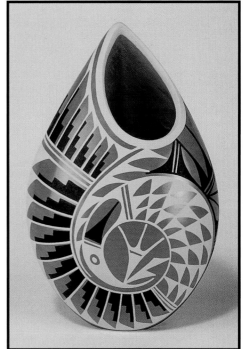

Coiled, contemporary shape, black and cream design. 7"h. x 4.25"w. Signed **G. (Geraldine) Sandia**. $330

Coiled olla, red micaceous clay with black design of dancers. 14"h. x 13"d. Signed **K. (Kenneth) J. Sando**, Jemez. $795

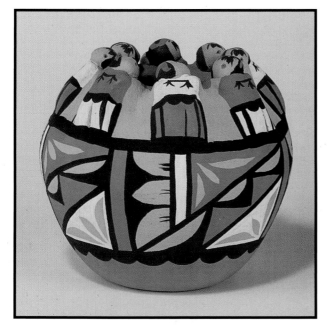

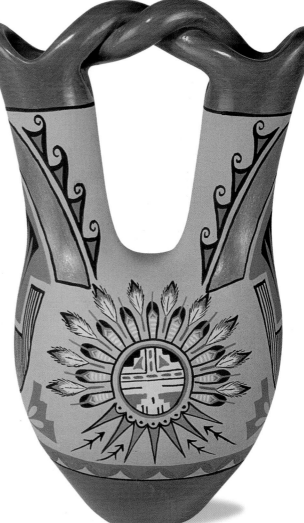

Above: Coiled bowl with figures of children looking over rim signifying friendship. 4.25"h. x 5"w. Signed **Caroline Sando**.$84

Right: Coiled wedding vase, stone polished with twisted handle, terracotta, brown, black, white, and blue design. 10.5"h x 7"w. Signed **V. (Veronica) Sando**. $285

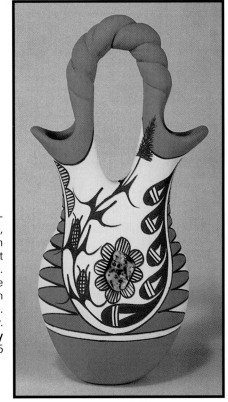

Coiled wedding vase, terracotta with black and light gray design. Turquoise stone in center. 8.75"h. x 4.25"w. Signed **Mary Small**. $195

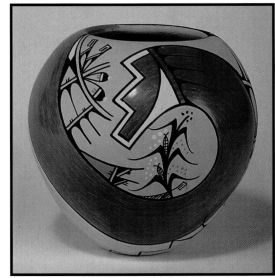

Coiled bowl, multicolored design with stone polished swirl. 6"h. x 6"w. Signed **Roberta Shendo**, Walatowa. $165

Coiled wedding vase, terracotta and brown stone polish with scraffitto hummingbird design. 10"h. x 7"w. Signed **Vangie Tafoya**. $540

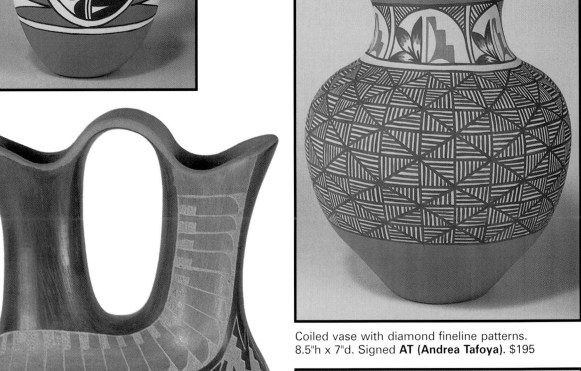

Coiled vase with diamond fineline patterns. 8.5"h x 7"d. Signed **AT (Andrea Tafoya)**. $195

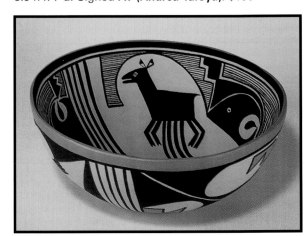

Coiled shallow bowl, deer design with terracotta and black geometric. 4 1/2"h. x 9"w. Signed **VJT (Verda J. Toledo)**. $165

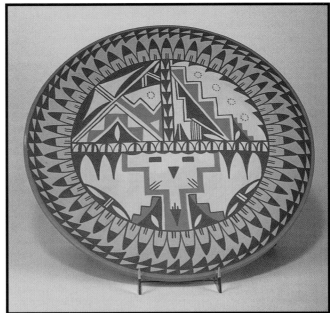

Coiled plaque with geometric designs and a kachina figure in center. 12.75"d. Signed **Mary Rose Toya**. $165

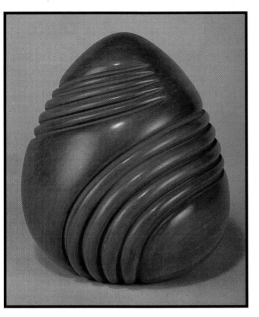

Coiled, stone polished egg shape, terracotta with ridges. 5.5"h. x 5"d. Signed **Damian Toya**. $285

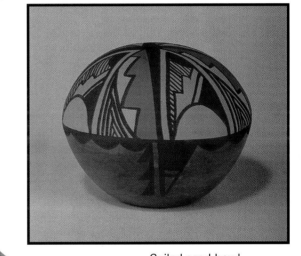

Coiled seed bowl with stone polished bottom. 3"h. x 3.5"d. Signed **M. (Mary) R. Toya**. $13.50

Coiled, stone polished olla, red with etched petal design. 11.5"h. x 12"d. Signed **Carol Vigil**, Jemez. $1,950

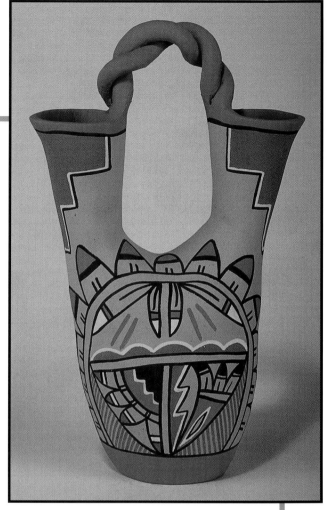

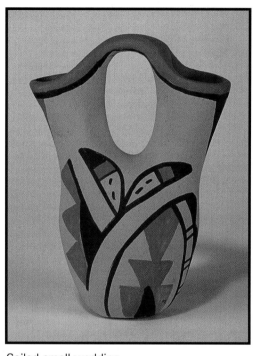

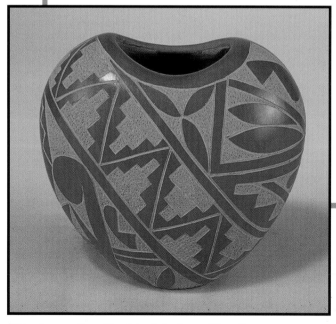

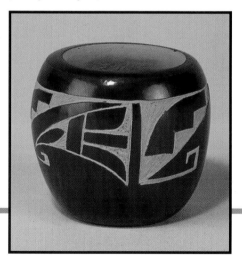

Coiled small wedding
vase, 5"h. x 4"d. Signed
A.W. (Angela Waquie) $10

Coiled wedding vase, multicolor
design. 9.5"h. x 6"w. Signed **JAW
(Joseph Waquie)** $39

Coiled small bowl, brown with
carved design. 1.75"h. x 2.25"d.
Signed **L. (Lawrence) Yepa**. $19.50

Vase, terracotta with etched designs. 4"h x 4"w.
Signed **Ida Yepa**, Jemez. $99

THE HEART

Art Lucario was dying. For several weeks Art had been feeling poorly. Thinking it was just a cold or flu, he thought he would feel better in only a matter of days and carry on his life as usual. Little did he know what was about to happen.

When Art visited the University of New Mexico hospital in Albuquerque, his physician completed a couple of tests to determine why Art had been feeling so weak for such a long time. The results confirmed the doctor's worst fear, that Art's heart had been damaged in some way. If it didn't improve soon, Mr. Lucario's chances for survival would be minimal.

The doctor determined that nothing short of a heart transplant would do Art any good. Art was put on a list of people in need of a new heart. As the days and weeks went by, Art's condition continually deteriorated. If a new heart could not be found soon, we would lose one of our favorite Laguna Pueblo artists.

As you might imagine, the pottery output that Art was accustomed to producing was down to about nothing. In the meantime, the family's expenses went on just the same. Something had to be done to ensure the survival of the family that was so dear to him.

One day Art and his wife, Velma, came into our store with sad looks on their faces. Both of these humble people wanted to say something but were finding it hard to get it out. I asked them if I could do something for them and they said that, as a matter of fact, I could. The Lucario's requested that I put a glass jar on the counter in our store and try to get people to donate their change, or whatever they could afford, to try to help while they were in this trying time of need. I agreed to do this for them. The glass jar had a simple hand-written note taped to its side stating that this family would appreciate any assistance they could get. This jar became quite a conversation piece at Palms, in the period of time it sat on the counter. People would ask about the person in need and would be generous in their donations to this worthwhile cause. It was amazing to see the generosity of our customers who were genuinely concerned about the life of a person most of them had never met. That jar brought in several hundred dollars and helped the Lucario family greatly in their time of need.

Fortunately, a matching donor heart was found for Art Lucario a couple of months later. When Art came into the store before he went into the hospital for the transplant, he thanked us for supporting him and his family in this time of great concern. We all knew the risks involved in this highly complex procedure and weren't sure if we ever would see each other again. I told Art I hoped everything would go well for him and that I was looking forward to the time when we could start to buy his pots on a regular basis again. Happily, Art survived the surgery and was back to normal about six months later.

When Art returned to Palms to sell us his ceramic etched pots (for which he is well known), we were very glad to see him, and there was a true feeling of companionship. Art's work was just as good, or better, than before he fell ill. But I was most impressed with the concern Art showed for the person who had provided a heart so that he could live. Art mentioned more than once how much he appreciated this person and this person's family, even though he had never met them.

To this day I feel good every time Art Lucario walks into the Palms. Not only is his work popular with our customers, but then we have an opportunity to talk —an opportunity we almost lost. Whenever I run across a piece of Art Lucario's pottery, I remember the struggle he went through to continue to create the work he does.

Coiled bowl with black and white design, terracotta at bottom. 7"h. x 7"d. Signed **L.A. (Lee Ann) Cheromiah**, Laguna, NM. $165

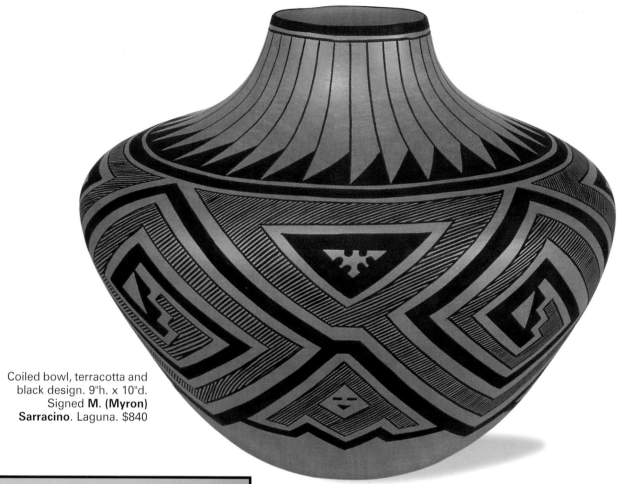

Coiled bowl, terracotta and
black design. 9"h. x 10"d.
Signed **M. (Myron)
Sarracino**. Laguna. $840

Molded, long-necked vase, black and white fineline
design with avanyu and red and blue trim. 10"h. x 8.5"d.
Signed **J.(Jon) Marris**, Laguna '95. $450

Molded olla, white with black Kokopeli and eagle kachina
etched designs, trimmed with terracotta. 8.5"h. x 10"d.
Signed **A. (Arthur) and V. (Velma) Lucario**, Laguna. $135

THE CLAN

I've never seen such a large disparity as there is from the old to the new in Navajo pottery. From traditional "pitch pots" to the great work of contemporary potters such as Lucy McKelvey, the Whitegoats, and others, there are vast differences.

The pitch pot is probably the most basic of all pot styles. Coiled from rich, brown clay, fired, and coated with heated pine pitch, its traditional use was utilitarian. The pitch coating seals the pottery and makes it suitable for holding water and other liquid. There are many shapes and designs produced, such as wedding vases, bowls, vases, and seed pots.

From that tradition, Lucy Luppe McKelvey developed pottery made from three different types of clay to get a kind of "swirl" look that can be found on pitch pots. Lucy adds traditional designs that tell the stories of certain Navajo ceremonies. Many of Lucy's pieces are simply stunning, and examples are included in the photographs here.

Finally, a most modern style of Navajo pottery has evolved. This pottery is poured in molds of various shapes, painted on a wheel in many colors, and, depending on how those colors come out, various designs are etched (cut) into the finish before the pot is fired.

The first pieces of this new type of Navajo pottery I saw were brought into Palms by Suzie Charlie in about 1991. When she showed me the pottery and told me the price she wanted for it, I thought the price was a little high and decided not to buy it. I really didn't think it would sell. BIG MISTAKE.

I freely admit this wasn't one of my brightest decisions, because in the next few months many of our customers began requesting the new Navajo etched pottery because it was colorful and intricately designed. I'm still teased by our staff about that decision. They tell me if I believe a certain style will not sell, we'd better buy some because it will certainly be the next hot item. Since then we have sold thousands of pieces of colorful, molded pottery made by many Navajo families.

We always have a memorable time when the Whitegoats or the Johnsons come into Palms to sell us their fine, colorful, etched pottery. Since it is such a long trip from their homes on the Navajo reservation to Albuquerque, the journey is made worthwhile by many members of the family making the trip together, including the artist, her husband, children, grandparents, a brother-in-law, and maybe a niece or nephew. They will all come into the store together and make themselves at home, which we encourage. A large amount of pottery is then unloaded onto our counters and organized by size so we can figure out the prices to pay for each piece. I don't think less than fifty pieces are ever delivered at any one time, including an entire range of shapes and sizes to give me a good variety. The proceeds from their sale are usually spent by the family at the large stores in Albuquerque.

It is always a pleasant experience to deal with Navajo women, for they are the ones in charge of each transaction, not the men. They are good business people looking for the best prices they can get, but they are always fair.

Coiled vase, First Prize, Inter-Tribal Indian Ceremonial 1998. "Whirling Rainbow Goddesses of the Windway Chant". 11"h x 15"d. Signed **Lucy Leuppe McKelvey**, Navajo. $4,950

Molded fetish pot with carved fetishes secured by leather cord, feathers, and crushed turquoise surface. Has a handful of cornmeal in the bottom of the pot for the fetishes to eat. 9.5"h. x 9.5"d. **Bernice Begay**. $225

Coiled olla, pine pitch with handles and horned toads attached. 15.5"h. x 10.25w. **Elsie Black**. $195

Large molded olla, etched. 13"h. x 9"d. Signed **P. (Peggy) Etsitty (Sam)** Dine, '99. $285

Molded seed bowl, etched multicolor designs. 7"h. x 7"d. Signed **Dena J. (Johnson)**. $84

Molded olla, etched multicolor designs. 3.75"h. x 5"d. Signed **Alvin & Ada M. (Morgan)**. $49.50

Molded wedding vase, etched multicolor designs. 7.5"h. x 4.5"w. Signed **Joann J. (Johnson)**. $39

Molded olla, etched multicolor designs. 11"h. x 5.5"d. Signed **Ella Morgan**. $165

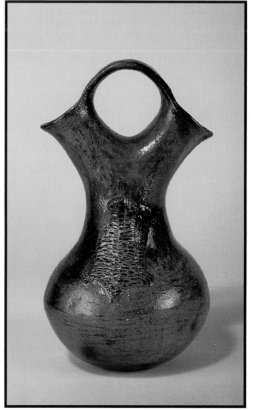

Coiled wedding vase, pine pitch with horned toad attached. 9"h. x 5"w. Signed **BM, (Betty Manygoats)**. Navajo. $69

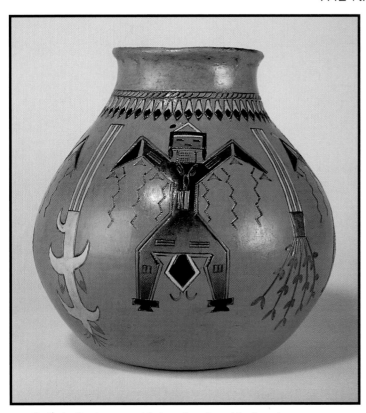

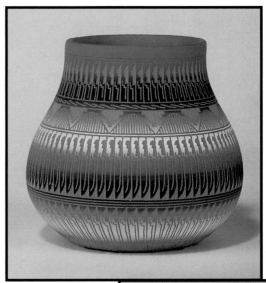

Molded olla, etched multicolor designs. 4.25"h. x 4.25"w. Signed **Em (Etta Morgan)** Dine, '99. $45

Coiled olla, brown with imprinted multicolored Yei figures and designs. 7.75"h. x 7"d. Signed **I.W. (Irene White)**. Navajo. $300

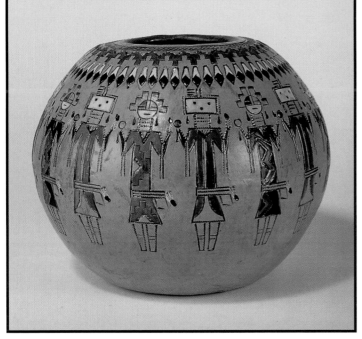

Coiled olla, brown with imprinted multicolored Yei figures and designs. 6.25"h. x 7.25"d. Signed **I.W. (Irene White)**. Navajo. $300

Molded seed pot with neck, bronze finish with sandpainting. 7.5"h. x 7.5"d. Signed **Craig White Eagle**. $150

Above: Molded seed bowl, pine pitch polish with bearclaw design (stamp was intended for silver). 4"h. x 4.75"d. **Michelle Williams**. $165

Left: Large molded olla, etched multicolor design. 11.5"h. x 13"d. Signed **Hilda Whitegoat**. $300

Coiled wedding vase, red into brown. 9"h x 4"w. Signed **Michelle Williams**. Navajo. $120

Coiled olla, pine pitch polish, red and brown imprinted design. 8.5"h. x 6.75"d. Signed **Lorraine Williams**. $300

Seed pot with multicolored design. 4.75"h. x 4.75"d. Signed **Lois (Gutierrez),** 1990. Pojoaque Pueblo, New Mexico. $525

SAN FELIPE

There are not many artists creating pottery at San Felipe, but we deal with a few. One is Marie Sandoval who creates traditional, mostly shallow bowls with geometric designs in both terracotta and white slip.

Another San Felipe artist we deal with is Hubert Candelario who takes his pottery making to a new level of detail. One of his "puzzle" pots is shown here. Micacious clay is his medium as he designs both "puzzle" pots and "swirl" seed pots. These forms are breathtaking.

Stone polished seed pot, red micaceous clay with carved black puzzle design. 8.5"h. x 8"w. Signed **Hubert Candelario**, San Felipe Pueblo, 1997. $2,400

Much has been written about San Ildefonso Pueblo, primarily because this is the home of Maria Martinez, arguably the best-known pueblo potter in all the world. An example of contemporary San Ildefonso pottery is included here as made by Carmelita Dunlap, Maria Martinez's niece. This jar is very similar to the pottery Maria made so many years ago. The classic matte-on-black polish design is exquisite.

Today I rarely can find outstanding large pottery pieces from San Ildefonso Pueblo, or Santa Clara for that matter.

Left: Coiled olla, black on black design with avanyu. 14.5"h. x 12"d. Signed **Carmelita Dunlap,** San Ildefonso Pueblo. $4,500

Below: Coiled, stone polished olla, black with terracotta trim and turquoise inlay. 4"h. x 3.75"d. Signed **Dora (Dora Tse-pe)** of San Ildelfonso. $2,400

There is one particular artist from San Juan Pueblo with whom I have the pleasure of dealing. Rosita De Herrera has been potting for many years and has a unique style, handed down from her mother, Tomasita Montoya. You can see a classic example of this style in the photograph. Rosita carves the clay deeply and outlines in white. Some of her pots are a combination of red traditional clay and micaceous clay with fine lines drawn within. No one else has a style quite like her's.

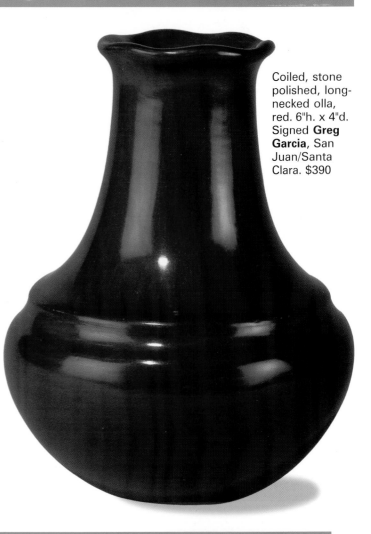

Coiled, stone polished, long-necked olla, red. 6"h. x 4"d. Signed **Greg Garcia**, San Juan/Santa Clara. $390

Bowl, red clay with carved designs highlighted in white. 4"h. x 6.25"d. Signed **Rosita De Herrera**, San Juan Pueblo. $285

Coiled olla with brown and terracotta designs. 8"h. x 8"w. Signed **Rachel Medina**, Tamaya-Santa Ana, 1998. $345

THE TRADE

One of my favorite memories of any potter from Santa Clara Pueblo came during the holiday season when Teresita Naranjo and her sister, Mary Cain, came to visit us at Palms. It has been a long-standing practice at Palms Trading Company to buy as much Indian jewelry and pottery as we could during the second week before Christmas. The reasons for this practice is, first, to insure a plentiful inventory, second to try to help the artisans with funds for their holiday celebrations, and third to make sure we could take care of our loyal customers in the last days before the holiday. Considering the shear number of artists with whom we deal, this created quite a crowd in the last few days, because after the deadline we would buy no more until after the first of the year. There were times a line of potters trying to sell a few items would stretch around the corner of our block and into the alley behind the store. I can remember taking hot coffee out to those people standing in the cold waiting for their turn to sell.

The following week was quite a bit less hectic, as we did no buying and tried to concentrate on servicing the hundreds of customers that would visit us each day. This would give us more personal contact with the people visiting Palms.

About half way through the week before Christmas, I would see a small, dark-haired lady coming through the door of the store. She always had her sister with her, but sometimes she would bring her brother-in-law and maybe a few children, and nephews and nieces. The lady I am speaking about, of course, is Teresita Naranjo.

Teresita had to be one of the most humble, pleasant, and charming ladies I have ever met. She did not have to be that way; she had a reputation as one of the finest potters ever at Santa Clara. Now even though we were not buying pottery that week, Teresita knew we would accommodate her and her family. This reasoning was not boastful in the least, it was just understood that she knew she was one of the most famous potters alive at the time, and she knew

that we realized it, too. The transactions with her are still etched in my mind.

This petite lady would walk up to a counter in our pottery room, set her basket on the floor, and begin to unwrap one of her masterpieces. Once the pot was out of its protective covering, she would gently sit it on the counter, look up at me, and ask me if I would like to trade. Teresita would give me her own special smile, the one that said she really didn't have to ask, and of course I would give the go-ahead for her and her family's shopping spree.

An average Teresita Naranjo pot in those times sold for about $1500. You can imagine the fun she would have looking through our jewelry, trying on different pieces, and finding just the right gift for everyone on her list. This shopping excursion would take one to two hours from the time she walked through the door until she brought the jewelry to me to see if the purchase price for the pot would cover the items she had chosen. I can't remember a time she didn't come out a little bit ahead. No cash ever exchanged hands. Pleasantries were exchanged, the gifts were packaged for the trip home, and Teresita would tell me she would see us again soon, although I knew it would not be until next Christmas. Just as quietly as she came in, she would leave.

As I reminisce about the many years this scenario was repeated, it saddens me to know that Teresita has passed on, and will not be coming in again. This was such a special time for me; I wish it could go on, and on, and on.

I enjoy knowing how these personal relationships develop and continue through the pottery, back to the people who create them. Every time I see a Teresita Naranjo pot, I remember those several occasions, all one year apart, when we would look into each other's eyes and understand without speaking. Teresita's memory lives on, not only in those of us who knew her personally, but in each person fortunate enough to have one of her magnificent pieces of pottery. It is pottery to cherish, just as I cherish those times we spent together.

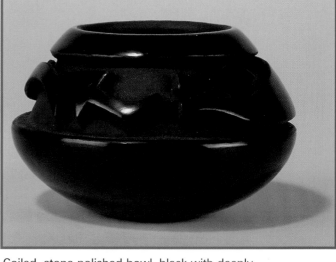

Coiled, stone polished bowl, black with deeply carved avanyu design. 2.75"h. x 4"d. Signed **Johanna and Anthony (Baca)**. $165

Coiled, stone polished olla, red with melon design. 6"h. x 4.5"d. Signed **Alvin Baca**. $330

Above: Coiled, stone polished seed pot, red with melon design. 2"h. x 4"d. Signed **David Baca**. $330

Left: Coiled, stone polished seed pot, black with deeply etched design. 1.25"h. x 3"d. Signed **Johanna and Anthony (Baca)**. $99

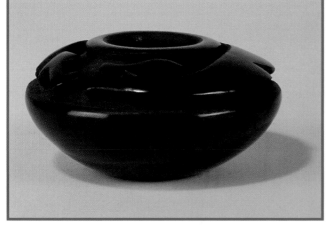

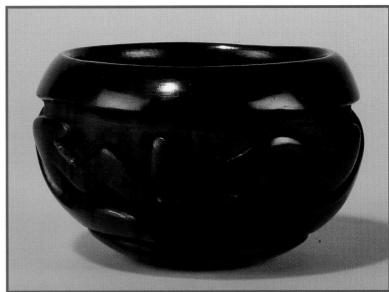

Coiled, stone polished bowl, black with deeply carved avanyu design. 3"h. x 5"d. Signed **Mary Cain**. $195

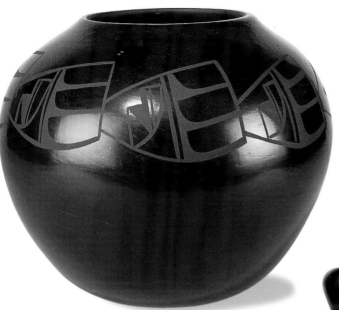

Stone polished bowl, black on black design. 9"h. x 10"d. Signed **Birdell Bourdon**, Santa Clara. $690

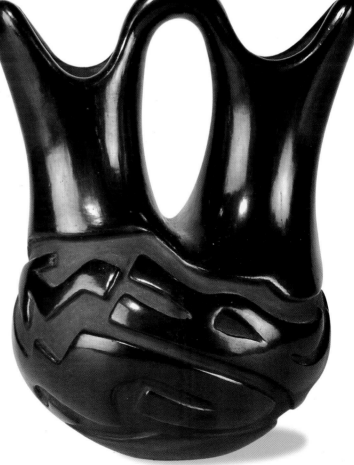

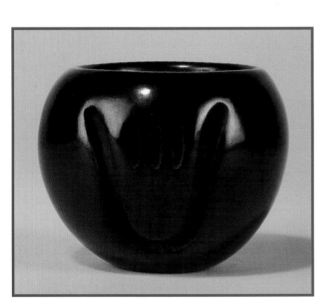

Coiled, stone polished bowl, black with deeply carved simple design. 2.25"h. x 3"d. Signed **Pamela Cata**. $47.50

Coiled, stone polished wedding vase, black with deeply carved design. 7.5"h. x 6.25"w. Signed **Mary Cain**. $990

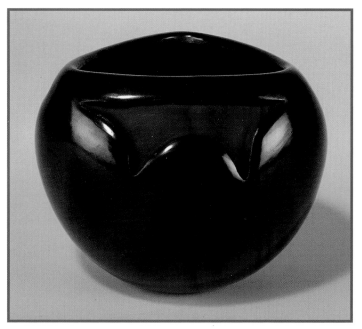

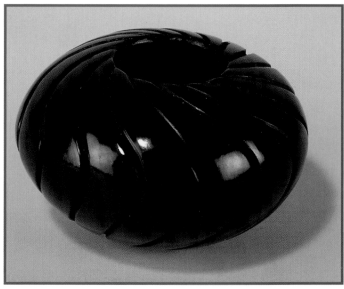

Coiled, stone polished bowl, black with deeply
carved design, triangular shaped rim. 3.5"h. x 4.5"d.
Signed **Sophie Cata**. $90

Coiled, stone polished seed pot, black with ridged swirl
design. 2"h. x 3.25"d. Signed **Denise Chavarria**. $165

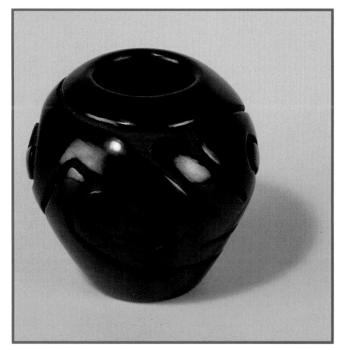

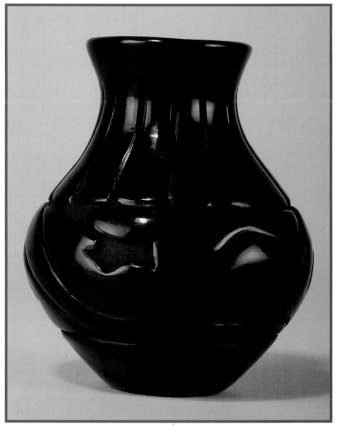

Coiled, stone polished olla, black with deeply carved
design. 3"h. x 3"d. Signed **Sunday (Loretta) Chavarria**.
Santa Clara. $165

Coiled, stone polished vase, black with deeply
carved feather and avanyu designs. 4.5"h. x 3.5"d.
Signed **Stella Chavarria**. $255

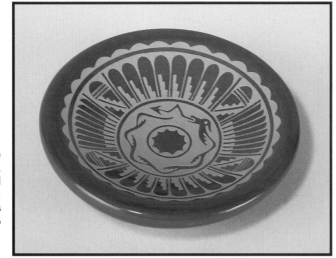

Coiled, stone polished, small bowl, red with painted design. .5"h. x 2.5"d. Signed **Dolores Curran**. $945

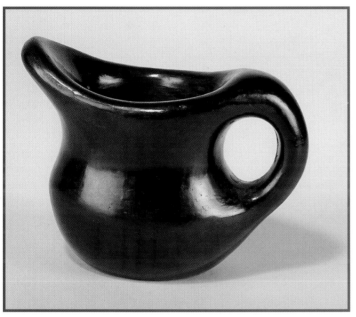

Coiled, stone polished pitcher, black. 3"h. x 4"w. Signed **Mary Eckleberry**. $69

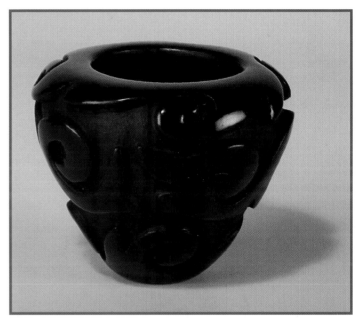

Coiled, stone polished olla, black with deeply carved spiral design. 3"h. x 3.75"d. Signed **Victor and Naomi Eckleberry**. $165

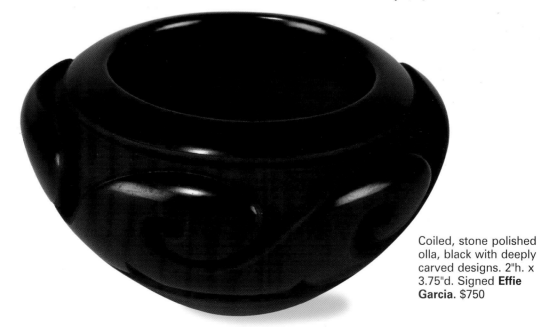

Coiled, stone polished olla, black with deeply carved designs. 2"h. x 3.75"d. Signed **Effie Garcia**. $750

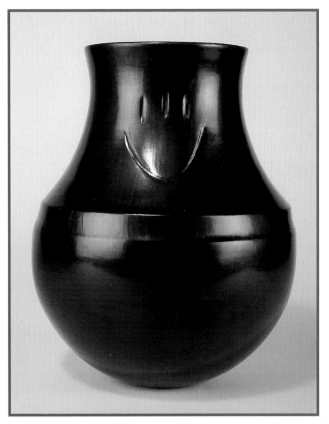

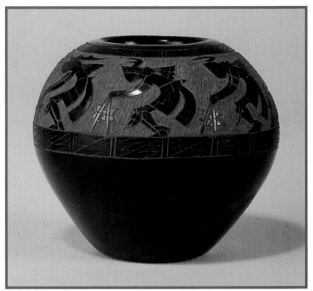

Stone polished olla, black with carved bear paw design. 9.5"h. x 6.75"d. Signed **Virginia Garcia,** Santa Clara. $675

Coiled, stone polished, small olla, black with etched dancers. 2.75"h. x 3"w. Signed **Goldenrod.** $1,035

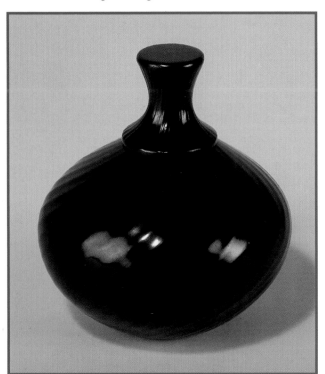

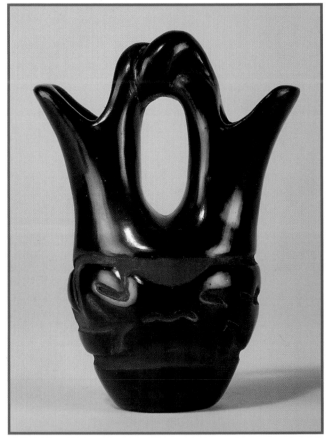

Coiled, stone polished jar with finial, black with light swirl design. 4"h x 3.75"d. Signed **Denny Gutierrez,** '97. $405

Coiled, stone polished small wedding vase, black with deeply carved design and twisted handle. 4.75"h. x 3.5"w. Signed **Jane & Starr (Jane Baca & Starr Tafoya).** $120

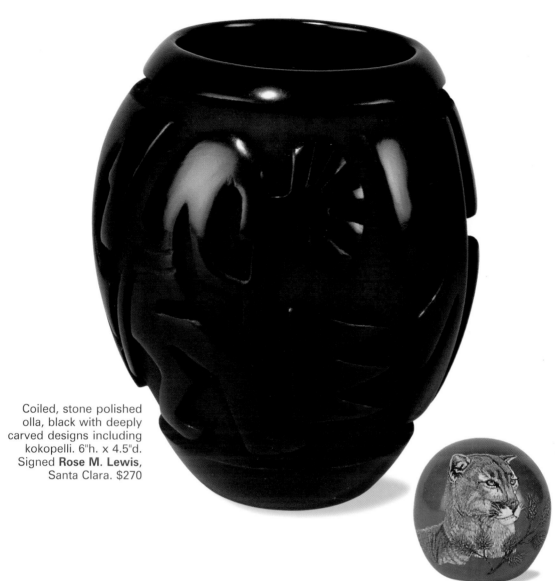

Coiled, stone polished olla, black with deeply carved designs including kokopelli. 6"h. x 4.5"d. Signed **Rose M. Lewis**, Santa Clara. $270

Coiled, stone polished, small seed pot, etched and painted cougar design. 1"h. Signed **Joseph Lonewolf**. $4,350

Coiled, stone polished seed pot with etched multicolored design. Snowy Egret. 2.25"h. x 2"w. Signed **Gregory Lonewolf**. $1,500

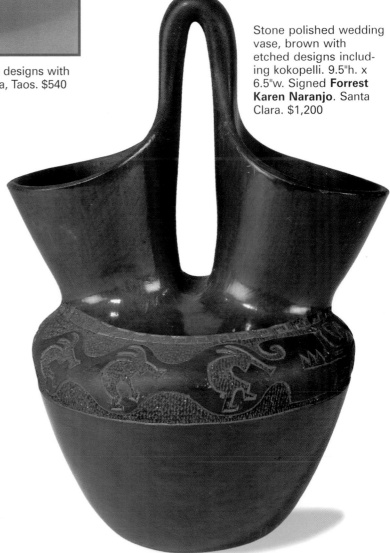

Stone polished pot, black with deeply carved kiva step designs. 4.75"h. x 5.75"d. Signed **Elizabeth Naranjo**, Santa Clara Pueblo. $300

Coiled, stone polished olla, brown with etched fine line designs with lizards. 5"h x 5.5"d. Signed **Bernice Naranjo**. Santa Clara, Taos. $540

Stone polished wedding vase, brown with etched designs including kokopelli. 9.5"h. x 6.5"w. Signed **Forrest Karen Naranjo**. Santa Clara. $1,200

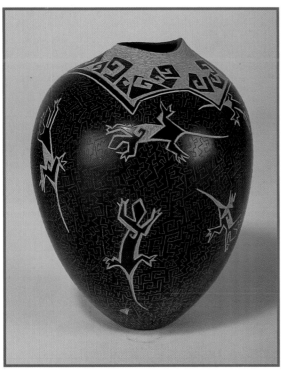

Coiled, stone polished olla, brown with etched lizard designs. 5.5"h. x 4"d. Signed **Dusty (Naranjo)**. Santa Clara. $300

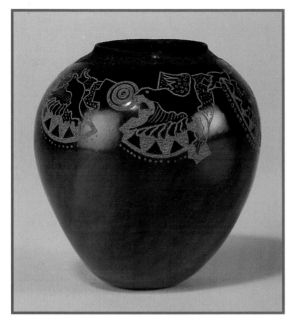

Coiled, stone polished, small olla, brown with etched bird designs. 3"h. x 2.75"d. Signed **Forrest N. (Naranjo).** $345

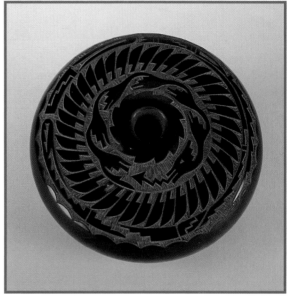

Coiled, stone polished, small seed pot, black with etched design. 1.5"h. x 2.5"d. Signed **Geri Naranjo.** $525

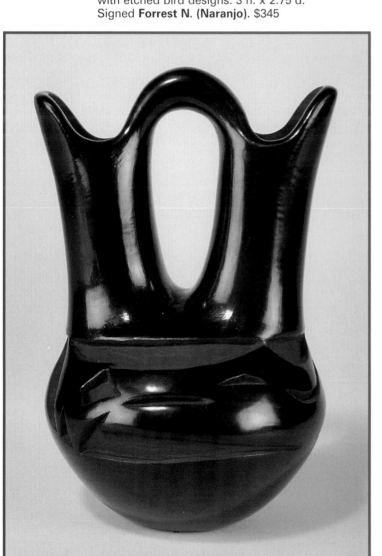

Coiled, stone polished wedding vase, black with deeply carved avanyu design. 8"h. x 5.25"w. Signed **Glenda Naranjo.** $300

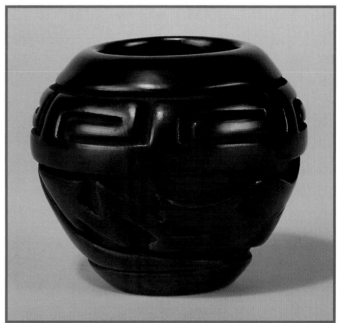

Coiled, stone polished olla, black with deeply carved wave and avanyu design. 3.25"h. x 4"d. Signed **Jennifer J. Naranjo.** $135

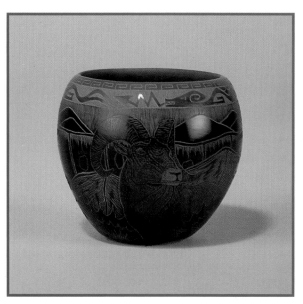

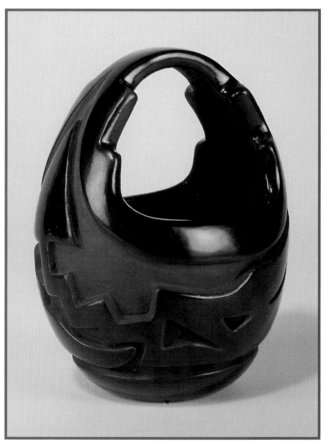

Coiled, stone polished, small olla, brown with etched landscape and ram designs. 2.25"h. x 2.5"d. Signed **Kevin Naranjo**. $675

Coiled, stone polished "basket" type bowl (egg shape with cutaway), black with deeply carved design. 6.25"h. x 4.75"w. Signed **Madeline Naranjo**. $375

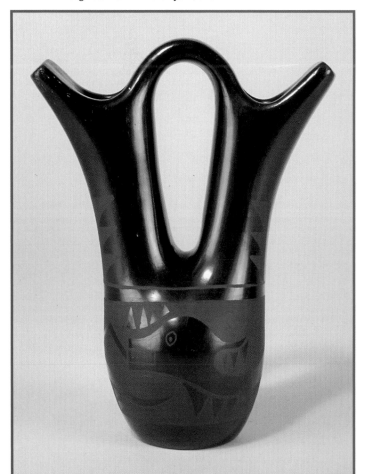

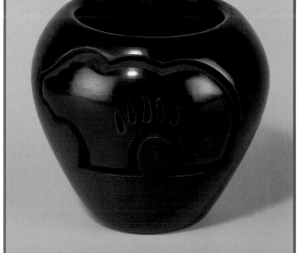

Above: Coiled, stone polished bowl, black with deeply etched bear design. 3.75"h. x 4"d. Signed **Sammy Naranjo**, '96, Santa Clara Pueblo. $255

Left: Coiled, stone polished wedding vase, black on black avanyu design. 6.25"h. x 5"w. Signed **Roberta (Naranjo)**. $450

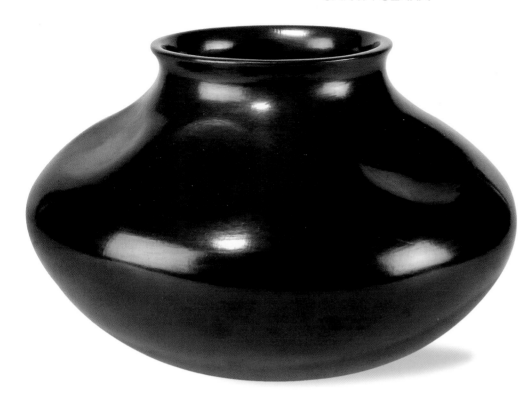

Stone polished pot, black with indented design. 8"h x 11.5"d. Signed **Sharon Naranjo-Garcia**, Santa Clara Pueblo. $900

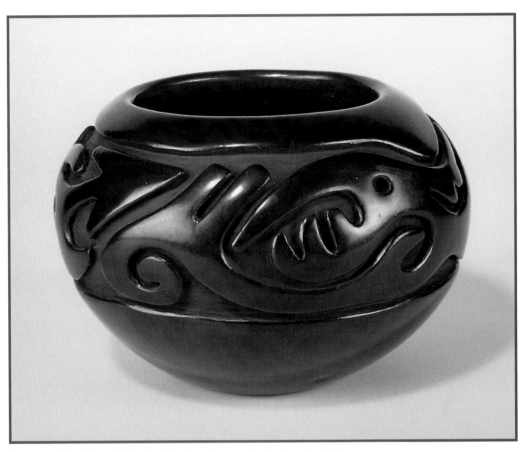

Stone polished bowl, black with deeply carved designs including avanyu, 5"h. x 7"d. Signed **Teresita Naranjo**, Santa Clara Pueblo. $3,000

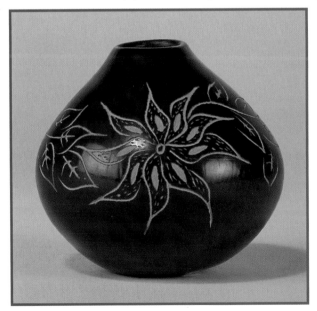

Coiled, stone polished seed pot, brown with etched floral design. 2.5"h. x 3"d. **Signed C. (Christine) Nieto.** $75

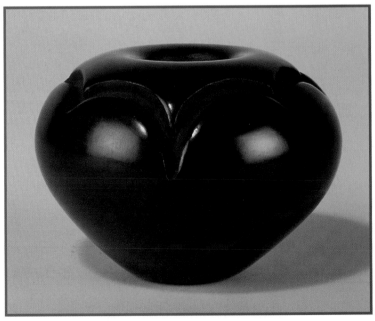

Coiled, stone polished seed pot, black with deeply carved design. 2.75"h. x 3.75"d. Signed **Elaine Salazar**. $99

Coiled seed pot, black with etched design, brown shading, inlaid stones, and 3" finial with star-shaped base. 7.25"h. Signed **Ron Suazo**, Santa Clara Pueblo. $675

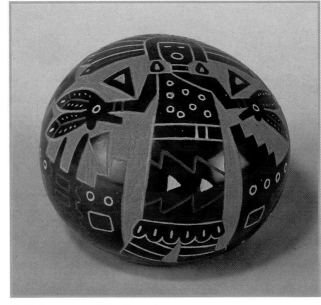

Coiled, stone polished seed pot, green with etched female dancer design. 2"h. x 2.25"d. Signed **Emily Tafoya**. $540

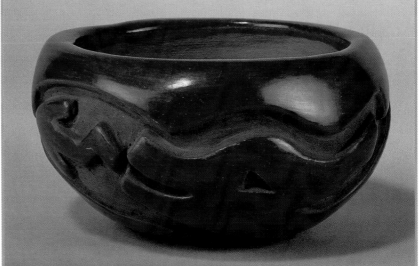

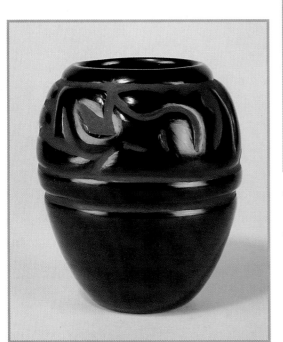

Above: Coiled, stone polished bowl, terracotta with deeply etched design painted with gray. 2.75"h. x 5"d. Signed **Doug Tafoya**. $135

Left: Coiled, stone polished olla, black with deeply carved avanyu design. 5.5"h. x 4.25"w. **Celes Tafoya** and **Evelyn Aguilar**. $210

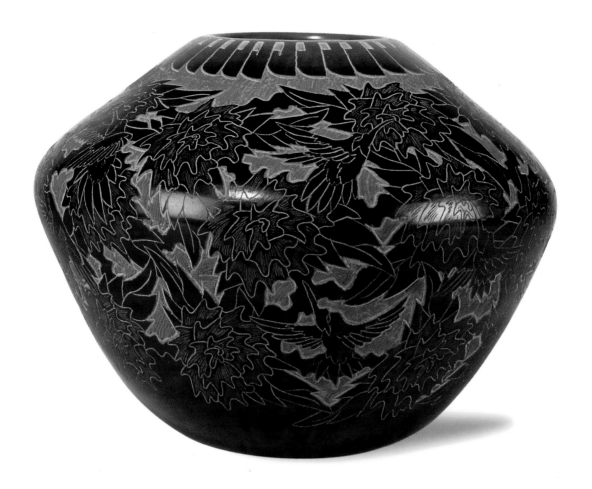

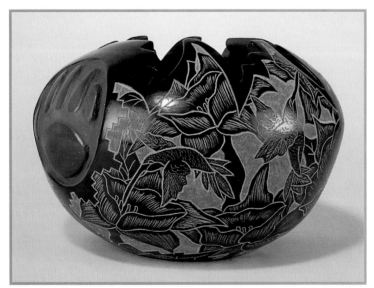

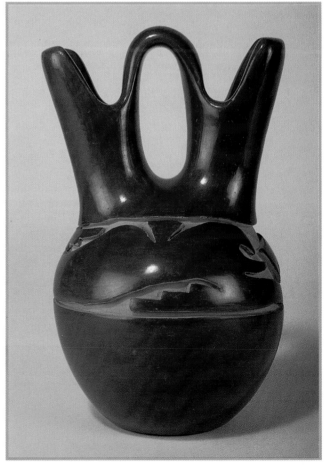

Top: Stone polished olla, black with floral etching and terracotta rim. 7.25"h. x 9.5"d. Signed **Eric Tafoya**, Santa Clara Pueblo. $1,500

Above left: Stone polished seed pot, black, carved rim, etched designs including hummingbirds and flowers. 5.25"h. x 8"d. Signed **Gwen Tafoya**, Santa Clara. $750

Right: Coiled, stone polished wedding vase, red with deeply carved design. 9"h. x 5.5"w. Signed **Mida Tafoya**, Santa Clara. $495

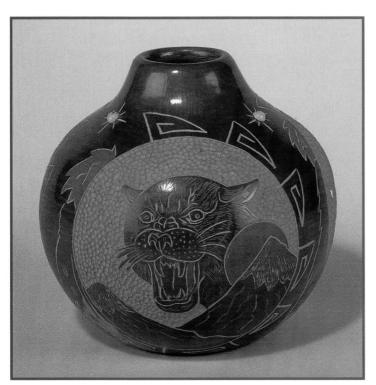

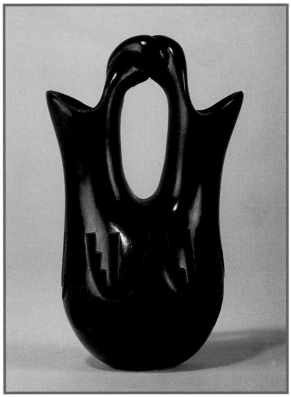

Coiled, stone polished seed pot, terracotta with etched mountain lion design. Turquoise stones set around top. 5"h. x 5"d. Signed **Marlin and Phyllis Tafoya-Hemlock**, Santa Clara Pueblo, N. M. $375.

Coiled, stone polished small wedding vase, black with deeply carved design, twisted handle. 4.25"h. x 2.5"d. Signed **Carol Velarde**. $285

Coiled, stone polished bowl, black with carved rim and micaceous clay. 2.5"h. x 5.5"d. Signed **Linda Tafoya-Oyenque**, Santa Clara-San Juan. $795

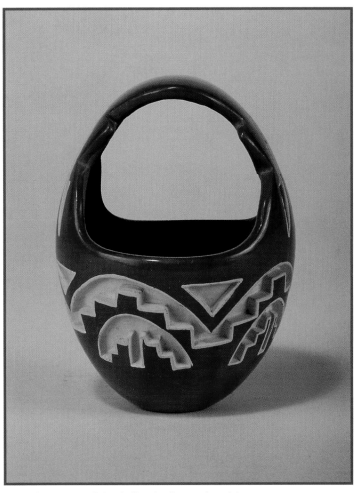

Coiled, stone polished, "basket" type bowl (egg shape with cutaway), terracotta with carved designs painted white. 4"h x 3"d. Signed **Carol Velarde**. $345

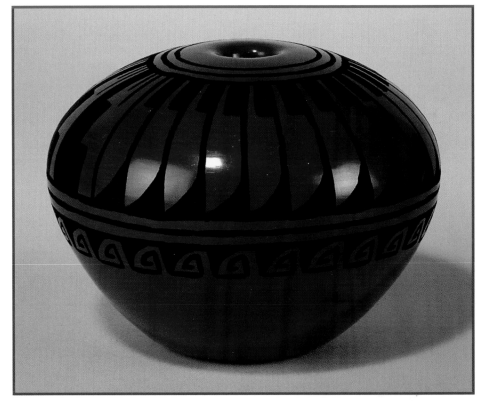

Above: Coiled, stone polished bowl, red with deeply carved bear paw design. 3.5"h. x 4.5"d. Signed **Tricia Velarde**. $99

Left: Coiled, stone polished seed pot, red with black painted design. 3.5"h. x 4.75"d. Signed **Minnie (Vigil)**. $375

THE FRIENDSHIP

"Guy, this is Robert Tenorio."

"Yes, Robert, what can I do for you?"

The voice on the other end of the telephone was clearly troubled. "Guy, sometime during the day someone broke into my house and stole several pieces of pottery. I'm calling a few dealers to see if the thieves try to sell them to let the police know." I told him that I would be happy to try to assist him in any way that I could, and that I would let him know if anything came up.

That phone conversation took place several years ago, at a time I barely knew Robert Tenorio. This type of thing is not an everyday occurrence, but it does happen occasionally. There are only so many places to sell items like the ones stolen from Mr. Tenorio's house. Thieves know that the more knowledgeable a person is about a particular piece of artwork, the more money they are likely to pay.

I thought nothing of the phone conversation for a few days, until one afternoon, about three days later, three men came into Palms with three pieces of pottery that looked suspiciously like Robert Tenorio's pots. I became alarmed immediately and asked the man trying to sell the pottery if he had made the pots. This person, with hesitations, said "yes." Oh-boy, I thought to myself, what do I do now? I made the decision to stall them long enough to call the proper authorities so they could apprehend the suspects. This turned out to be the hard part, because these people were not in the mood to stand around and chat.

As one of my employees called the Albuquerque police, I tried to think of ways to stall them so the cops would have enough time to get over to the store and apprehend them. My heart was racing as I went to the back room and stood there for a while just killing time. After that, I came back to tell them I had to consult with someone else to make sure I could buy the pots. Finally, I looked the pots over again, pretending to look for imperfections in the pieces.

I was beginning to run out of ideas on how to keep them in the store, when several plain-clothes officers came rushing into the store, pursuing the suspected thieves. Immediately, the men were forced to the ground, handcuffed, and given their rights. The men who had tried to sell the pottery yelled at me that they were "going to get me for calling the cops." I thought about that for a minute, but after a while, I realized that this was just an empty threat and I knew I had done the right thing. Needless to say, Robert Tenorio was elated that we had recovered his pottery. The next day he came to Palms and thanked everyone involved in the recovery effort.

Since that time, Robert Tenorio and I have become friends, not just acquaintances. We share mutual respect for one another, realizing we are in this world together, willing to help when given the opportunity.

Santo Domingo pottery is one of the most traditional pottery styles in existence today, and Robert Tenorio is one of its most prominent makers. A master potter, he is one of the most recognized and respected potters in any pueblo. He is probably the foremost expert on traditional potting methods and the intricacies of pottery creation. There is very little variation in coiling methods or design, but when I talk to Robert about his and other Santo Domingo pottery one would think he was describing plans to building the space shuttle.

Robert is constantly trying new slips and natural paints to achieve even the slightest variation in texture or color. Yet, while he continues to improve his work or emulate the work of older potters, Robert still adheres to the basic colors and designs of traditional pottery. His work retains his unique appearance and texture. You can appreciate the artist a little better when you hold a piece of his work and look at his designs.

Robert visits our store about once a month, providing a real treat for me. Not only does he have some of his newest creations with him, but he usually gives me another lesson of pottery-making techniques. I have learned much from him, such as the way he polishes the pottery with either egg whites or baked-in grease, or that certain slips don't adhere to some clay as well as they do to others, leaving streaks in the pottery that look as though the pot needs another coat of paint. These cannot be learned by any other method than experimentation.

Our trading post goes into action when Robert Tenorio arrives. He comes in the door and first asks if I need any of his pottery. Of course, the answer is always, "Yes." He then leaves to retrieve the basket or box containing the pieces we will be discussing. Almost every time he sells pottery to us, some of the transaction will include trading for other goods we carry, such as Pendleton blankets and jewelry. I've never known anyone else who needs so many presents in such short spans of time as this man. We're happy to oblige him, of course, but I think this shows what a fine human being he is that he would need so many gifts. It seems to me that Robert is always trying to help other people.

Robert Tenorio lives simply, and he seems content and happy every time I see him. I think this attitude is reflected in his pottery. I believe that pottery is a reflection of the person who created it and remains a symbol, not only of that person's life, but also of their soul. Pottery makers are normal people with the same problems and dilemmas that we all have. Pueblo pottery is a piece of someone's life, not just a clump of fancy dirt.

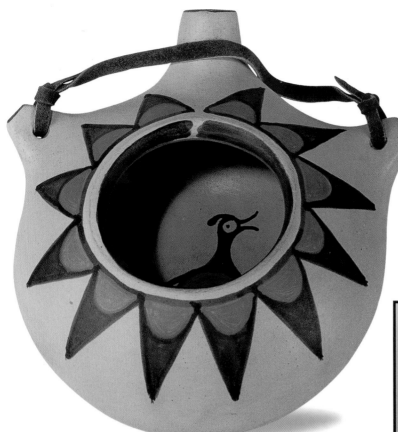

Left: Coiled canteen, cutaway with bird design painted inside. 9"h. x 7.5"d. Signed **Arthur and Hilda Coriz**. $375

Below: Coiled bowl, black, white, and terracotta design. 7.5"h. x 11"w. Signed **AML (Anna Marie Lovato)**. $135

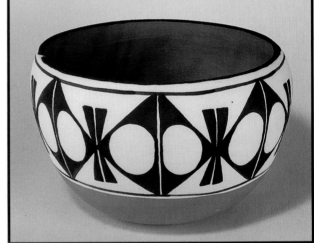

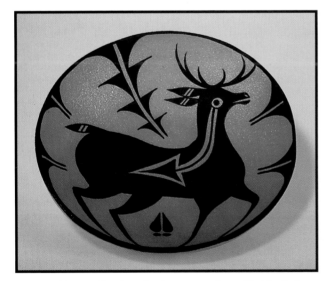

Above: Bowl, red micaceous clay with black deer design. 2"h x 8.75"d. Signed **P L. (Pedro Lovato)** Santo Domingo Pueblo. $54

Right: Coiled olla, bird design. 11"h. x 10.5"w. Signed **Paulita Pacheco**. $150.

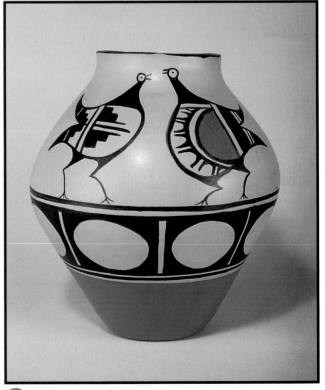

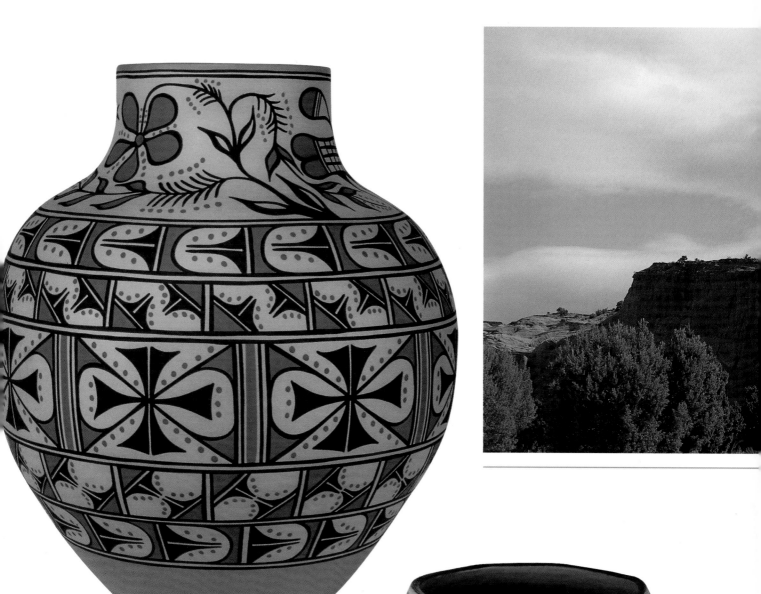

Above: Coiled olla, terracotta with black and gray design. 14"h. x 13"w. Signed **Thomas Tenorio**. $585

Right: Coiled olla, bird and flower design. 8.5"h. x 11"w. Signed **Robert Tenorio**, Tewa. $2,400

THE ADVICE

Ralph Aragon is one of my good friends from Zia Pueblo. He and I like to talk about different things when he comes to Albuquerque to sell his pottery and other artwork.

Zia is a New Mexico Indian Pueblo about fifty miles northwest of Albuquerque. You can see the old village from Highway 44 as you head Northwest to the four corners area. Like many of the other pueblos in the area, the buildings are adobe and centrally located around a plaza where dances and other ceremonies are performed for the community.

Ralph Aragon is a very important part of the Zia community, working in many ways to run the pueblo smoothly. Whether he helps clean the ditches in the spring so the water can flow freely to the crops, or participates in the pueblo council, he does what he can to contribute.

There are two things that Ralph has told me that I would like to share with you. The first and most important message is that in striving to do the best he can for his family, his community, and his faith, he always tries to achieve balance. When I talk with Ralph, I can see that he practices what he preaches. Ralph is the most unassuming, quiet, and pleasant individual I have ever met. Whether he speaks of jogging to keep in shape, how his daughter is doing in college, or negotiating the prices of his pottery, Mr. Aragon is always quite the gentleman.

This balance can be seen in his work. Ralph's pottery is handmade, but his designs are contemporary. He borrows ancient rock art designs and puts them on his pots, using a background of vibrant colors such as greens, blues, grays, and purples. These designs are interesting to me, because they show a connection between past generations and art of today. I like to use Ralph's pottery as an example of balance in life, because, like the story of the Acoma pot being a symbol of life, death, and afterlife, these pots are tied to the ancient past. People who have gone before looked at these same symbols. We have to wonder what they had in mind when they created them, but I believe the meanings were much the same as we see them today.

The most interesting story Ralph told me, however, had to do with the Zia Pueblo Council.

Men from the village are asked to serve on the council by standing council members. One must then serve a certain amount of time. Once that time has passed, the only way for a member to leave the council, is when the other members have determined he did a good job. If he has not done a satisfactory job, he must stay on the council until he does!

Since this membership is voluntary and no one is paid, each man tries to do the best he can.

I've often thought this was wonderful way to get the best out of politicians. What if American politicians got paid only if they had done a good job? I doubt many would ever be paid under such a system.

Since Zia is such a small pueblo, all of the members contribute to the good of the community. Ralph Aragon, through his beliefs and his work, epitomizes what is unique about these people.

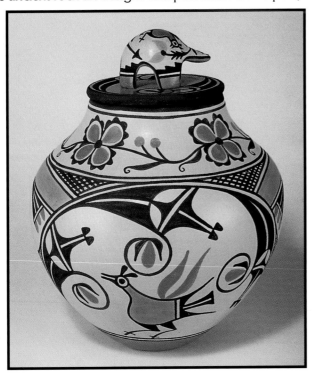 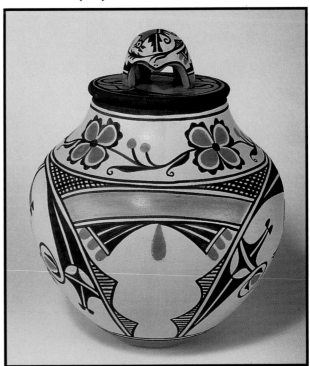

Coiled olla with bear lid and bird and floral designs finial. 11"h. x 10"d. Signed **Elizabeth Medina**. $690

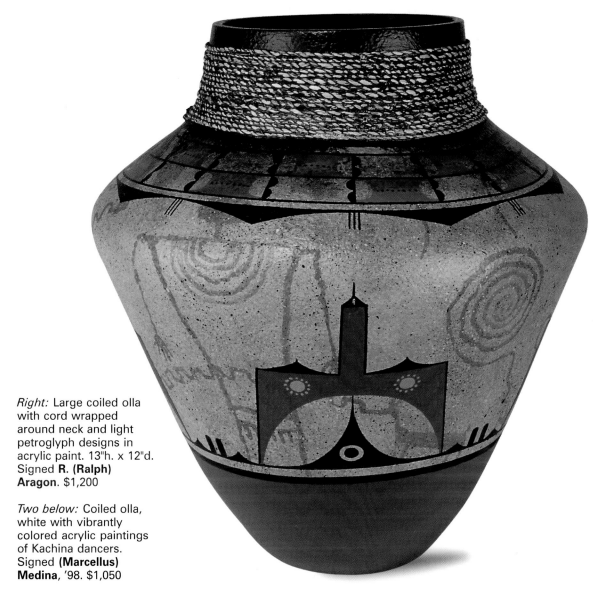

Right: Large coiled olla with cord wrapped around neck and light petroglyph designs in acrylic paint. 13"h. x 12"d. Signed **R. (Ralph) Aragon**. $1,200

Two below: Coiled olla, white with vibrantly colored acrylic paintings of Kachina dancers. Signed **(Marcellus) Medina**, '98. $1,050

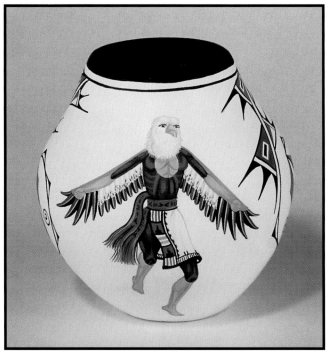 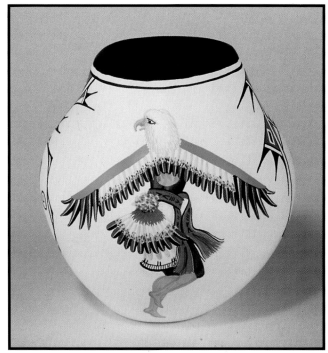

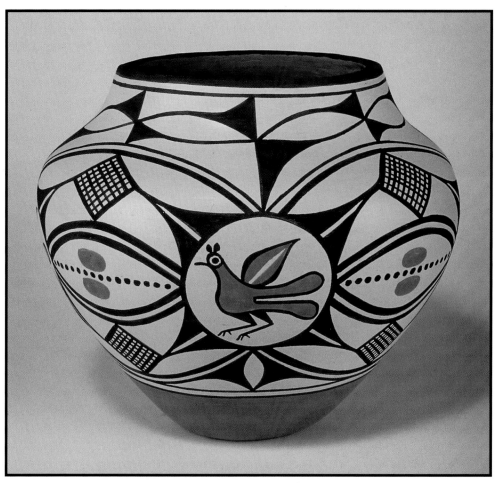

Coiled olla, pattern including bird design with stone polishing. 8.5"h. x 10"d. Signed **Sofia Medina**. $495

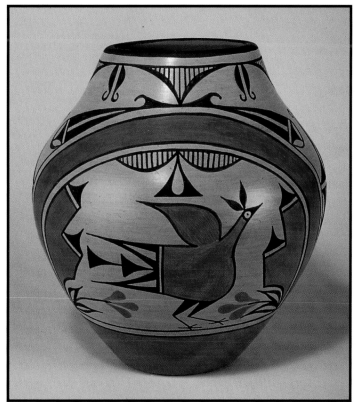

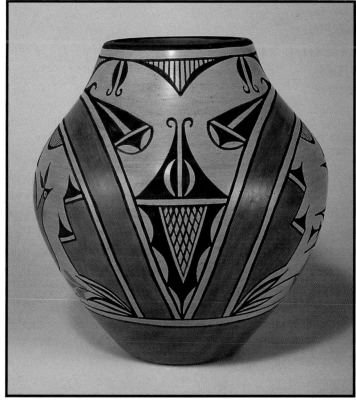

Coiled olla, design with bird image with stone polishing. 9"h. x 9"d. Signed **Erlinda Pino**. $375

ZUNI

The pueblo of Zuni, in New Mexico, is well known for the jewelry created there. However, the Zuni also create some of the most exquisite pottery available today. Most of the pottery from Zuni Pueblo has designs with a heartline deer, (deer with an arrow showing a path from the mouth to the animal's heart), or stylized lizards, along with sharp geometric designs. Zuni handmade pottery is quite desirable and collectible today.

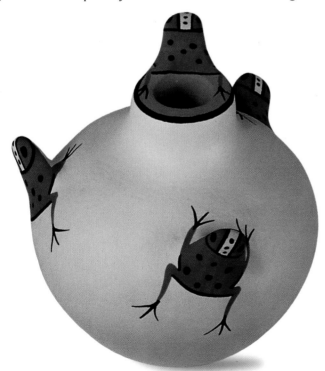

Coiled, small seed pot, white with frog designs. 3"h. x 3"d. Signed **Agnes Peynetsa**, 1999. Zuni. $135

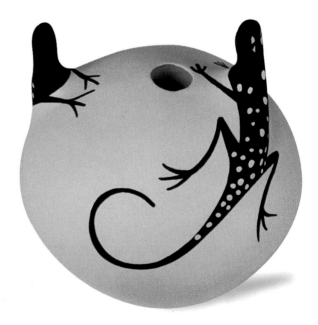

Coiled, small seed pot, white with lizard designs. 2.75"h. x 2.5"d. Signed **Agnes Peynetsa**, 1999. Zuni. $99

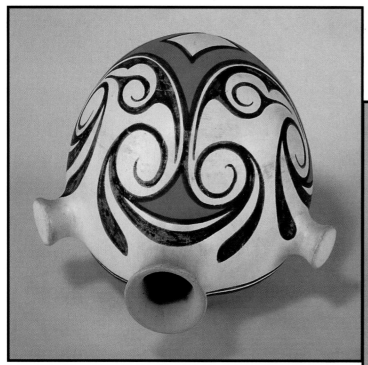

Coiled canteen, white with brown and terracotta designs. 4.5"h. x 4.25"d. Signed **A. (Anderson) Peynetsa**. Zuni. $240

Bowl, terracotta with black and white lizard design. 7"h. x 8.25"d. Signed **P. (Pricilla) Peynetsa**, Zuni. $450

THE STORYTELLERS

AND FIGURINES

ALPHABETICALLY ARRANGED BY ARTISTS

THE IMAGINATIONS

It gives me great pleasure to think, talk, and write about the pueblo storyteller makers. As a whole, these people, both men and women, have the greatest personalities of all the artists who work with clay. For the most part, these artists mirror the work they create.

All the storytellers and figurines pictured in this book are traditionally made pieces. The clay is gathered from places near the respective pueblos. The mud is dried, ground, and sifted. Finally, the clay is made moist again with water, to the desired consistency of the artist. Each main figure is built to the proper size to hold the number of children the maker wishes it to hold. Proportions are very important to each maker, as you can see in the photos. Some of the children are shown just sitting there listening, while other children are shown at play and still others may be sleeping. The variety provides the joy and uniqueness of each of these figures. None are the same, and although the styles may be similar, each has a personality of its own.

I would like to share stories of my experiences with two of the premier storyteller makers, now deceased, Mary E. Toya and Dorothy Trujillo. Mary was from Jemez Pueblo and Dorothy lived at Cochiti.

One day, we learned that Mary Toya was very ill and the doctors did not expect her to live much longer. Mary's daughters had informed us of the gravity of the situation and mentioned that if we wanted to see her once more, we had better go soon. Before long I found myself driving towards Jemez on another beautiful New Mexico day. As I recall, there was not a cloud in the sky and visibility was clear as far as the eye could see. The air was fresh and the colors of that day were vivid and breathtaking. As I drove Northwest to the Jemez Pueblo, I wondered how I would be received and what Mary and the family would really think of my coming to visit.

I arrived at the Toya house and walked up to the door and knocked. The door was answered by one of Mary's daughters. This woman looked very happy to see me and invited me in. As I entered the house, I noticed the modesty of the place. This house was simple, but I could feel the love and closeness of this family as I looked around. When I glanced over to the left, I noticed a *huge* storyteller that Mary had made some years before. This doll had more than one hundred children clinging to it. This masterpiece sat enclosed in a glass case with a first-place, blue ribbon hanging from it. In my mind, even today, this symbolizes not only the pride and talent of the Toya family, but could evoke the same thoughts and emotions of any storyteller-making family.

A single figurine can represent the legacy of the entire family: mother, father, and children. The large doll can tie much of the family's past, present, and future together. Past generations gave this gift to the young members of the family and it will be passed on to future generations.

Further into the house, I was led into the kitchen where I saw the rest of the Toya women. These girls were all in the small kitchen working on a new batch of storytellers. Some of them were creating with the clay on the kitchen table, others were washing utensils and tools, and still others were watching the temperature of the oven, where a new set of dolls was being fired. I felt so welcome and part of the group that I will always treasure that morning. I was able to see bits and pieces of the entire process, from beginning to end, just by walking into that kitchen.

Further along, I finally did what I had come to do, see and speak with the matriarch of the Toya family. Mary was also happy to see me; her face lit up in the morning light, despite the pain she must have been feeling. I don't think I have ever seen a person so close to death, yet so happy to be there in the midst of her family and friends. We visited for only a brief time, but I didn't need to be there for a long time to appreciate this wonderful lady. I realized, as I said good-bye for the final time, that there are real people behind the hundreds of storytellers and works of art I see every day. These people have families, both large and small, and they put their hearts and souls into every figure they create. Mary E. Toya passed away several days later, but she lives on through her art and her family.

Dorothy Trujillo, from Cochiti Pueblo, was quite the pious and religious person with a deep devotion to Mary, the mother of Jesus. Dorothy used to pray a great deal and would tell me, when she came to sell storytellers, that she was always praying for me, my uncle Angelo (now deceased), and our business.

Dorothy would ask me, before I bought her dolls, how well her other dolls were selling. If I said I hadn't sold very many of her storytellers since the last time I saw her, she would say "I'll start praying for you tonight and we'll see what happens." If I happened to tell her that we had sold many of her dolls since her last visit, Dorothy would tell me I sold them because of her prayers.

One comes to realize that the artworks of clay that these people create are extensions of their beliefs. We must look at the figures not as just another novelty, but as possessing the spirit of the maker in each figure.

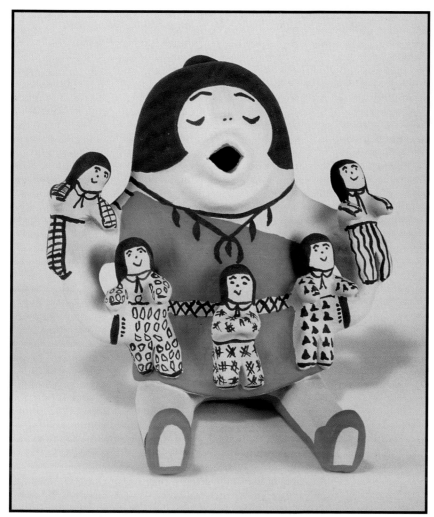

Storyteller, 5 children. 5.25"h. Signed **Martha Arquero**, Cochiti. $165

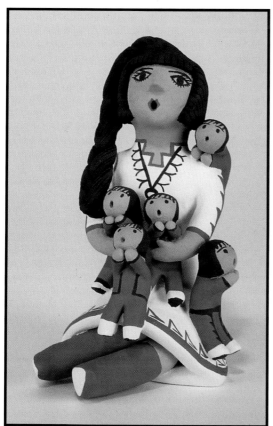

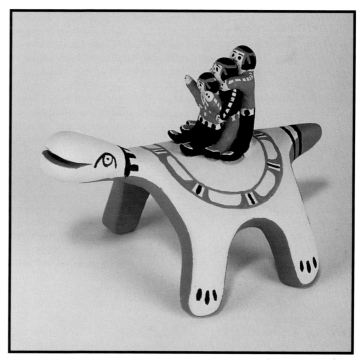

Above: Turtle with three riders, 4.25"h. x 6"l. Signed **Mary O. Chalan**, Cochiti. $99

Left: Storyteller, 5.5"h. Signed **Anita Cajero**, Jemez. $135

Bear and rider, rawhide and felt trim. 9.5"h. x 9.5"l.
Farrell Cockrun, Blackfoot. $285

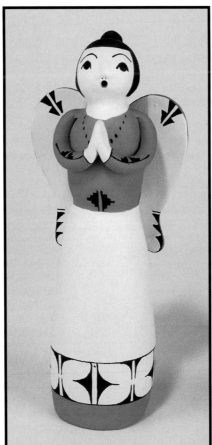

Angel, 8"h. **Angel Coriz**, Santo Domingo. $84

Storyteller, 7.25"h. Signed **L. (Leonard) Tsosie Corn Hill**, Jemez. $285

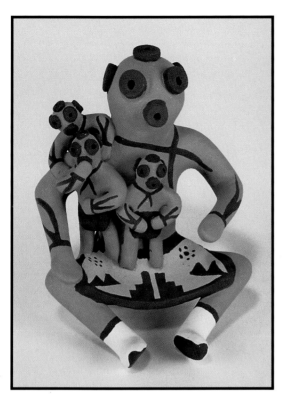

Mudhead storyteller, 5.25"h. Signed
Ben F. (Fragua), Jemez. $150

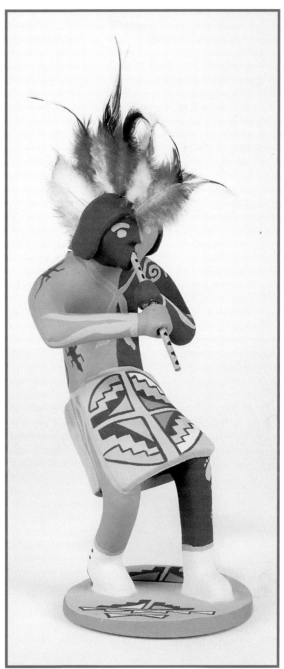

Clay
Kokopelli
with feather
headdress.
10.5"h.
Signed **B. F.
(Fragua),**
Jemez. $165

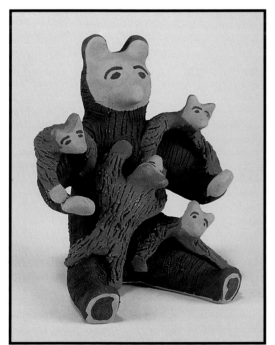

Bear storyteller, 5"h. Signed
Ben F. (Fragua), Jemez. $99

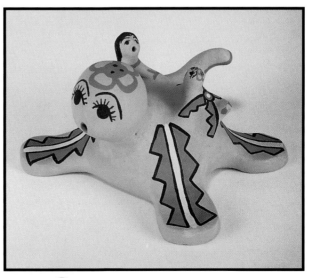

Turtle with two
children, 3.5"h.
x 5"l. Signed
Ardina Fragua,
Jemez. $135

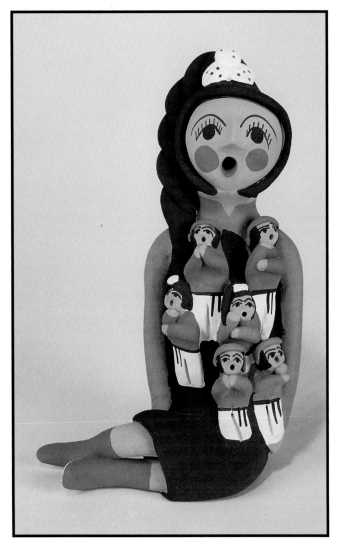

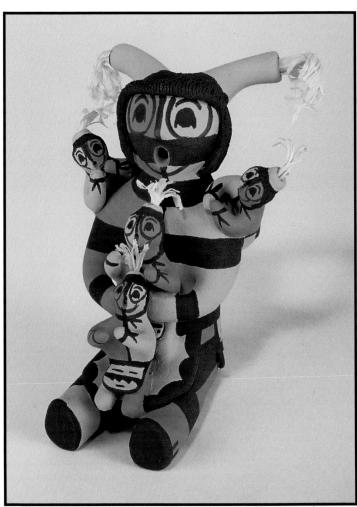

Above left: Storyteller, 6 children. 8"h. Signed **Cheryl Fragua**, Jemez. $120

Above right: Mudhead storyteller, 5.5"h. x 5.5"l. Signed **F. (Felicia) Fragua**, Jemez. $285

Right: Koshari storyteller, 6"h. Signed **Janeth Fragua**, Jemez. $135

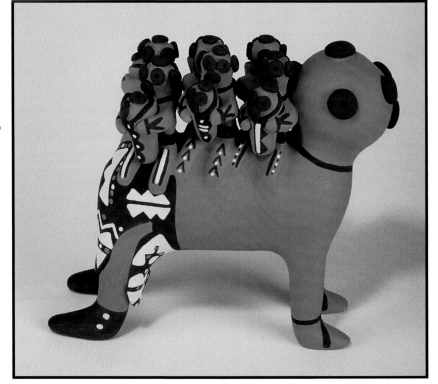

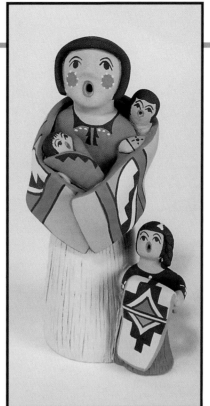

Storyteller, 8"h.
Signed **Philip M.
Fragua**, Jemez.
$285

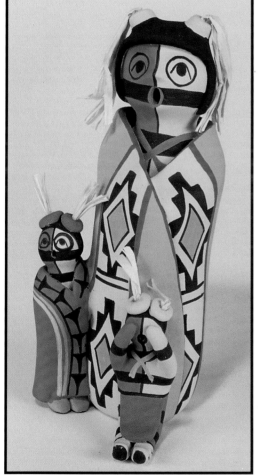

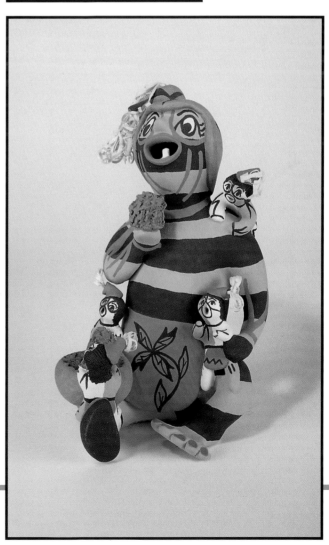

Above: Koshari storyteller, 2 children,
cornhusk tassels. 8"h. Signed **Linda
Lucero Fragua**, Jemez. $345

Right: Koshari storyteller, cornhusk
tassels. 9.25"h. Signed **Rose T. Fragua**,
Jemez. $390

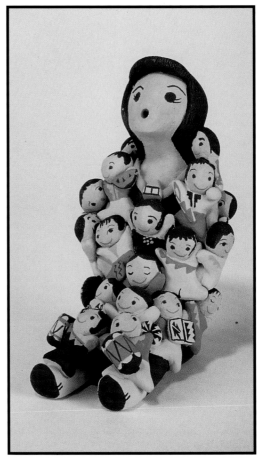

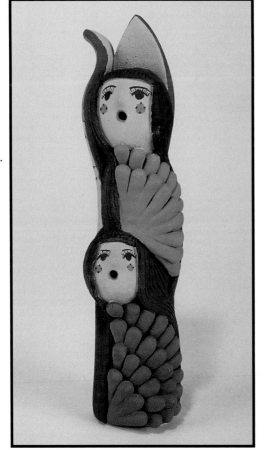

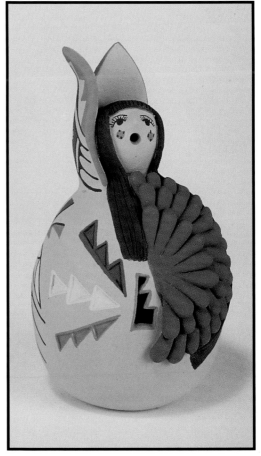

Top left: Owl figure, 5"h. Signed **Lenora F. (Fragua),** Jemez. $49.50

Top right: Storyteller, 17 children. 6.75"h. Signed **G. (Genevieve) Gachupin,** Jemez. $99

Bottom left: Corn Maiden figure, two maidens. 7.5"h. Signed **J. (Joseph) R. Gachupin,** Jemez. $240

Bottom right: Corn Maiden figure, 6.5"h. Signed **J.(Joseph) R. Gachupin,** Jemez. $240

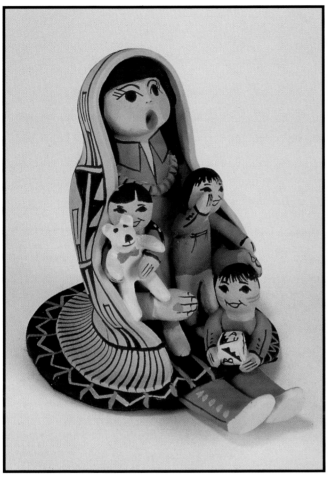

Storyteller, 5"h. Signed **(Carol) Lucero Gachupin**, Jemez. $270

Mudhead, black. 2.5"h. Signed **Dorothy & Paul. (Gutierrez)**. Santa Clara. $39

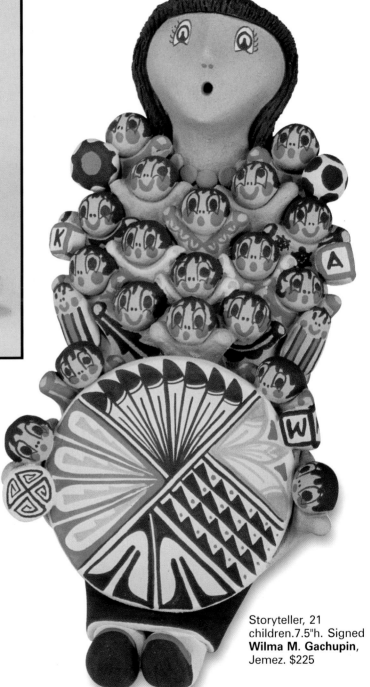

Storyteller, 21 children. 7.5"h. Signed **Wilma M. Gachupin**, Jemez. $225

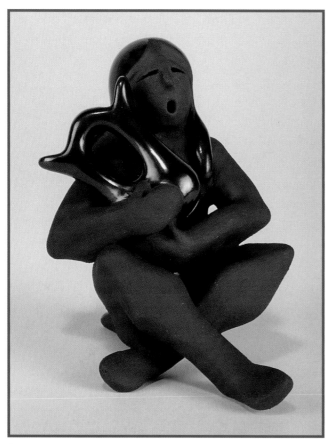

Figure with wedding vase, black. 4.25"h.
Signed **Gary Gutierrez**, Santa Clara. $285

Storyteller, 4"h. Signed **Margaret
(Gutierrez)**. Santa Clara. $495

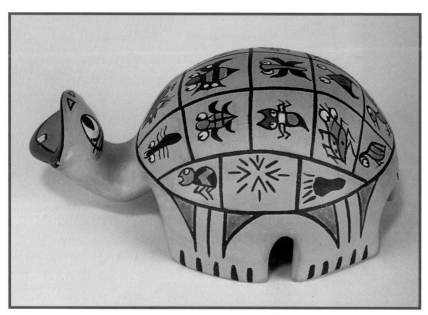

Turtle, 3"h. x 6"l. **Margaret
Gutierrez**, Santa Clara. $495

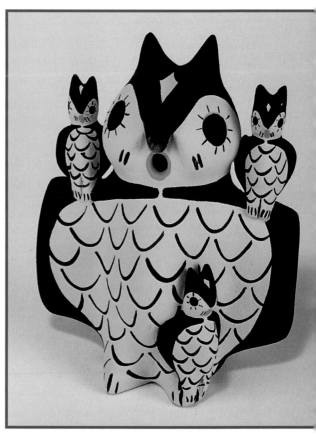

Storyteller, 7"h. Signed **Mary R. Herrera**,
Cochiti. $84

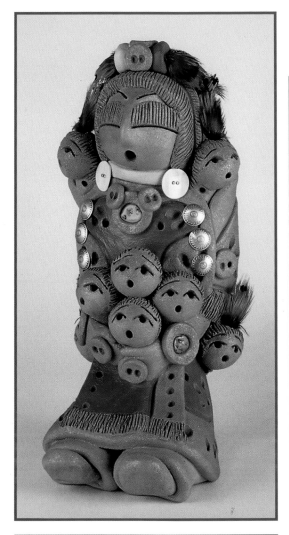

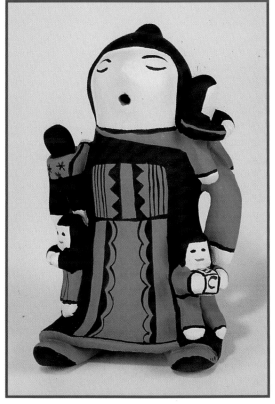

Above: Mask, trimmed with feathers, deerskin, and metal. 19"h. x 11"w. **Peter Ray James**, Navajo. $795

Top left: Storyteller, micaceous clay with buttons and feathers. 14.5"h. **Cheyenne Jim**. Navajo. $690

Left: Storyteller, 4 children. 6"h. Signed **M. Lewis**. Acoma. $99

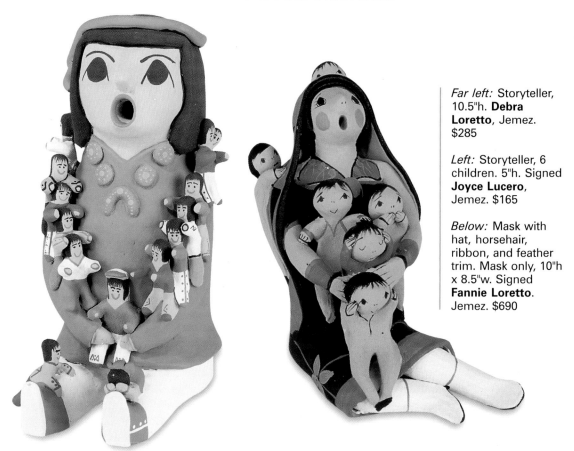

Far left: Storyteller, 10.5"h. **Debra Loretto**, Jemez. $285

Left: Storyteller, 6 children. 5"h. Signed **Joyce Lucero**, Jemez. $165

Below: Mask with hat, horsehair, ribbon, and feather trim. Mask only, 10"h x 8.5"w. Signed **Fannie Loretto**. Jemez. $690

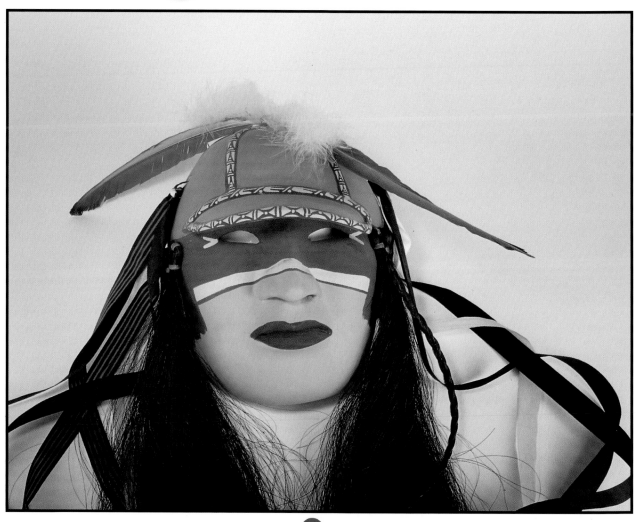

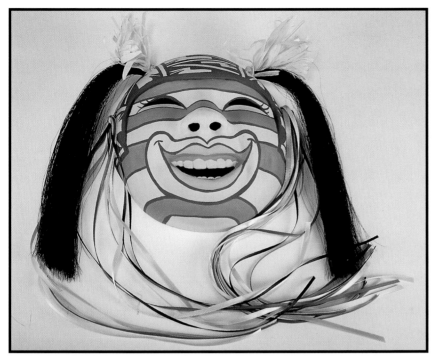

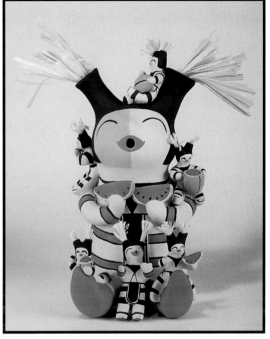

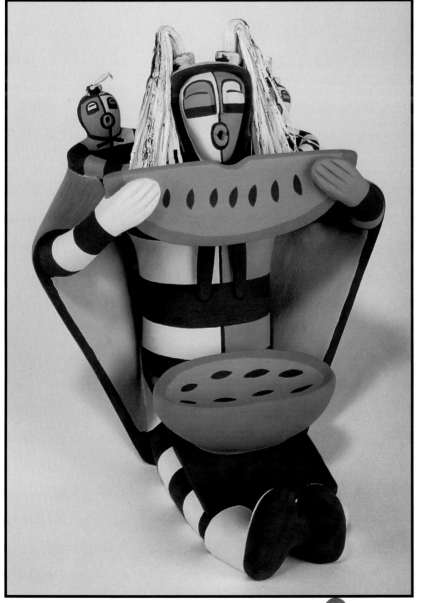

Top left: Mask, trimmed with horsehair, ribbon, and cornhusk. Mask only, 9"h x 8"w. Signed **Fannie Loretto**. Jemez. $285

Above: Storyteller, with cornhusk tassels. 15"h. **Lupe Lucero**, Jemez. $450

Left: Storyteller with cornhusk tassels. 8.5"h. Signed **R. (Reyes) Panana**. $495

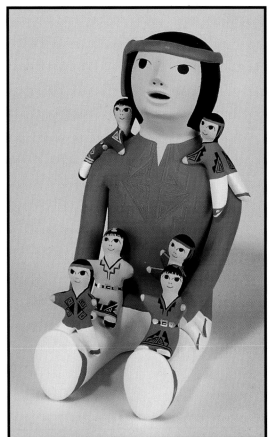

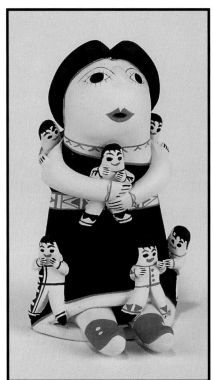

Left: Storyteller, 5"h. Signed **P. (Phyllis) Nez**. Navajo, Cochiti. $135

Below: Storyteller, 4 children. 6.25"h. Signed **Marilyn Ray**, Acoma, '99. $1,950

Above: Storyteller, 6 children. 7"h. Signed **Mary E. Quintana**. Cochiti. $345

Right: Storyteller, 5.5"h. Signed **Pablo Quintana**, Cochiti. $99

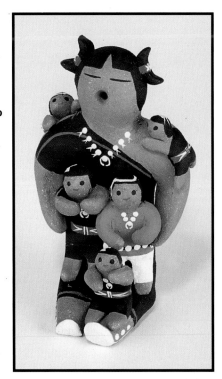

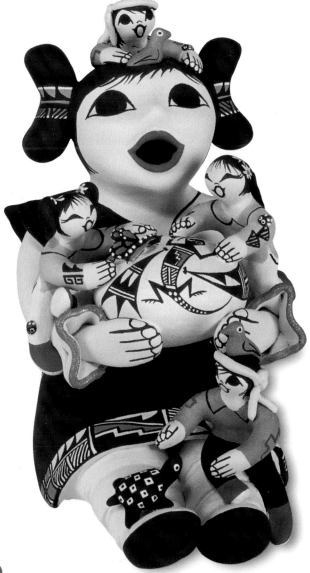

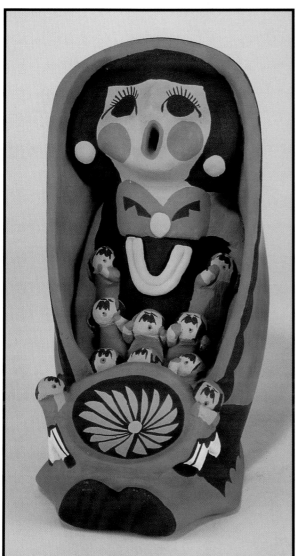

Left: Storyteller with manta, 8.5"h. Signed **Caroline Sando**, Jemez. $210

Bottom left: Storyteller, 4.5"h. Signed **N.S. (Norma Suina),** Hopi, Cochiti. $135

Below: Storyteller, 15"h. Signed **K. (Kenneth) J. Sando**, Jemez. $1,650

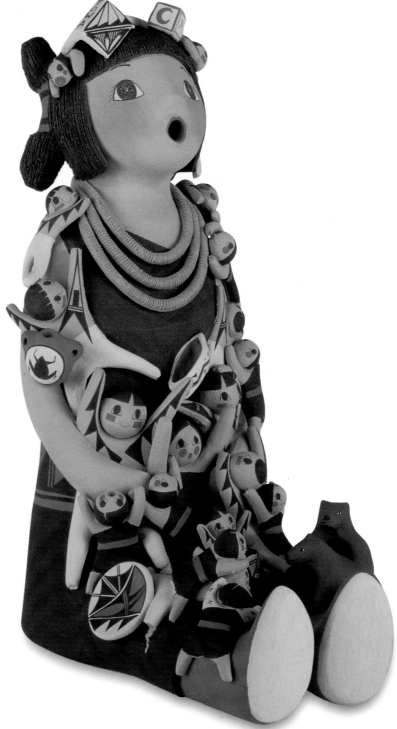

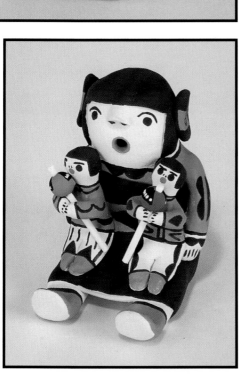

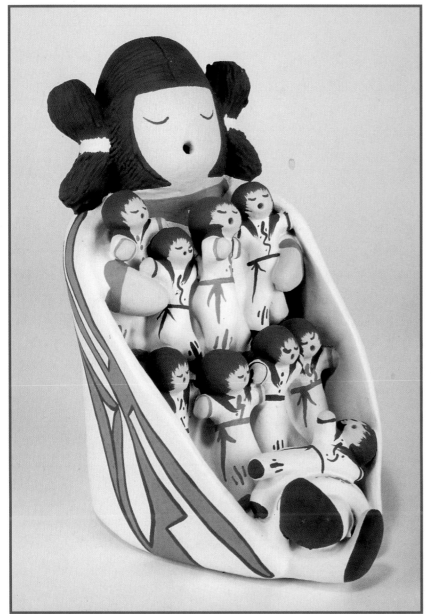

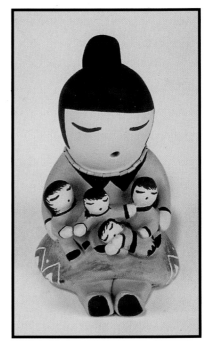

Storyteller with turqouise heishi necklace, 4"h. Signed **Lynette Teller**, Isleta. $165

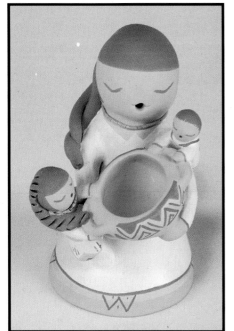

Above: Storyteller with manta, 8.5"h. Signed **C. (Christine) Teller**, Isleta. $450

Left: Storyteller with turquoise heishi necklace, 4.75"h. Signed **Stella Teller**, Isleta. $600

Right: Storyteller, 8"h. Signed **Mona Teller**, Isleta. $390

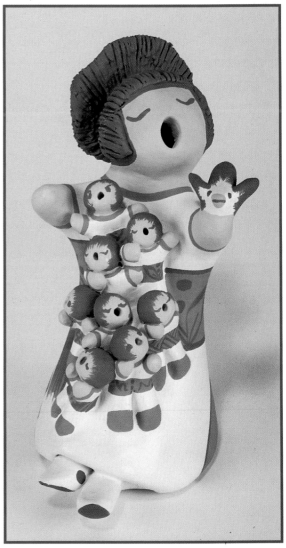

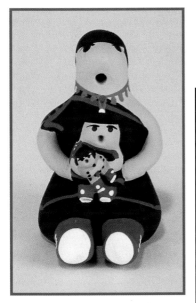

Storyteller, 2.75"h. Signed
G. (Gary) Tenorio, Santo
Domingo. $39

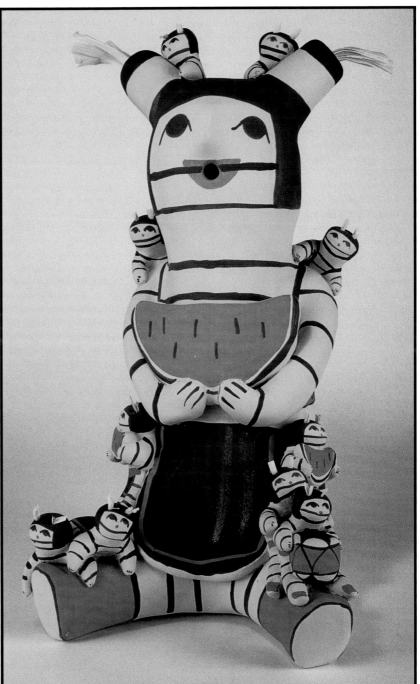

Storyteller, cornhusk tassels. 14.5"h.
Marie Toya, Jemez. $585

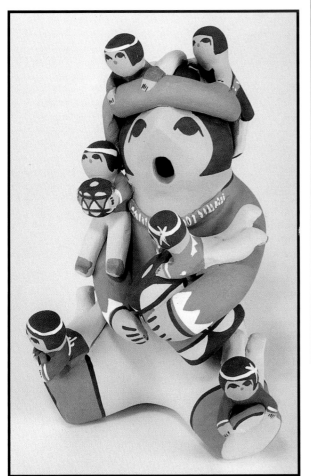

Storyteller, 8.75"h. Signed
Judy Toya, Jemez. $165

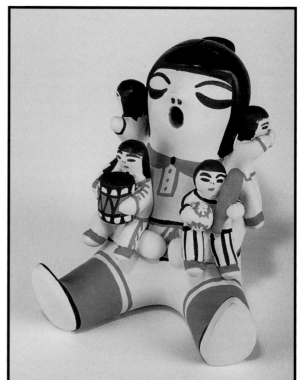

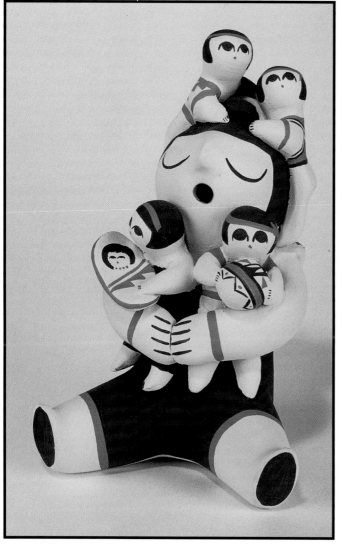

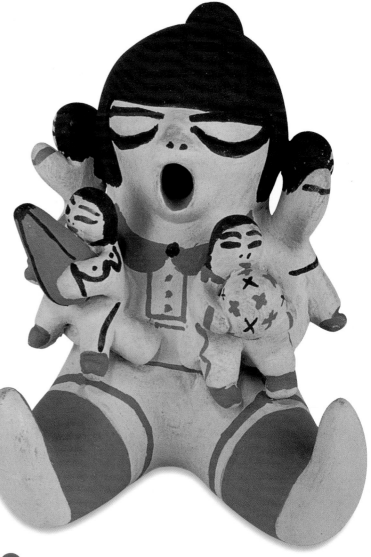

Above: Storyteller, 4 children. 7.75"h. Signed **Yolanda Toya Toledo**, Jemez. $135

Top right: Storyteller, 5.5"h. Signed **C. (Cecilia) Trujillo**, Cochiti. $150

Right: Storyteller, 6"h. Signed **D. (Dorothy) Trujillo**, Cochiti. $300

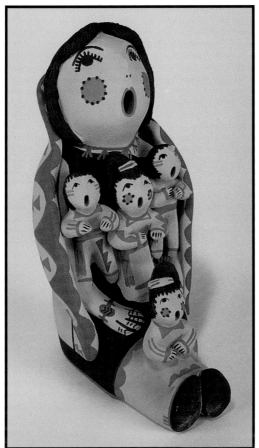

Left: Storyteller, 7.5"h. Signed **E. (Emily) Fragua Tsosie**, Jemez. $285

Bottom left: Storyteller, 7.5"h. Signed **D. Tsosie**, Jemez. $225

Below: Drummer, rawhide and wood drum. 9.5"h. Signed **Mary and Leonard Trujillo**, Cochiti Pueblo. $840

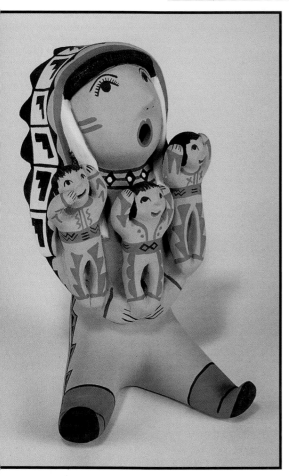

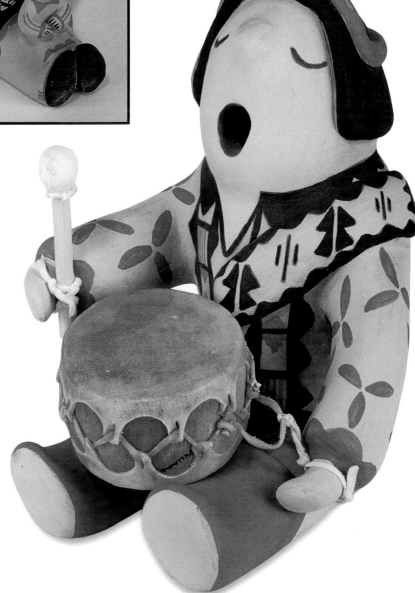

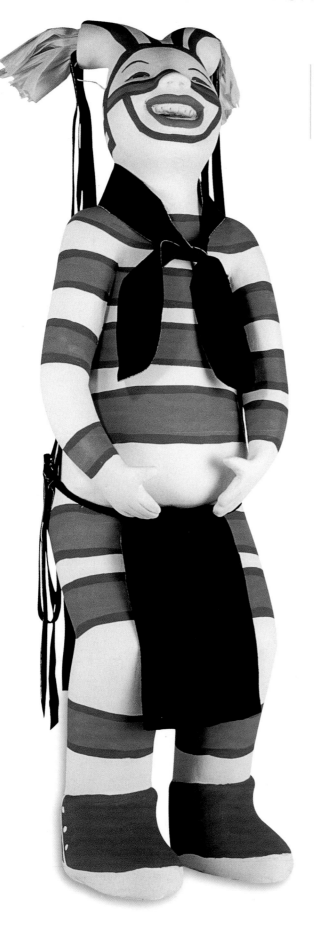

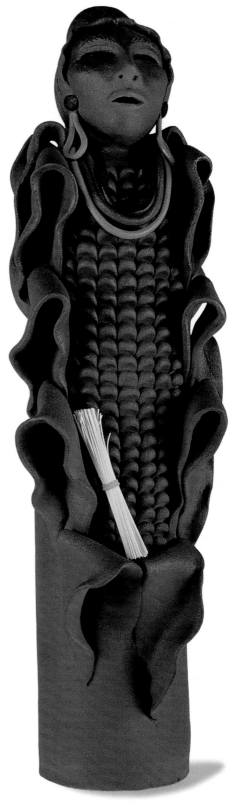

Left: Koshari figure, striped, black ultrasuede and cornhusk trimming. 25"h. **Kathleen Wall**. Jemez. $1,350

Below: Clay Corn Maiden, red with blue. 22"h. **Nora Yazzi**, Navajo. $690

THE DIRECTORY OF ARTISTS/INDEX

including potters, kachina carvers, jewelers,
and sculptors alphabetically arranged by artists

Aaron Abeita
(M) Laguna
Born: 3/1/79
Parents: Abeita family from Laguna
Teacher: Erwin Pino
Type of Work: Kachina
4 years of experience
Awards: I've never entered.
Favorite Part of Work: I like to paint the most.
Signature: Aaron Abeita

Andy Abeita
(M) Isleta
Born: 7/24/63
Parents: Richard and Elizabeth Abeita
Teacher: Self-taught
Type of Work: Stone carving, fetishes
15 years of experience
Awards: First Place Gallup Indian Ceremonial 1987, '88, '90, '93,and '95; Best of Show, Dallas Indian Market; and Best of Class at the New Mexico State Fair.
Favorite Part of Work: I like to teach the traditional Indian values.
Signature: a stylized A.

Gloria A. Abeita
(F) Isleta
Born: 3/19/48
Parents: Jose and Dora Jojola
Teacher: My mother
Type of Work: Ceramic and traditional
7 years of experience
Awards: None yet
Favorite Part of Work: Sales, marketing, and meeting people.
Signature: L. Abeita, Isleta N.M.

Tamra L. Abeita
(F) Acoma
Born: 4/7/59
Parents: Jimmy and Rachael James
Teacher: Self-taught
Type of Work: Traditional Acoma and storytellers
13 years of experience
Awards: I've won many awards at Santa Fe Indian Market, N.M. State Fair and The Gallup Indian Ceremonial.
Favorite Part of Work: I like all aspects of working with the clay.
Signature: T. Abeita, Acoma N.M.

Elizabeth Abeyta
(F) Navajo (Half)
Born: 4/6/55
Parents: Narciso Abeyta
Teacher: I.A.I.A., San Francisco Institute
Type of Work: Mixed media, clay
24 years of experience
Awards: First Place at Santa Fe Indian Market 5 years in a row, also at the Gallup Indian Ceremonial.
Favorite Part of Work: I like to make one-of-a-kind pieces.
Signature: Nah-Glee-eh-bah

Darrin Aguilar
(M) Santo Domingo
Born: 2/27/80
Parents: Joe and Helen Aguilar
Teacher: My brother
Type of Work: Traditional pottery
5 years of experience
Awards: None yet
Favorite Part of Work: I like to make the red pots the most.
Signature: A moon and a star

Evelyn Aguilar, Page 65
(F) Santa Clara
Born: 3/28/55
Parents: Jose and Celes Tafoya
Teacher: My mother
Type of Work: Traditional polished, carved
13 years of experience
Awards: Santa Fe Indian Market, First, Second and Third. N.M. State Fair, First, Second and Third.
Favorite Part of Work: Polishing is my favorite part of my work.
Signature: Celes and Evelyn, Santa Clara

Rafealita Aguilar
(F) Santo Domingo
Born: 8/15/36
Parents: Juan and Miguelita
Teacher: My mother
Type of Work: Traditional pottery
47 years of experience
Awards: None
Favorite Part of Work: I like all the parts of my work making pottery, especially the big ones.
Signature: Rafealita Aguilar

Vidal Aguilar
(M) Santo Domingo
Born: 5/24/72
Parents: Joe and Helen Aguilar
Teacher: Self-taught
Type of Work: Traditional pottery
7 years of experience
Awards: I won an award at the Santa Fe Indian Market in Santa Fe New Mexico.
Favorite Part of Work: I like to make all different shapes of pottery.
Signature: I use a corn trademark.

Marcella Agustine
(F) Acoma
Born: 11/11/60
Parents: Rebecca and Harold Pasquale
Teacher: My grandmother
Type of Work: Traditional seedpots
12 years of experience
Awards: None
Favorite Part of Work: Making the bowls and then painting them.
Signature: Marcella Agustine, Acoma

Ira Allison
(M) Laguna
Born: 6/17/77
Parents: Sharon Allison
Teacher: Jocelyn Vote
Type of Work: Hopi Kachina carvings
3 years of experience
Awards: I won two art awards in High School competitions.
Favorite Part of Work: I like all aspects of carving.
Signature: Yey-A-Ma

Louise Amos
(F) Acoma
Born: 11/3/46
Parents: Lorenzo and Frances Abieta
Teacher: Dolores Stern, Grandmother
Type of Work: Traditional and ceramic
37 years of experience
Awards: N.M. State Fair
Favorite Part of Work: Working with the traditional clay.
Signature: Louise Amos, Acoma N.M.

Richard Anderson, Jr.
(M) Navajo
Born: 2/27/68
Parents: Navajo
Teacher: My elders and grandparents
Type of Work: Traditional weapons and clothing
22 years of experience
Awards: None
Favorite Part of Work: I like to make my artifacts the REAL way, with no plastic or glue.
Signature: AAK ELLSAH

Jennifer Andrew, Page 32
Jemez

Adrian Antonio
(M) Acoma
Born: 7/28/61
Parents: Rafalita, Acoma
Teacher: Self-taught
Type of Work: Ceramic etched and painted
8 years of experience
Awards: None
Favorite Part of Work: Carving the designs.
Signature: Antonio, Acoma N.M.

Deidra Antonio
(F) Acoma
Born: 11/10/63
Parents: Ann Romero, Acoma
Teacher: My mother
Type of Work: Painted and etched ceramic.
11 years of experience
Awards: I've won a few ribbons at ceramic shows.
Favorite Part of Work: Painting is my favorite part.
Signature: DSA, Acoma N.M.

Earlene Antonio, Page 10
(F) Acoma Pueblo
Born: 10/19/68
Parents: Alfred and Rafaelita Romero
Teacher: My grandmother and mother
Type of Work: Traditional Acoma pottery
10 years of experience
Awards: None yet
Favorite Part of Work: Painting and selling my work.
Signature: E. Antonio, Acoma N.M.

Frederica Antonio
(F) Acoma
Born: 9/17/68
Parents: Earl and Florina Vallo, Acoma
Teacher: My mother-in-law, Mildred
Type of Work: Traditional and ceramic
9 years of experience
Awards: None
Favorite Part of Work: Painting is my favorite part of my work.
Signature: F.V. Antonio, Acoma N.M.

Hilda Antonio
(F) Acoma
Born: 8/7/38
Parents: Eva Histia
Teacher: My mother
Type of Work: Traditional Acoma pottery
57 years of experience
Awards: I've won many awards including First, Second and Third Place ribbons at many art shows.
Favorite Part of Work: I like to do anything that needs to be done.
Signature: H.A. or H. Antonio Acoma N.M.

Josephine Antonio
(F) Acoma
Born: 1/19/36
Parents: Jose and Mary Antonio
Teacher: My mother
Type of Work: Traditional and ceramic pots
27 years of experience
Awards: I've won a blue ribbon at Santa Fe Indian Market.
Favorite Part of Work: Painting the pottery is my favorite part.
Signature: J. Antonio, Acoma N.M.

Lucille M. Antonio
(F) Acoma
Born: 12/23/55
Parents: Lupe Louis, Acoma N.M.
Teacher: My mother
Type of Work: Trad itional and ceramic pottery
5 years of experience
Awards: None yet
Favorite Part of Work: Forming the pots and painting them are my favorite parts of my work.
Signature: Lucille Antonio, Acoma N.M.

Melissa C. Antonio, Page 11
(F) Acoma
Born: 10/15/65
Parents: Gilbert and Lillie Concho, Acoma
Teacher: Mildred Antonio (mother in law)
Type of Work: Very intricate patterns.
11 years of experience
Awards: State Fair awards - '92 First and Second place ribbons; '93 Third Place ribbon; '94 Best of Show and First Place ribbon.
Favorite Part of Work: Finally painting after all the design work.
Signature: M.C. Antonio

Mildred Antonio, Page 11
(F) Acoma
Born: 3/22/37
Parents: Mr. and Mrs. Joe Torivio
Teacher: My Auntie Marie
Type of Work: Traditional and ceramic
26 years of experience
Awards: none
Favorite Part of Work: I like all the parts of pottery making and especially selling.
Signature: "M. Antonio, Acoma N.M."

Stephanie Antonio
(F) Acoma
Born: 4/8/20
Parents: Acoma
Teacher: My sister
Type of Work: Ceramic etched pottery
5 years of experience
Awards: None
Favorite Part of Work: Carving all the designs that are in my mind.
Signature: Stephanie Antonio, Acoma N.M.

Steven Antonio
(M) Acoma
Born: 3/5/65
Parents: Acoma
Teacher: Deidra Antonio
Type of Work: Ceramic pottery
11 years of experience
Awards: None
Favorite Part of Work: Designing the pottery.
Signature: DSA, Acoma N.M.

Florence Aragon, Page 10
(F) Acoma
Born: 5/31/29
Parents: Lupe Aragon, Acoma
Teacher: My mother
Type of Work: Traditional Acoma pottery
32 years of experience
Awards: I've won awards at Santa Fe Indian Market, Gallup Indian Ceremonial, and New Mexico State Fair.
Favorite Part of Work: I like all the parts of my work from forming the pots to painting the designs and then selling them.
Signature: F. Aragon, Acoma N.M.

John F. Aragon, Page 10
(M) Acoma
Born: 11/24/62
Parents: Florence Aragon
Teacher: Grandmother-Lupe Aragon
Type of Work: Traditional pottery
17 years of experience
Awards: Ribbons at SWAIA Market, Gallup Ceremonial, New Mexico State Fair.
Favorite Part of Work: Discovering new designs to work with.
Signature: John F. Aragon

Karen J. Aragon
(F) Acoma
Born: 9/22/56
Parents: Clifford and Alice Aragon
Teacher: Self-taught
Type of Work: Traditional and ceramic
15 years of experience
Awards: I've won a few awards.
Favorite Part of Work: Working with large seedpots and bears with fine line and etching.
Signature: K. Aragon, Acoma N.M.

Leslie Aragon
(F) Zia
Born: 12/27/73
Parents: Ralph and Joan Aragon, Zia
Teacher: My father and grandmother
Type of Work: Traditional and ceramic
7 years of experience
Awards: None
Favorite Part of Work: I like to form pots and paint them.
Signature: L Aragon, Zia N.M.

Rachel Aragon, Page 11
(F) Acoma
Born: 10/27/38
Parents: Lupe Aragon, Acoma
Teacher: My mother
Type of Work: Traditional Acoma pottery
32 years of experience
Awards: I've won many awards at Santa Fe Indian Market, New Mexico State Fair, and Gallup Indian Ceremonial.
Favorite Part of Work: I like to make the best pottery I possibly can and create the designs precisely.
Signature: Rachael Aragon, Acoma N.M.

Ralph Aragon, Page 72, 73
(M) Zia, Laguna, San Felipe
Born: 8/24/44
Parents: James and Claudia Aragon
Teacher: IAIA, Candelaria Gachupin
Type of Work: Petroglyh Art
22 years of experience
Awards: N.M. State Fair, Heard Museum Show, Santa Fe Indian Market, and Gallup Indian Ceremonial.
Favorite Part of Work: Painting the different rock art designs on as many media as I can.
Signature: R. Aragon

Wilbert Aragon, Page 11
(M) Acoma
Born: 5/5/66
Parents: Wilbert and Angelina Aragon
Teacher: My mother
Type of Work: Ceramic carved pottery
7 years of experience
Awards: None
Favorite Part of Work: Trying to come up with different styles, designs and colors.
Signature:, Jr., D. (Diane) Aragon, Acoma N.M.

Rachael Arnold
(F) Acoma N.M.
Born: 3/10/30
Parents: Mannie Ortiz, Acoma
Teacher: Self-taught
Type of Work: Traditional storytellers
24 years of experience
Awards: I've won awards at various art shows.
Favorite Part of Work: I like to work with the clay the most.
Signature: R. Arnold, Acoma N.M.

Martha Arquero, Page 79
(F) Cochiti
Born: 5/15/44
Parents: Damacia Cordero, Cochiti
Teacher: My mother
Type of Work: Traditional pottery
22 years of experience
Awards: I've won awards for my Drummer and Frog Storytellers.
Favorite Part of Work: Shaping the pottery is my favorite part of my work.
Signature: Martha Arquero, Cochiti N.M.

Linda Askew, "Jo Povi"
(F) Santa Clara
Born: 9/7/52
Parents: Andy and Marie Askew
Teacher: My mother and grandmother
Type of Work: Traditional pottery
13 years of experience
Awards: I won a First Place award for my storyteller at the Indian Pueblo Cultural Center in Albuquerque.
Favorite Part of Work: I like when my pots are finished.
Signature: Jo Povi, Santa Clara N.M.

Christopher Augustine (Garcia)

(M) Acoma
Born: 6/22/65
Parents: Elizabeth Garcia (Lewis)
Teacher: Grandmother—Elizabeth Garcia
Type of Work: Traditional pottery
20 years of experience
Awards: I've never entered my work.
Favorite Part of Work: I like to paint the most.
Signature: Chris Augustine Acoma N.M.

Alvin Baca, Page 54

(M) Santa Clara
Born: 8/8/66
Parents: Angela and Tony Baca
Teacher: My mother
Type of Work: Traditional melon bowls
10 years of experience
Awards: Third Place at Santa Fe Indian Market, First at Eight Northern Pueblo Show and awards at N.M. State Fair.
Favorite Part of Work: My favorite part is making the pottery and selling them.
Signature: Alvin Baca, Santa Clara N.M.

Angela Baca

(F) Santa Clara
Born: 11/6/27
Parents: Cleto and Severa Tafoya
Teacher: My mother
Type of Work: Traditional melons, bear paw
37 years of experience
Awards: Heard Museum Show, Best of Show, Eight Northern Pueblo Show, Santa Fe Indian Market, and N.M. State Fair.
Favorite Part of Work: I like to create the pieces and sell them.
Signature: Angela Baca, Santa Clara N.M.

Anthony and Johanna Baca (Hererra), Page 54

(M) Santa Clara, (Tesuque)
Born: 2/3/65
Parents: Matilda Baca, Santa Clara
Teacher: Johanna and Corn Moquino
Type of Work: Deep carved traditional black
17 years of experience
Awards: None yet
Favorite Part of Work: We like firing and polishing the best.
Signature: Johanna and Anthony

David (Yellow Mountain) Baca, Page 54

(M) Santa Clara
Born: 6/2/51
Parents: Tony and Angela Baca
Teacher: My mother and self
Type of Work: Traditional melon bowls
16 years of experience
Awards: Santa Fe Indian Market, Eight Northern Pueblo Show, N.M. State Fair and Gallup Indian Ceremonial.
Favorite Part of Work: Creating the pieces and selling them are my favorite parts.
Signature: David Yellow Mountain Baca

Evangeline Baca

(F) Jemez and Santa Clara
Born: 8/3/64
Parents: Ruby C. Waquiue, Jemez
Teacher: My husband
Type of Work: Traditional and etched bowls.
5 years of experience
Awards: None yet
Favorite Part of Work: Polishing is my favorite part.
Signature: Evangeline, with a bear paw.

Jane Baca, Page 58

(F) Santa Clara
Born: 3/7/27
Parents: Herman and Marnita Velarde
Teacher: Self-taught
Type of Work: Traditional black pottery
27 years of experience
Awards: I've won many awards at Santa Fe Indian Market and Eight Northern Pueblo Shows including First, Second and Third Place Ribbons.
Favorite Part of Work: Molding each piece is my favorite part of my work.
Signature: Jane or Jane and Starr

Vida and Joseph Baca

(F) Santa Clara, Zuni
Born: 8/25/64
Parents: Terry and Janice Wyaco
Teacher: Mida Tafoya and Watching
Type of Work: Traditional black
7 years of experience
Awards: I've won many First, Second and Third Place awards as well as a Best of Show.
Favorite Part of Work: Thinking of new designs for my pottery.
Signature: Vida and Joseph Baca

Wilma Baca

(F) Jemez
Born: 9/1/67
Parents: John and Linda Baca
Teacher: My grandmother
Type of Work: Traditional polished, incised
12 years of experience
Awards: None yet
Favorite Part of Work: I like to make the pot with the design already in mind.
Signature: Wilma L. Baca, Jemez

Sedrick Banteah

(M) Zuni
Born: 5/29/53
Parents: Albert and Anita Banteah, Zuni
Teacher: Self-taught
Type of Work: Fetish carving
7 years of experience
Awards: None
Favorite Part of Work: Detailing the animals.
Signature: S. Banteah, Zuni.

Leo Barber, Jr.

(M) Navajo
Born: 11/18/58
Parents: Navajo
Teacher: My Father
Type of Work: Navajo Kachina dolls
27 years of experience
Awards: None
Favorite Part of Work: Painting the dolls is my favorite part of the process.
Signature: L. Barber, Jr.

Darrell Bedoni

(M) Navajo
Born: 3/15/61
Parents: Navajo
Teacher: John Rainer, Jr. Taos Pueblo
Type of Work: Flutes
18 years of experience
Awards: I've won many awards at several different shows.
Favorite Part of Work: I like the awards I win and the sounds of my flutes when they're done.
Signature: Darrell Bedoni, Navajo

Arlene Begay
(F) Navajo
Born: 12/3/72
Parents: Thomas and Ella Begay
Teacher: Etta Morgan
Type of Work: Navajo etched pottery
3 years of experience
Awards: None
Favorite Part of Work: I like the whole part of the pottery work.
Signature: A.B., Dine

Bernice Begay, Page 46
(F) Navajo
Born: 7/11/36
Parents: Navajo
Teacher: My grandmother, in the 1960s
Type of Work: Fetish bowls
27 years of experience
Awards: New York, N.M. State Fair, Casa Grande AZ.
Favorite Part of Work: Working on different shapes.
Signature: No signature

Joseph Begay
(M) Navajo
Born: 8/16/64
Parents: Navajo
Teacher: Self-taught
Type of Work: Fetishes
8 years of experience
Awards: None
Favorite Part of Work: Finishing the pieces to see my creations.
Signature: J.B.

Ben Begaye
(M) Navajo
Born: 8/13/60
Parents: Hosteen and Mae Begaye
Teacher: Self-taught
Type of Work: Contemporary Navajo jewelry
17 years of experience
Awards: I've won awards at the Picuris Fiesta, Red Rock Indian Art Show and the San Felipe Fiesta.
Favorite Part of Work: I like to design my own pieces.
Signature: Ben Begaye with feather, Sterling

Tammy Bellson
(F) Zuni
Born: 10/14/66
Parents: Eva and William Nashboo, Zuni
Teacher: My grandmother
Type of Work: Traditional Zuni pottery
8 years of experience
Awards: None yet
Favorite Part of Work: I like to design my pottery in unique ways.
Signature: T.B. Zuni N.M.

Darrell Ben
(M) Navajo
Born: 11/29/66
Parents: Joe and Stella Ben
Teacher: Herbert Ben, (Medicine Man)
Type of Work: Traditional sandpainting
17 years of experience
Awards: I've won many awards at various art shows such as Gallup Indian Ceremonial, and N.M. State Fair.
Favorite Part of Work: I like to do large sandpaintings of Whirling Logs, Storm patterns and Home of the Bear.
Signature: D. or Darrell Ben, Navajo

Cecelia Benally
(F) Navajo
Born: 1/25/71
Parents: Navajo
Teacher: Susie Charlie
Type of Work: Navajo etched
7 years of experience
Awards: None
Favorite Part of Work: I like to make the designs and paint it.
Signature: Cecilia Benally

Flemming Benally
(M) Navajo
Born: 8/28/64
Parents: Irene McBrown
Teacher: My uncle Alfred McBrown
Type of Work: Navajo Kachina dolls
6 years of experience
Awards: None
Favorite Part of Work: I like painting the most.
Signature: F.B. Navajo

Larry Bennett
(M) Navajo
Born: 3/29/57
Parents: James and Marie Bennett
Teacher: Self-taught
Type of Work: Inlay jewelry
4 years of experience
Awards: None
Favorite Part of Work: I like to do stone inlay the most.
Signature: LB

Eva Bitonie
(F) Navajo
Born: 4/29/68
Parents: Navajo
Teacher: My mother
Type of Work: Storytellers
4 years of experience
Awards: None
Favorite Part of Work: I like to make miniature storytellers.
Signature: E.B.

Anna Bitsie
(F) Navajo
Born: 8/26/60
Parents: Navajo
Teacher: My husband
Type of Work: Navajo kachinas
7 years of experience
Awards: none
Favorite Part of Work: All the processes of my artwork are my favorites.
Signature: F.B.

Lucy Bitsilly
(F) Navajo
Born: 10/30/25
Parents: Navajo
Teacher: My mother
Type of Work: Navajo weaving
52 years of experience
Awards: I've won a few awards for my work.
Favorite Part of Work: I like all my weaving, all kinds of designs.

Elsie Black, Page 46
(F) Navajo
Born: 7/4/57
Parents: Katherine Hicks, Navajo
Teacher: Mother—Katherine Hicks
Type of Work: Pottery, old style
17 years of experience
Awards: First Place '89 Art Show, AZ
Favorite Part of Work: Every step of pottery making.
Signature: EB

Sasha Bluesky
(M) Navajo
Born: 4/18/72
Parents: Navajo
Teacher: Self-taught
Type of Work: Traditional etched pottery
13 years of experience
Awards: I won awards at the New Mexico State Fair in 1993.
Favorite Part of Work: Carving the designs into the pot is my favorite part of my work.
Signature: Sasha Bluesky

Lenelle Boone
(F) Zuni
Born: 12/5/70
Parents: Harvey Harker, Sr.
Teacher: My father
Type of Work: Fetishes
5 years of experience
Awards: First Place at Gallup Indian Ceremonial.
Favorite Part of Work: I like to please my customers the most.
Signature: Ingrave my name.

Birdell Bourdon, Page 55
(F) Tewa Navajo, Santa Clara
Born: 11/29/57
Parents: Marie Askan
Teacher: My mother and myself
Type of Work: Traditional black on black
24 years of experience
Awards: None
Favorite Part of Work: I like all the aspects of my work.
Signature: Birdell, Santa Clara, N.M.

Jenny Bourdon
(F) Santa Clara
Born: 5/4/85
Parents: Birdell and Fred Bourdon
Teacher: Parents
Type of Work: Pottery animals
14 years of experience
Awards: Haven't entered yet.
Favorite Part of Work: Shaping the clay.
Signature: Jenny

Cyndee S. Brophy
(F) Jemez
Born: 11/20/57
Parents: Arthur and Rose Sandia
Teacher: My grandmother and parents
Type of Work: Traditional pottery
15 years of experience
Awards: Honorable mention and several shows.
Favorite Part of Work: Creating the pieces and selling them.
Signature: Cyndee S. Brophy, Jemez N.M.

Debbie G. Brown
(F) Acoma
Born: 12/12/62
Parents: Sarah Garcia, Acoma
Teacher: My mother
Type of Work: Traditional Acoma pottery
30 years of experience
Awards: Santa Fe Indian Market
Favorite Part of Work: I like making the pots, because I can coil and coil until I'm tired of it.
Signature: Debbie Brown, Acoma N.M.

Lula Brown
(F) Navajo
Born: 5/12/55
Parents: Navajo
Teacher: My mother
Type of Work: Navajo rugs
37 years of experience
Awards: I've won many awards at various art shows.
Favorite Part of Work: Weaving many different designs is my favorite part.
Signature: none

Rose M. Brown
(F) Cochiti, San Ildefonso
Born: 3/12/59
Parents: San Ildefonso
Teacher: Marie P. Romero, Cochiti
Type of Work: Storytellers
16 years of experience
Awards: None yet
Favorite Part of Work: Creating the storytellers and the joy it brings to the people and myself.
Signature: Rose M. Brown Cochiti N.M.

Leanna Brownlie
(F) Navajo
Born: 1/1/68
Parents: Navajo
Teacher: IAIA Santa Fe, New Mexico
Type of Work: Traditional pottery and figurines
5 years of experience
Awards: I've won First, Second, and Third Place awards at a few art shows in the last couple of years.
Favorite Part of Work: Beginning the process is my favorite part.
Signature: LEANNA —DINE'

Theodore Bryan
(M) Navajo
Born: 5/16/63
Parents: Steven and Nellie Bryan
Teacher: My brother-in-law
Type of Work: Navajo kachinas
5 years of experience
Awards: None
Favorite Part of Work: I like to sell my work.
Signature: T. Bryan

Kelly N. Byars
(M) Choctaw
Born: 7/17/62
Parents: Choctaw
Teacher: Art Institute
Type of Work: Stone sculpture
9 years of experience
Awards: I've won three awards at different kinds of shows.
Favorite Part of Work: The selling and appreciation of my work.
Signature: Nitsuhi

Joy Cain
(F) Santa Clara
Born: 10/25/47
Parents: Mary Cain, Santa Clara
Teacher: Mom and Christina Naranjo
Type of Work: Traditional polished pottery
22 years of experience
Awards: Many First and Second Place awards.
Favorite Part of Work: I love to create and design the bowls. Firing the pottery is the hardest.
Signature: Joy Cain, Santa Clara

Mary Cain, Page 53, 55
(F) Santa Clara
Born: 4/20/15
Parents: Christina Naranjo
Teacher: My grandmother and mother
Type of Work: Black and red carved
72 years of experience
Awards: Santa Fe Indian Market, N.M.State Fair, Gallup Indian Ceremonial.
Favorite Part of Work: I like all of my work, all steps.
Signature: Mary Cain, Santa Clara Pueblo

Anita Cajero, Page 32, 79
Jemez

Gabriel P. Cajero
(M) Jemez
Born: 5/16/61
Parents: Loretta Cajero, Jemez
Teacher: Loretta Cajero
Type of Work: Traditional polished pottery
26 years of experience
Awards: N.M. State Fair, Gallup Indian Ceremonial
Favorite Part of Work: The entire process.
Signature: G. Cajero, Jemez

Victoria T. Calabaza
(F) Santo Domingo
Born: 4/1/59
Parents: Emiliano and Petra Tenorio
Teacher: My grandmother
Type of Work: Traditional pottery
14 years of experience
Awards: None
Favorite Part of Work: Making each pot, painting them, and also selling . (Making lots of money.)
Signature: Vicky Calabaza, Santo Domingo

Hubert Candelario, Page 50
(M) San Felipe
Born: 11/2/65
Parents: Phillip and Angelina Candelario
Teacher: Self-taught
Type of Work: Traditional mica pottery
11 years of experience
Awards: I've won awards at the State Fair, Gallup Ceromonial, Best of Show, First, Second, Third. I've won awards at Santa Fe Indian Market, Gallup Indian Ceremonial and the New Mexico State Fair.
Favorite Part of Work: I like to get to know the people that buy my work.
Signature: Hubert Candelario, San Felipe

Jeffrey Castillo
(M) Navajo
Born: 8/27/49
Parents: Navajo
Teacher: Self-taught
Type of Work: Traditional silver jewelry, silver kachinas
22 years of experience
Awards: I've won many awards at art shows such as Santa Fe Indian Market, Gallup Indian Ceremonial and others.
Favorite Part of Work: I like all facets of my work.
Signature: J.C./ Sterling Stamp

Pamela Cata, Page 55
Santa Clara

Sophie Cata, Page 56
(F) Santa Clara
Born: 8/11/57
Parents: Frances Salazar, Santa Clara
Teacher: Mother and grandmother
Type of Work: Black and red, carved and plain
27 years of experience
Awards: Never entered
Favorite Part of Work: Giving the pottery the final polish.
Signature: Sophie Cata

Stacy Cata
(F) San Juan
Born: 10/12/78
Parents: Frank and Sophie Cata
Teacher: My mother
Type of Work: Traditional black polished
3 years of experience
Awards: None
Favorite Part of Work: Molding and polishing are my favorite parts.
Signature: Stacy Cata, San Juan

Barbara Cerno, Page 12
(F) Acoma
Born: 10/20/51
Parents: Acoma
Teacher: Annie Cerno
Type of Work: Traditional pottery
31 years of experience
Awards: Indian Market, Gallup Ceremonial, New Mexico State Fair
Favorite Part of Work: Looking at the finished product.
Signature: Barbara and Joseph Cerno

Brenda Cerno
(F) Acoma
Born: 5/3/59
Parents: Daisy and Stan Leon
Teacher: My grandmother
Type of Work: Acoma pottery
23 years of experience
Awards: N.M. State Fair, and other pottery shows
Favorite Part of Work: Molding the pots.
Signature: B.L. Cerno, Acoma N.M.

Joseph Cerno
(M) Acoma
Born: 1/30/47
Parents: Acoma
Teacher: Annie Cerno
Type of Work: Traditional pottery
30 years of experience
Awards: Indian Market, Gallup Ceremonial, New Mexico State Fair
Favorite Part of Work: Painting.
Signature: Barbara and Joseph Cerno

Mary O. Chalan
(F) Cochiti
Born: 8/21/39
Parents: Raymond and Barbara Herrera
Teacher: Mother
Type of Work: Pottery
24 years of experience
Awards: Honorable Award, State Fair; Blue ribbons from Colorado and Arizona
Favorite Part of Work: Forming the storytellers and seeing them take shape
Signature: Mary O. Chalan

Daisy Chapa
(F) Isleta
Born: 5/11/43
Parents: Mariand Montoya
Teacher: My mother and grandmother
Type of Work: Storyteller necklaces
7 years of experience
Awards: I won a Second Place at the N.M. State Fair.
Favorite Part of Work: Working with the clay.
Signature: "Chapa, Isleta"

Fred Chapeila
(M) Hopi/Tewa
Teacher: Father
Type of Work: Kachinas
16 years of experience
Awards: Never entered
Favorite Part of Work: all facets of working with wood
Signature: Fred Chapeila

Valine Chapo
(F) Navajo
Born: 1/2/73
Parents: Raymond and Lucy Chapo
Teacher: My mother
Type of Work: Storytellers
3 years of experience
Awards: None yet
Favorite Part of Work: I like painting my storytellers the most.
Signature: Valine Chapo

Karen Charley
(F) Navajo
Born: 12/22/74
Parents: Navajo
Teacher: My sisters
Type of Work: Pottery
3 years of experience
Awards: None yet
Favorite Part of Work: I enjoy making the pottery.
Signature: Karen Charley

Tom Charley
(M) Navajo
Born: 6/1/52
Parents: Joan and Joe Sandoval
Teacher: My grandfather
Type of Work: Traditional and contemporary jewelry
22 years of experience
Awards: I've won awards at the Windowrock Arts and Crafts Fair, The Northern Navajo Fair, and the Shiprock Fair and Rodeo.
Favorite Part of Work: I like soldering and stamping.
Signature: TC Sterling

Lawrence Charley II
(M) Hopi/Navajo
Born: 2/11/68
Parents: Lawrence and Joanna Charley
Teacher: My uncle from Hopi
Type of Work: Hopi sculpture
12 years of experience
Awards: I won a First Place ribbon at a Job Corp Art Show.
Favorite Part of Work: I like to paint and to carve.
Signature: Lawrence Charley

Brenda Charlie
(F) Acoma
Born: 1/28/63
Parents: Patrick and Emmalita Chino
Teacher: My mother Emmalita Chino
Type of Work: Traditional and ceramic
12 years of experience
Awards: None yet
Favorite Part of Work: My favorite part is when my artwork is completed.
Signature: Brenda Charlie, Acoma N.M.

Lucille and Herman Charlie
(F) Navajo
Born: 4/30/48
Parents: Navajo
Teacher: Self-taught in 1974
Type of Work: Navajo Kachina dolls
23 years of experience
Awards: At the Maisels Art Show.
Favorite Part of Work: We like to paint the most.
Signature: Herman Charley, Navajo

Michael Charlie
(M) Navajo
Born: 8/4/76
Parents: Raymond and Susie Charlie
Teacher: My mother
Type of Work: Etched Navajo pottery
3 years of experience
Awards: Never entered
Favorite Part of Work: I like to look at the finished product.
Signature: Michael Charlie Navajo

Myron Charlie
(M) Navajo
Born: 5/17/75
Parents: Raymond and Susie Charlie
Teacher: Susie Charlie, mother
Type of Work: Navajo etched pottery
10 years of experience
Awards: Too many awards to remember.
Favorite Part of Work: People asking me what most of the designs mean and what the color and designs represent.
Signature: Myron Charlie Navajo

Susie Charlie, Page 45
(F) Navajo
Born: 12/31/59
Parents: Eli and Margaret Whitegoat
Teacher: My parents
Type of Work: Ceramic carved Navajo
12 years of experience
Awards: I've won awards in California Art shows.
Favorite Part of Work: I like to try new designs.
Signature: Susie Charlie, Navajo

Denise Chavarria, Page 56
(F) Santa Clara
Born: 12/4/59
Parents: Loretto and Stella Chavarria
Teacher: My mother
Type of Work: Traditional black and red
16 years of experience
Awards: First, Second and Third at Santa Fe Indian Market.
Favorite Part of Work: Building and polishing the pottery.
Signature: Denise Chavarria, Santa Clara

Loretta (Sunday) Chavarria, Page 56
(F) Santa Clara
Born: 8/31/63
Parents: Loretto and Stella Chavarria
Teacher: My mother
Type of Work: Traditional black and red
9 years of experience
Awards: None
Favorite Part of Work: I like to carve the pots the best.
Signature: Sunday Chavarria, Santa Clara

Mildred Chavarria
(F) Santa Clara
Born: 2/3/46
Parents: Pablita Chavarria
Teacher: My mother and sister
Type of Work: Traditional polished
10 years of experience
Awards: None
Favorite Part of Work: I like the polishing, and forming the pots.
Signature: Millie Chavarria, Santa Clara

Stella Chavarria, Page 56
(F) Santa Clara
Born: 1/23/39
Parents: Jose and Teresita Naranjo
Teacher: Self-taught
Type of Work: Traditional black and red
37 years of experience
Awards: Third Place at Santa Fe Indian Market.
Favorite Part of Work: I like carving the best.
Signature: Stella Chavarria, Santa Clara

Celina Chavez, Page 32
(F) Jemez
Born: 12/21/49
Parents: Jemez
Teacher: My mother
Type of Work: Traditional pottery
32 years of experience
Awards: I've won a few awards.
Favorite Part of Work: I like all parts of my work, especially the painting.
Signature: C.C. Jemez N.M.

Ilene N. Chavez
(F) Acoma
Born: 7/20/70
Teacher: Self-taught
Type of Work: Traditional and ceramic
10 years of experience
Awards: Never entered
Favorite Part of Work: Doing fine line work
Signature: I. Chavez

Pete (Red Eagle) Chavez
(M) Taos
Born: 6/3/65
Parents: Mary Martinez, Taos
Teacher: My uncles and God
Type of Work: Stone sculpture
4 years of experience
Awards: N.M. State Fair
Favorite Part of Work: Being able to transform rock into faces and other figures.
Signature: Red Eagle

Fannie Chavez (Platero)
(F) Navajo
Born: 7/23/44
Parents: Mary Platero, Arturo Chavez
Teacher: My great grandfather, and Mom
Type of Work: Navajo custom jewelry
28 years of experience
Awards: California Indian Market, Pasadena Indian Market, and Colorado Indian Market.
Favorite Part of Work: I like every detail, I'm very enthusiastic in my Jewelry making.
Signature: F.C.

Elton Cheromiah, Page 43
(M) Laguna
Born: 8/20/75
Parents: Josephita Cheromiah
Teacher: My grandmother
Type of Work: Traditional Laguna pottery
6 years of experience
Awards: I won a First Place ribbon for one of my large pots.
Favorite Part of Work: I like to make my pots in the old traitional way and then put the very old designs on them.
Signature: Elton Cheromiah, Laguna N.M.

Evelyn Cheromiah
(F) Laguna
Born: 8/20/28
Parents: Mariano Cheromiah, Laguna
Teacher: My grandmother and mother
Type of Work: Traditional
27 years of experience
Awards: N.M. State Fair, Santa Fe Indian Market, Gallup Indian Ceremonial and many more.
Favorite Part of Work: All of it, start to finish.
Signature: E. Cheromiah

Lee Ann Cheromiah, Page 43
(F) Laguna
Born: 6/24/54
Parents: Evelyn Cheromia , Laguna
Teacher: Evelyn Cheromiah
Type of Work: Traditional Laguna pottery
22 years of experience
Awards: 1994 Santa Fe Indian Market, N.M. State Fair
Favorite Part of Work: I like most of the processes exept sanding the pot before I design it.
Signature: L.A. Cheromiah, Old Laguna

Alfreda Chinana
(F) Jemez
Born: 5/12/68
Parents: Mary and Lizardo Chinana
Teacher: My mother
Type of Work: Traditional Jemez pottery
9 years of experience
Awards: None
Favorite Part of Work: I like to paint the pots the most.
Signature: Chinana, Jemez N.M.

Angela Chinana, Page 33
(F) Jemez Pueblo
Born: 12/6/76
Parents: Tito and Lorraine Chinana
Teacher: My mother Lorraine
Type of Work: Traditional Polished scraffito
7 years of experience
Awards: I won a First Place ribbon at the Santa Fe Indian Market in 1994.
Favorite Part of Work: I like carving new designs and creating new styles and shapes of pottery.
Signature: Angela Chinana, Walatowa N.M.

David G. Chinana
(M) Jemez
Born: 11/22/61
Parents: Mr. and Mrs. Lizardo Chinana
Teacher: My mother
Type of Work: Traditional pottery
12 years of experience
Awards: None
Favorite Part of Work: Painting after the piece is made.
Signature: D. Chinana, Jemez N.M.

Donald R. Chinana, Page 33
(M) Jemez
Born: 11/5/63
Parents: Anacita Chinana, Jemez
Teacher: Mother
Type of Work: Hand made pottery
19 years of experience
Awards: Never entered
Favorite Part of Work: Following a piece start to end.
Signature: Donald Chinana

Dorina Y. Chinana
(F) Jemez
Born: 8/29/62
Parents: George and Petra Yepa
Teacher: My mother
Type of Work: Traditional pottery
12 years of experience
Awards: None
Favorite Part of Work: I like just about everything about making pottery.
Signature: D. Y. C. Jemez N.M.

Florinda Chinana
(F) Jemez
Born: 9/25/54
Parents: Lupe L. Yepa, Jemez
Teacher: My mother
Type of Work: Miniature traditional pottery
34 years of experience
Awards: None
Favorite Part of Work: Painting and selling are my favorite parts of my work.
Signature: Yepa, Jemez N.M.

George Chinana, Page 33
Jemez

Georgia F. Chinana, Page 32
Jemez
Born: 2.22.59
Parents: Ancita Chinana, Jemez
Teacher: Mother
Type of Work: Bowls and wedding vases
13 years of experience
Awards: Never entered
Favorite part of work: Polishing and painting the pots
Signature: Chinana

Lorraine Chinana, Page 33
(F) Jemez
Born: 11/17/55
Parents: Albert and Marie Vigil, Jemez
Teacher: My grandmother
Type of Work: Traditional polished, red and gray
18 years of experience
Awards: I've won awards at the Eight Northern Pueblo Shows, and the Santa Fe Indian Market.
Favorite Part of Work: I like to polish the pottery, create new designs and incise each piece.
Signature: Lorraine Chinana, Jemez N.M.

Marie M. Chinana
(F) Jemez
Born: 7/6/62
Parents: Martha Toya
Teacher: My mother
Type of Work: Traditional pottery
17 years of experience
Awards: None
Favorite Part of Work: Molding the pieces.
Signature: D. and M. Chinana, Jemez

Martina Chinana
(F) Jemez
Born: 10/25/63
Parents: Lizardo and Mary Chinana
Teacher: My grandmother and mother
Type of Work: Pots and wedding vases
12 years of experience
Awards: None
Favorite Part of Work: Painting, etching, and firing.
Signature: M. Chinana, Jemez

Patrina Chinana
(F) Jemez
Born: 8/23/66
Parents: Mary and Lizardo Chinana
Teacher: My mother
Type of Work: Traditional Jemez pottery
8 years of experience
Awards: None
Favorite Part of Work: I like painting the most.
Signature: Chinana, Jemez N.M.

Peggy Chinana
(F) Jemez
Born: 2/21/64
Parents: Virginia Chinana, Jemez
Teacher: My mother
Type of Work: Traditional Jemez pottery
17 years of experience
Awards: None
Favorite Part of Work: I like to make miniatures, wedding vases, and bowls.
Signature: P.C. Jemez N.M.

Percy Chinana, Page 34
(F) Jemez
Born: 7/10/46
Parents: Anacita Chinana, Jemez
Teacher: My mother
Type of Work: Traditional Jemez pottery
32 years of experience
Awards: None
Favorite Part of Work: I like to mold each piece.
Signature: P. Chinana, Jemez N.M.

Ronald Chinana
(M) Jemez
Born: 9/13/61
Parents: Jemez
Teacher: My mother
Type of Work: Traditional Jemez bowls
9 years of experience
Awards: None
Favorite Part of Work: I like painting the most.
Signature: R. Chinana, Jemez N.M.

Virginia Chinana
(F) Jemez
Born: 6/26/38
Parents: Lupe Yepa, Jemez
Teacher: My mother
Type of Work: Traditional miniatures
37 years of experience
Awards: None
Favorite Part of Work: Creating the pots and then painting them.
Signature: V.C. Jemez N.M.

Brian A. Chino, Page 12
(M) Acoma
Born: 11/21/60 (deceased)
Parents: Elmer and Edna Chino, Acoma
Teacher: Self-taught
Type of Work: Traditional fine line
12 years of experience
Awards: I've won many awards at various art shows such as N.M. State Fair, Gallup Indian Ceremonial and Eight Northern Pueblo Shows.
Favorite Part of Work: Shaping and painting are my favorite parts of my work.
Signature: B. Chino, Acoma N.M.

Corrine J. Chino
(F) Acoma
Born: 5/17/57
Parents: Mr. and Mrs. Elmer L. Chino
Teacher: Edna G. Chino (mother)
Type of Work: Ceramic and traditional
12 years of experience
Awards: Never entered
Favorite Part of Work: Watching pottery develop.
Signature: Chino

Doris M. Chino
(F) Acoma Pueblo
Born: 5/22/52
Parents: Fermin and Sarah Martinez, Acoma
Teacher: Self-taught
Type of Work: Pottery and storytellers
4 years of experience
Awards: I've won awards at Tuscon Women's Invitational, Red Earth, and Laughlin Balloon Fiesta—featured artist, First, and Third.
Favorite Part of Work: I like making storytellers and painting. I also like to come up with different designs.
Signature: Chino with kokopelli

Edna G. Chino
(F) Acoma
Born: 6/13/35
Parents: Clifford and Lita Chino, Acoma
Teacher: Mother
Type of Work: Traditional pottery
30 years of experience
Awards: I've won awards at New Mexico State Fair and Bi-County Fair.
Favorite Part of Work: I like to make the pottery as well as paint.
Signature: E. Chino or Chino

Emmalita C. Chino
(F) Acoma
Born: 6/6/31
Parents: Margaret Charlie, Acoma
Teacher: Marie Z. Chino, Acoma
Type of Work: Traditional and ceramic
57 years of experience
Awards: I've won awards at Arts and Crafts shows in Utah, New Mexico, and Arizona.
Favorite Part of Work: I like to make seedpots the most, although, every part of the process is interesting to me.
Signature: E. Chino, Acoma N.M.

Francine Chino
(F) Acoma/Hopi
Born: 8/30/70
Parents: Mr. and Mrs. Sandy Chino
Teacher: My mother Diana
Type of Work: Traditional pottery
8 years of experience
Awards: None
Favorite Part of Work: I like to etch the pots the most.
Signature: F. Chino, Acoma N.M.

Iona K. Chino, Page 12
(F) Acoma
Born: 11/26/56
Parents: Irma Maldonado, Acoma
Teacher: My grandmother, Santana Antonio
Type of Work: Traditional and ceramic pots
17 years of experience
Awards: I won a Second Place ribbon at the 1996 N.M. State Fair in Albuquerque.
Favorite Part of Work: I like the work of designing the pots.
Signature: I. Chino, Acoma N.M.

Julian Chino
(M) Acoma
Born: 12/10/71
Parents: Matthew and Mary Chino
Teacher: My mother
Type of Work: Ceramic pottery
4 years of experience
Awards: None
Favorite Part of Work: I like to paint the most.
Signature: J. Chino, Acoma N.M.

Monica Chino
(F) Acoma
Born: 12/4/70
Parents: Patrick and Emma Chino
Teacher: My mother
Type of Work: Traditional and ceramic
4 years of experience
Awards: None
Favorite Part of Work: Learning to make traditional pottery from scratch.
Signature: M.C. Acoma N.M.

Patrick C. Chino
(M) Acoma
Born: 7/31/40
Parents: Marie Z. Chino, Acoma
Teacher: Emmalita C. Chino, Acoma
Type of Work: Traditional and ceramic
27 years of experience
Awards: N.M. State Fair, Gallup Indian Ceremonial, First, Second, and Grand Prize awards.
Favorite Part of Work: I like vases, mimbres designs, and the tradition associated with the creating of the pottery.
Signature: P. Chino, Acoma N.M.

Ramona Chino
(F) Acoma
Born: 2/7/64
Parents: Marvin and Theresa Lukee
Teacher: My mother
Type of Work: Ceramic pottery
11 years of experience
Awards: None
Favorite Part of Work: I like to paint all different types of designs.
Signature: R.C. Acoma N.M.

Shirley Chino
(F) Acoma
Parents: Acoma
Teacher: My grandma
Type of Work: Ceramic animals
20 years of experience
Awards: I've never entered.
Favorite Part of Work: I like to give each animal its own personality.
Signature: S.C. Acoma

Rose Chino (Garcia)
(F) Acoma
Born: 2/8/28
Parents: Marie Z. Chino, Acoma N.M.
Teacher: My mother Marie.
Type of Work: Traditional Acoma pottery
32 years of experience
Awards: I've won many awards at Santa Fe Indian Market, N.M. State Fair, and Gallup Indian Ceremonial.
Favorite Part of Work: My favorite part of my work is painting and also shaping each piece.
Signature: Rose Chino Garcia, Acoma N.M.

Anthony Chosa
(M) Jemez
Born: 3/6/61
Parents: Antonita Collateta
Teacher: Donald Chinana
Type of Work: Traditional
11 years of experience
Awards: Never entered.
Favorite Part of Work: Scraping the clay.
Signature: AC/Anthony Chosa Jemez

Clara Chosa
(F) Jemez
Born: 1/27/35
Parents: Sylvia and Francisco Chosa
Teacher: My mother
Type of Work: Traditional Jemez pottery
47 years of experience
Awards: none
Favorite Part of Work: Mixing, making, and painting.
Signature: C.C. Jemez N.M.

Erna Chosa, Page 26
(F) Jemez, Hopi, Tewa
Born: 4/6/59
Parents: Antonita Chosa
Teacher: Self-taught
Type of Work: Traditional Hopi style
22 years of experience
Awards: Never entered
Favorite Part of Work: Creating the vessels.
Signature: Erna Chosa

Patricia Chosa
(F) Jemez
Born: 1/26/48
Parents: Jemez
Teacher: Santa Fe Indian School
Type of Work: Traditional pottery
22 years of experience
Awards: I've won a Second Place award.
Favorite Part of Work: I like to make owls, quail, and storytellers.
Signature: P.C. Jemez N.M.

Alfreida Clark
(F) Navajo
Born: 11/18/63
Parents: Richard and Minnie Clark
Teacher: My uncle
Type of Work: Navajo kachinas
12 years of experience
Awards: none
Favorite Part of Work: I like painting the most.
Signature: A. Clark, Navajo

R. Claw, Page 26
Hopi

Clarence Cleveland
(M) Navajo-Hopi
Born: 5/16/48
Parents: Navajo-Hopi
Teacher: Watching others
Type of Work: Traditional Hano clowns
23 years of experience
Awards: I've never entered because my wife believes it may hurt our children in some way by seeking awards.
Favorite Part of Work: Selling my kachinas at the Palms Trading Company.
Signature: Clarence Cleveland

Sadie Cleveland
(F) Navajo
Born: 6/30/68
Parents: Johnny and Martha Cleveland
Teacher: Self-taught
Type of Work: Navajo kachinas
3 years of experience
Awards: None
Favorite Part of Work: I like to do the kachina dolls in the dreamcatchers.
Signature: Sadie Cleveland, Navajo

Farrell Cockrun, Page 80
(M) Blackfoot
Born: 11/22/62
Parents: Eva Horn, Browning Montana
Teacher: Self-taught
Type of Work: Sculpture, painting, arts
17 years of experience
Awards: None yet
Favorite Part of Work: I like to create and mold any type of sculpture, any kind of Indian art.
Signature: Farrell Cockrun

Iva A. Colaque
(F) Jemez
Born: 11/24/77
Parents: Goldie Colaque, Jemez
Teacher: My aunt and mother
Type of Work: Handmade pottery
5 years of experience
Awards: none
Favorite Part of Work: Making the pottery.
Signature: I.C. Jemez

Albertaleen Collateta
(F) Navajo
Born: 2/6/73
Parents: Robert and Kathleen Collateta
Teacher: My mother
Type of Work: Hopi pottery
4 years of experience
Awards: None
Favorite Part of Work: Molding and polishing are my favorite parts.
Signature: A. Collateta

Antonita C. Collateta, Page 26
(F) Hopi-Tewa
Born: 1/9/43
Parents: Hopi
Teacher: Sarah Collateta
Type of Work: Traditional pottery
12 years of experience
Awards: None yet
Favorite Part of Work: I like to get the money from selling my work, but seriously, I like to see that I do the best job I can on the pots.
Signature: ACC

Kathleen Collateta
(F) Hopi
Born: 12/2/46
Parents: Clark and Hope Tungavia
Teacher: Grandmother
Type of Work: Hopi pottery
7 years of experience
Awards: Never entered
Favorite Part of Work: Molding the clay into the shape I want and painting it when it is done.
Signature: K. Collateta

Kathleen S. Collateta
(F) Hopi/Jemez
Born: 11/24/69
Parents: Antonita and Tom Collateta
Teacher: My grandmother and mother
Type of Work: Traditional Hopi pottery
10 years of experience
Awards: Not yet, but hopefully soon.
Favorite Part of Work: Designing in the old traditional ways.
Signature: K. Collateta, Hopi/Tewa

Robertaleen Collateta
(F) Navajo
Born: 12/19/71
Parents: Robert and Kathleen Collateta
Teacher: My mother
Type of Work: Traditional Hopi pottery
4 years of experience
Awards: None
Favorite Part of Work: Molding and polishing are the favorite parts of my work. I also like to paint the pottery.
Signature: R. Collateta

Zona Collateta
(F) Hopi-Tewa
Born: 4/30/76
Parents: Antonita Collateta
Teacher: My mother
Type of Work: Traditional Hopi pottery
10 years of experience
Awards: None yet
Favorite Part of Work: I like to make my work progress without problems.
Signature: ZC

Robert Collateta, Jr.
(M) Hopi
Born: 1/2/78
Parents: Robert and Kathleen Collateta
Teacher: Mother
Type of Work: Hopi pottery
3 years of experience
Awards: Never entered
Favorite Part of Work: Molding a piece into the shape I see in my mind.
Signature: Collateta

Antoinette Concha
(F) Jemez and Taos
Born: 9/8/64
Parents: Alma Maestas and Del Concha
Teacher: My mother
Type of Work: Figurines and storytellers
20 years of experience
Awards: I've won a couple of them.
Favorite Part of Work: Painting is my favorite part.
Signature: A. Concha, Jemez N.M.

Alma Concha (Maestas)
(F) Jemez and Laguna
Born: 10/9/41
Parents: Louis and Carrie R. Loretto
Teacher: My mother Carrie
Type of Work: Pottery and figurines
49 years of experience
Awards: I've won awards at Santa Fe Indian Market, Gallup Indian Ceremonial, Eight Northern Pueblo Shows, and Heard Museum in Phoenix.
Favorite Part of Work: I like all the processes of my work with the clay.
Signature: ALMA, Jemez N.M.

Anthony Concho, Page 13
(M) Acoma
Born: 2/7/66
Parents: Mrs. Laura Vallo
Teacher: Ergil Vallo (brother)
Type of Work: Contemporary etched pottery
8 years of experience
Awards: Never entered
Favorite Part of Work: Making my own designs
Signature: A. C. Acoma, N.M.

Carolyn Concho, Page 12
(F) Acoma
Born: 9/15/61
Parents: Edward and Katherine Lewis
Teacher: Self-taught
Type of Work: Traditional seedpots
15 years of experience
Awards: First, Second and Third Awards at Santa Fe Indian Market, and the Heard Museum Show.
Favorite Part of Work: I like to paint the seedjars.
Signature: C. Concho, Acoma N.M.

Cyrus Concho
(M) Acoma
Born: 2/25/44
Parents: Acoma
Teacher: My friends
Type of Work: Ceramic etched and painted
14 years of experience
Awards: None
Favorite Part of Work: I like to put different designs on my pottery.
Signature: LC/CC Acoma N.M.

Eva Concho
(F) Acoma
Born: 3/28/66
Parents: Floyd and Angela Concho
Teacher: My grandmother and in-laws
Type of Work: Traditional and ceramic pots
5 years of experience
Awards: None yet
Favorite Part of Work: Creating the traditional pieces is my favorite part.
Signature: E. Concho, Acoma N.M.

Frances Concho (Patricio)
(F) Acoma
Born: 7/16/48
Parents: Jose and Helen Patricio, Acoma
Teacher: Parents
Type of Work: Traditional
42 years of experience
Awards: Best of Show, N M State Fair
Favorite Part of Work: Working and forming the clay.
Signature: Frances Concho Acoma

John Concho
(M) Acoma
Born: 4/9/64
Parents: Domingo Concho
Teacher: My mother
Type of Work: Ceramic pottery
3 years of experience
Awards: None
Favorite Part of Work: Painting original Indian designs on my work.
Signature: John C. Acoma N.M.

Lorianne Concho
(F) Acoma
Born: 11/22/64
Parents: Acoma
Teacher: My friend
Type of Work: Ceramic etched and painted
14 years of experience
Awards: None
Favorite Part of Work: I like to design the pottery.
Signature: LC/CC Acoma N.M.

Rachel Concho
(F) Acoma
Born: 1/31/36
Parents: Santana Cerno, Acoma
Teacher: My mother
Type of Work: Traditional pottery
41 years of experience
Awards: Best of Shows at Santa Fe Indian Market, and Eight Northern Pueblos Show.
Favorite Part of Work: Shaping the pieces.
Signature: R. Concho, Acoma

Angel Coriz, Page 80
(F) Santo Domingo
Born: 12/5/68
Parents: Luciano and Marie Coriz
Teacher: My mother
Type of Work: Storyteller jewelry
8 years of experience
Awards: None yet
Favorite Part of Work: I like to paint my necklaces after I've formed them.
Signature: A. Coriz

Arthur Coriz, Page 70
(M) Santo Domingo
Born: 10/21/48 (deceased)
Parents: Santo Domingo
Teacher: Self-taught
Type of Work: Traditional pottery
32 years of experience
Awards: Santa Fe Indian Market
Favorite Part of Work: Everything from start to finish.
Signature: Arthur and Hilda Coriz

Hilda Coriz Page 70
(F) Santo Domingo
Born: 2/7/49
Parents: Santo Domingo
Teacher: Self-taught
Type of Work: Traditional pottery
32 years of experience
Awards: Santa Fe Indian Market
Favorite Part of Work: Everything, from start to finish.
Signature: Arthur and Hilda Coriz, Hilda Coriz

Kensey Corkey
(M) Navajo
Born: 5/12/54
Parents: Navajo
Teacher: My friends
Type of Work: Navajo kachinas
10 years of experience
Awards: None
Favorite Part of Work: I like all parts of my work.
Signature: K.C.

"Coyote," see Tim Smith

Elizabeth Curley
(F) Navajo
Born: 8/11/52
Parents: Navajo
Teacher: My Grandpa
Type of Work: Traditional storytellers
20 years of experience
Awards: I've won awards at the New Mexico State Fair in Albuquerque.
Favorite Part of Work: I like to put the figurines together from the beginning.
Signature: E F Curley

Dolores Curran, Page 57
(F) Santa Clara
Born: 7/3/55
Parents: Santa Clara
Teacher: Mother
Type of Work: Traditional matte finish
17 years of experience
Awards: I've won many awards at various art shows such as Santa Fe Indian Market and the N.M. State Fair.
Favorite Part of Work: Painting the most precise designs I can.
Signature: Dolores Curran, Santa Clara

Tony Dallas
(M) Hopi
Born: 3/23/56
Parents: Patrick and Marrietta Dallas
Teacher: Lucy Suina, Hopi, Pima
Type of Work: Storytellers and figurines
17 years of experience
Awards: I've won awards at N.M. State Fair, and Gallup Indian Ceremonial.
Favorite Part of Work: Painting my storytellers and clowns is my favorite part of my work.
Signature: TD, HOPI

Alice Dashee
(F) Hopi
Born: 5/3/46
Parents: Hopi and Tewa
Teacher: My friends
Type of Work: Traditional Hopi pottery
24 years of experience
Awards: None yet
Favorite Part of Work: I like the fact that I work in my home and can have my own hours.
Signature: Alice Dashee

Dennis Daubs
(M) Jemez
Born: 12/15/60
Parents: Gerri Gauchupin Daubs
Teacher: Juanita Fragua
Type of Work: Traditional incised pottery
19 years of experience
Awards: I've won awards at the Santa Fe Indian Market, the New Mexico State Fair and the Heard Museum Show in Pheonix.
Favorite Part of Work: I like when the pieces are finished.
Signature: Dennis Daubs, Jemez Pueblo N.M.

Glendora Daubs, Page 34
Jemez

Joseph S. David
(M) Tewa
Born: 9/29/71
Parents: Irma David
Teacher: Uncle Frank
Type of Work: Kachina Doll carving
17 years of experience
Awards: None
Favorite Part of Work: Seeing what kind of doll the wood will bring forth.
Signature: Joey David

Darla K. Davis
(F) Acoma
Born: 8/3/60
Parents: Rachael and James White
Teacher: My mom and grandmother
Type of Work: Traditional pottery
18 years of experience
Awards: Second place at Window Rock, First at the Arizona Arts and Crafts show, Third Place at the Native American Art Show.
Favorite Part of Work: I like to design and paint the most.
Signature: Darla Davis, Acoma, John 3:16

Miriam Davis
(F) Laguna
Born: 12/3/52
Parents: Ortiz family, Laguna, Jemez
Teacher: Self-taught
Type of Work: Pottery
17 years of experience
Awards: Never entered
Favorite Part of Work: The entire creative process
Signature: M. Davis Laguna, N.M.

Nuvadi Dawahoya
(M) Hopi
Born: 12/26/76
Parents: Dinah and Beauford Dawahoya
Teacher: Self-taught
Type of Work: Hopi Kachina dolls
3 years of experience
Awards: None
Favorite Part of Work: Doing different dolls.
Signature: Nuvadi, D.

Rosita DeHerrera, Page 52
(F) San Juan
Born: 9/1/44
Parents: Tomasita and Juan Montoya
Teacher: My mother
Type of Work: Traditional carved
25 years of experience
Awards: I've won many awards at Eight Northern Pueblo Shows and Gallup Indian Ceremonial.
Favorite Part of Work: I like to polish and fire my work.
Signature: Rosita DeHerrera, San Juan

Lance Deysee
(M) Zuni
Born: 2/24/77
Parents: Alfred and Rebecca Deysee
Teacher: My grandfather
Type of Work: Traditional stone fetishes
5 years of experience
Awards: None yet
Favorite Part of Work: I like to detail each piece and see how close I can come to reality.
Signature: LD

Juanita DuBray
(F) Taos
Born: 6/20/29
Parents: Mr. and Mrs. Elisio Suazo
Teacher: Self-taught
Type of Work: Traditional Taos pottery
20 years of experience
Awards: I won an award at San Ildefonso once.
Favorite Part of Work: I like to make all types of pottery and storytellers.
Signature: J. Suazo, DuBray, Taos N.M.

Carmelita Dunlap, Page 51
(F) San Ildefonso
Born: 7/6/25
Parents: San Ildefonso
Teacher: Self-taught
Type of Work: Matte on black
67 years of experience
Awards: I've won many, many awards from all over but probably the most from Santa Fe Indian market every year.
Favorite Part of Work: I have always liked to construct the larger pieces but I really like to sell it!
Signature: Carmelita Dunlap

Jeannie Dunlap
(F) San Ildefonso
Born: 12/2/53
Parents: Carmelita Dunlap
Teacher: My mother
Type of Work: Black on black pottery
22 years of experience
Awards: I've won many awards at the Santa Fe Indian Market over several years as well as the N. M. State Fair, The Heard Museum and The Santa Monica Indian Art Show.
Favorite Part of Work: I really like to see my work when it is finished.
Signature: Mountain Flower Dunlap

Shawna Dunlap
(F) San Ildefonso
Born: 10/31/75
Parents: Linda Dunlap
Teacher: Carmelita Dunlap
Type of Work: Matte on black
3 years of experience
Awards: None yet
Favorite Part of Work: I like to make my pottery as close to my grandmother's, Carmelita Dunlap, as I can.
Signature: Shawna Dunlap

Preston V. Duwyenie, Page 5
Hopi Pueblo
Parents: Hubbell and Edith Duwyenie
Teacher: self-taught and schools
Type of Work: Pottery and jewelry
20 years experience
Awards: I've won 1st, 2nd, 3rd, Classifications, Divisions, Honorable Mentions, and Best of Shows at various shows
Favorite Part of Work: I ike to meet the public and look at the finished work.
Signature: With a symbol on the bottom

Mary Eckleberry, Page 57
(F) Santa Clara
Parents: Christina Naranjo
Teacher: My mother
Type of Work: Traditional melon pots
12 years of experience
Awards: I've won ribbons at various art shows such as Picuris, Espanola Valley and the New Mexico State Fair.
Favorite Part of Work: Polishing the pottery is my favorite part of my work.
Signature: Mary Eckleberry, Santa Clara

Naomi Eckleberry, Page 57
(F) Santa Clara
Born: 1/16/60
Parents: Mary Eckleberry
Teacher: My mother
Type of Work: Traditional Santa Clara pots
12 years of experience
Awards: We don't enter many shows.
Favorite Part of Work: Designing the pottery is my favorite part of my work.
Signature: Naomi Eckleberry, Santa Clara

Victor Eckleberry, Page 57
(M) Santa Clara
Born: 12/1/58
Parents: Mary Eckleberry
Teacher: My mother
Type of Work: Traditional Santa Clara
12 years of experience
Awards: We don't enter many shows.
Favorite Part of Work: Carving the pottery is my favorite part.
Signature: Victor Eckleberry, Santa Clara

Robert Edaakie
(M) Isleta, Zuni
Born: 5/16/56
Parents: Ted and Tillie Edaakie
Teacher: Self-taught
Type of Work: Pottery
17 years of experience
Awards: None
Favorite Part of Work: Painting the kachina faces on my pots.
Signature: R.A. Edaakie, Isleta

Emma Elkins
(F) Santa Clara
Born: 3/27/40
Parents: Lavirgin Tafoya, Santa Clara
Teacher: Mom and Sheri Tafoya
Type of Work: Traditional pottery
12 years of experience
Awards: None
Favorite Part of Work: Carving the pots.
Signature: PO' POVI, Santa Clara

Delores Eriacho
(F) Navajo
Born: 11/2/62
Parents: Navajo
Teacher: My sister
Type of Work: Ceramic pottery
7 years of experience
Awards: None
Favorite Part of Work: I like painting the most.
Signature: Eriacho, Navajo

Aaron L. Esidro
(M) Laguna
Born: 7/21/70

Teacher: Self-taught
Type of Work: Carver (kachinas)
7 years of experience
Awards: Never entered
Favorite Part of Work: Seeing a piece start to finish.
Signature: A. Esidro

Bessie Esquibel
(F) Jemez
Born: 9/23/37
Parents: Abel Sando, Jemez
Teacher: My sister
Type of Work: Storytellers and figurines
10 years of experience
Awards: None yet
Favorite Part of Work: Painting my storytellers.
Signature: B. Esquibel, Jemez

Berleen Estevan
(F) Acoma
Born: 10/5/75
Parents: Charleen Estevan, Acoma
Teacher: My mother
Type of Work: Ceramic and traditional
7 years of experience
Awards: I've never entered.
Favorite Part of Work: I like to paint the designs on the pottery the best.
Signature: B. Estevan Acoma, New Mexico

Jennifer Estevan, Page 13
(F) Acoma
Born: 6/15/63
Parents: Virginia Estevan, Acoma
Teacher: Mother
Type of Work: Traditional bowls and vases
16 years of experience
Awards: N.M. State Fair
Favorite Part of Work: Creating my intricate lightning designs, making my pieces unique.
Signature: Jennifer Estevan

Marcia Estevan
(F) Acoma
Born: 5/14/64
Parents: Patsy Mike, Acoma
Teacher: My mother and myself
Type of Work: Traditional and ceramic pots
5 years of experience
Awards: None
Favorite Part of Work: I like the painting the most.
Signature: Marcia Estevan, Acoma N.M.

Paula Estevan
(F) Acoma
Born: 9/19/67
Parents: Patsy Mike, Acoma
Teacher: Self-taught
Type of Work: Ceramic and traditional pots
14 years of experience
Awards: None
Favorite Part of Work: I like to see the results after the firing.
Signature: P. Estevan, Acoma N.M.

Kimberly Eteeyan
(F) Jemez
Born: 6/11/64
Parents: William and Mary Eteeyan
Teacher: My mother
Type of Work: Storytellers and bowls
12 years of experience
Awards: Honorable mention at N.M. State Fair and Gallup Indian Ceremonial
Favorite Part of Work: Carrying on the traditions of our people.
Signature: K.E. Jemez

Carl Etsate
(M) Zuni
Born: 7/11/71
Parents: Beverly Etsate
Teacher: Self-taught
Type of Work: Fetish carving
8 years of experience
Awards: I've never entered my work.
Favorite Part of Work: I like everything from start to finish.
Signature: CE

Emma J. Etsitty
(F) Navajo
Born: 11/3/59
Parents: Francis and Mae Etsitty
Teacher: Everson Whitegoat
Type of Work: Navajo etched
8 years of experience
Awards: None
Favorite Part of Work: I like to hand paint my work, design it and carve it.
Signature: E. Etsitty, Navajo

Peggy Etsitty, Page 46
Navajo

Felicita Eustace
(F) Cochiti
Born: 8/7/27
Parents: Seferina Herrera
Teacher: Juanita Arquero
Type of Work: Storytellers
11 years of experience
Awards: Gallup Indian Ceremonial and Santa Fe Indian Market.
Favorite Part of Work: I like working with the clay and painting.
Signature: Felicita Eustace, Cochiti N.M.

Jody Folwell
(F) Santa Clara
Born: 8/4/42
Parents: Santa Clara
Teacher: Parents and community
Type of Work: Contemporary pottery
46 years of experience
Awards: Best of Show at the Santa Fe Indian Market.
Favorite Part of Work: Pushing the limits of my creativity.
Signature: JODY

Polly Folwell
(F) Santa Clara
Born: 12/28/62
Parents: Jody Folwell
Teacher: My Parents and the community
Type of Work: Contemporary pottery
22 years of experience
Awards: None yet
Favorite Part of Work: I like to follow in my mom's footsteps and see how I can be the same, yet different.
Signature: Polly

Susan Folwell
(F) Santa Clara
Born: 6/20/70
Parents: Jody Folwell, Santa Clara
Teacher: My mother and grandmother
Type of Work: Contemporary Indian pottery
10 years of experience
Awards: I've won a First Place award at Santa Fe Indian Market.
Favorite Part of Work: Following in my mother's footsteps.
Signature: SF or Suasan or Mesa Flower

Evangelita Foster
(F) Navajo
Born: 3/23/69
Teacher: Friends
Type of Work: Navajo Kachina (Koshari)
3 years of experience
Awards: Never entered
Favorite Part of Work: Carving the figures.
Signature: E. Foster

Peter Foster
(M) Navajo
Born: 12/12/58
Teacher: Self-taught
Type of Work: Wood carver (Kachina Dolls)
12 years of experience
Awards: Never entered
Favorite Part of Work: Carving the dolls from wood.
Signature: Peter Foster

Andrea V. Fragua
(F) Jemez
Born: 3/31/48
Parents: Evelyn M. Vigil, Jemez
Teacher: My mother
Type of Work: Traditional Jemez and Pecos
26 years of experience
Awards: The Museum of New Mexico award.
Favorite Part of Work: Wedding vases and bowls, but I really like all of the processes of creating pottery.
Signature: A.V.F. Jemez N.M.

B.J. Fragua
(F) Jemez
Born: 10/10/62
Parents: Manuel and Juanita Fragua
Teacher: My mother
Type of Work: Traditional pottery
15 years of experience
Awards: First and Third at Santa Fe Indian Market.
Favorite Part of Work: Creating, polishing, and painting.
Signature: B.J. Fragua, Jemez N.M.

(M) Jemez
Born: 3/26/61
Parents: Felix Fragua, Jemez
Teacher: Bonnie and Rose Fragua
Type of Work: Traditional pottery
5 years of experience
Awards: None
Favorite Part of Work: I like all the parts of making pottery.
Signature: B. Fragua, Jemez N.M.

Bonnie Fragua
(F) Jemez
Born: 3/24/66
Parents: Felix and Grace Fragua
Type of Work: Storytellers and other figures
16 years of experience
Awards: Eight Northern and other art shows
Favorite Part of Work: Creating a new piece and painting it
Signature: Bonnie Fragua

(F) Jemez
Born: 1/20/70
Parents: Christino and Vera Fragua
Teacher: Rose Fragua and Emily Tsosie
Type of Work: Storytellers and figurines
11 years of experience
Awards: None yet
Favorite Part of Work: Painting is my favorite part of my work.
Signature: Cheryl Fragua, Jemez N.M.

Chris Fragua
(M) Jemez
Born: 1/10/43
Parents: Grace L. Fragua
Teacher: My mother
Type of Work: Storytellers and figurines
14 years of experience
Awards: I've never entered my work.
Favorite Part of Work: I like the whole process that goes into making the pottery.
Signature: Chris Fragua

Cindy Fragua
(F) Jemez
Born: 3/4/63
Parents: Rose T. Fragua
Teacher: Rose and Emily Fragua
Type of Work: Storytellers
14 years of experience
Awards: Third Place at 1994 N.M.State Fair
Favorite Part of Work: Creating and painting the storytellers then wondering what stories they may tell.
Signature: Cindy Fragua, Jemez

Clifford Fragua
(M) Jemez
Born: 4/10/57
Parents: Jemez Pueblo
Teacher: My mother
Type of Work: Traditional figurines
30 years of experience
Awards: I've won many awards at various art shows.
Favorite Part of Work: I like all aspects of my pottery making.
Signature: Clifford K. Fragua

Jemez
Born: 9/12/58
Parents: Juanita & Manuel Fragua
Teacher: Mother
Type of work: Traditional pottery
23 years experience
Awards: I've won numerous awards from the Santa Fe Indian Market, The New Mexico State Fair, and The Gallup Ceremonial
Favorite Part of Work: My favorite part of making the pottery is carving out the designs
Signature: with a Cornstalk

(F) Jemez
Born: 5/9/64
Parents: Rose T. Fragua, Jemez
Teacher: My mother
Type of Work: Storytellers
14 years of experience
Awards: None yet
Favorite Part of Work: Making the storytellers then painting them.
Signature: Janeth Fragua, Jemez

(F) Jemez
Born: 3/15/35
Parents: Rita Magdalena, Zia, Jemez
Teacher: My mother
Type of Work: Traditional polished Jemez
24 years of experience
Awards: I've won all sorts of ribbons from many, many art shows across the country.
Favorite Part of Work: I like to make my melon pots the most.
Signature: Name and an Arrow

Lenora G. Fragua, Page 35, 84
(F) Jemez
Born: 4/18/38
Parents: Mr. Joe R. Gachupin, Jemez
Teacher: My mother
Type of Work: Traditional pottery
44 years of experience
Awards: None
Favorite Part of Work: I like all the processes of my work.
Signature: L.G.F. Jemez N.M.

Linda L. Fragua, Page 83
(F) Jemez
Born: 11/28/54
Parents: Joe and Rebecca Lucero
Teacher: My mother
Type of Work: Traditional pottery and storytellers
24 years of experience
Awards: I've won many awards at various art shows around the Southwest.
Favorite Part of Work: I like to make my storytellers the most.
Signature: Linda Lucero Fragua, Jemez N.M.

Mabel Fragua
(F) Jemez
Born: 3/27/47
Parents: Josephine Loretto
Teacher: Self-taught
Type of Work: Traditional pottery
39 years of experience
Awards: None
Favorite Part of Work: Creating each piece.
Signature: M.F. Jemez N.M.

Melinda Toya Fragua
(F) Jemez
Born: 3/18/59
Parents: Mary E. and Casimiro Toya, Sr., Jemez
Teacher: My mother
Type of Work: Storytellers
17 years of experience
Awards: I've won First, Second, and Third Place ribbons for my work at Eight Northern Pueblo Shows.
Favorite Part of Work: My favoite part of my work would be making the dolls.
Signature: Melinda Toya Fragua, Jemez N.M

Philip M. Fragua, Page 83
Jemez

Raylene Fragua
(F) Jemez
Born: 10/22/78
Parents: Robert and Mabel Fragua
Teacher: Myself
Type of Work: Storytellers
5 years of experience
Awards: None
Favorite Part of Work: Creating each individual piece in its own unique way.
Signature: R.F. Jemez N.M.

Rose T. Fragua, Page 83
Jemez

Vera C. Fragua
(F) Jemez
Born: 11/25/42
Parents: Jemez Pueblo
Teacher: The Fragua Family
Type of Work: Figurine and storyteller pottery
15 years of experience
Awards: I've never entered my work.
Favorite Part of Work: I like to paint the most.
Signature: Vera C. Fragua

Virginia (Ponca) Fragua, Page 36
(F) Jemez
Born: 9/25/61
Parents: Mr. and Mrs. Moses Fragua
Teacher: My mother, Lenora Fragua
Type of Work: Traditional and melon bowls
17 years of experience
Awards: None
Favorite Part of Work: Painting is my favorite part.
Signature: P. Fragua, Jemez N.M.

Felicia Fragua (Wallowing Bull)
(F) Jemez
Born: 10/23/64
Parents: Felix and Grace Fragua
Teacher: Grace, Bonnie and Rose Fragua
Type of Work: Traditional storytellers
21 years of experience
Awards: I've won some First Place awards for my miniature storytellers.
Favorite Part of Work: I like to create the dolls First and then my next favorite thing is to paint them.
Signature: Felicia Fragua, Jemez N.M.

Sterling Francis
(M) Hopi/Laguna
Born: 7/4/72
Parents: Teodore* and Virgie Francis
Teacher: My father
Type of Work: Kachina dolls
10 years of experience
Awards: N.M.State Fair, Gallup Indian Ceremonial.
Favorite Part of Work: Painting the finished doll.
Signature: Sterling Francis, Sr.

Ted Francis, Jr.
(M) Laguna
Born: 1/26/62
Parents: Ted and Virginia Francis
Teacher: My father and uncles
Type of Work: Traditional and contemporary kachinas
12 years of experience
Awards: None yet
Favorite Part of Work: I like my work when it is finished.
Signature: Ted Francis, Jr.

Ted Francis, Sr.
(M) Laguna, Hopi
Born: 5/18/37
Parents: Benjamin and Carol Francis
Teacher: George Ddwakuku, Sr.
Type of Work: Kachina carving
22 years of experience
Awards: Best of Show, First and Second Places at many shows.
Favorite Part of Work: Carving from scratch.
Signature: Ted Francis, Sr.

Elizabeth Frank (Curley)
(F) Navajo
Born: 8/11/52
Parents: Navajo
Teacher: My grandparents
Type of Work: Traditional storytellers
30 years of experience
Awards: I've won some First Place ribbons.
Favorite Part of Work: I like to look for the natural clay then get started working on my storytellers, putting each one together.
Signature: E.C.F., Navajo

Claudia K. Frye
(F) Apache/Tewa
Born: 9/5/54
Parents: F—Tesuque, M—Mescalero
Teacher: Self-taught
Type of Work: Mixed
17 years of experience
Awards: N.M. State Fair 1992
Favorite Part of Work: Making large pots with ancient designs.
Signature: K'A-WEEN Tesuque

Ira Funmaker
(M) Ho-Chunk Nation
Born: 4/9/56
Parents: Adam Funmaker and Doris Stacy
Teacher: An elder from the tribe
Type of Work: Handmade flutes
9 years of experience
Awards: I have one of my flutes in the Smithsonian Institution in Washington D.C.
Favorite Part of Work: The favorite part of my work is seeing the satisfaction of the buyers of my work and their appreciation of craftsmanship and sound.
Signature: Ira Funmaker

Bertha Gachupin
(F) Jemez
Born: 4/11/54
Parents: Persingula M. Gachupin, Jemez
Teacher: My grandmother
Type of Work: Traditional pottery
12 years of experience
Awards: None yet
Favorite Part of Work: Making melon bowls and polishing them.
Signature: Bertha Gauchupin

Carla C. Gachupin
(F) Jemez
Born: 8/13/70
Parents: Matthew and Genevieve Gachupin
Teacher: Mother and other relatives
Type of Work: Pottery, storytellers
8 years of experience
Awards: Never entered
Favorite Part of Work: Trying different things; painting and adding different images.
Signature: C. Gachupin, Jemez N.M.

Carmelita Gachupin, Page 36
(F) Jemez
Born: 5/3/51
Parents: Gerry Daubs, Jemez
Teacher: Vangie Tafoya
Type of Work: Ceramic Jemez style
24 years of experience
Awards: None yet
Favorite Part of Work: I like to paint, it gives me time to myself, away from the kids.
Signature: C. Gachupin, Jemez N.M.

Carol Lucero Gachupin, Page 85
Jemez

Clara Gachupin, Page 36
Jemez - Walatowa
Born: 11/30/48
Parents: Jose Maria and Reyes S. Toya
Teacher: Mother
Type of Work: Traditional pottery
30 years experience
Awards: I've won 1st Place at the Santa Fe Indian Market in 1998.
Favorite part of work: I like painting the most. I don't like to sand the clay, I get lazy
Signature: Clara Gachupin- Jemez Pueblo, NM

Genevieve Gachupin, Page 84
(F) Jemez
Born: 1/12/48
Parents: Jemez
Teacher: Self-taught
Type of Work: Pottery and storytellers
32 years of experience
Awards: Second Place at a Youngbrook show.
Favorite Part of Work: Painting
Signature: G. Gachupin, Jemez.

Joseph R. Gachupin, Page 84
(M) Jemez
Born: 12/14/53
Parents: Irene Gachupin Jemez
Teacher: My wife
Type of Work: Traditional and contemporary
23 years of experience
Awards: Second Place at Denver and First Place at Eight Northern Pueblos Show.
Favorite Part of Work: I love to have different ideas and bring them to something tangible.
Signature: J. R. Gachupin, Jemez N.M.

Laura Gachupin, Page 36
(F) Jemez
Born: 11/4/54
Parents: Marie G. Romero
Teacher: Persingula M. Gachupin
Type of Work: Traditional and contemporary
22 years of experience
Awards: Indian Market, Santa Fe. N.M. State Fair , Eight Northern Pueblo Show.
Favorite Part of Work: Doing everything from scratch, digging for gold.
Signature: Laura Gachupin

M. F. Gachupin, Page 36
Jemez

Rebecca T. Gachupin
(F) Jemez
Born: 11/17/55
Parents: Andrea C. Tsosie, Jemez
Teacher: Mother
Type of Work: Zia-style pottery
12 years of experience
Awards: Never entered
Favorite Part of Work: Bringing color to the piece.
Signature: RG

Wilma M. Gachupin, Page 85
(F) Jemez
Born: 7/30/57
Parents: Lawrence Sands and J. Gonzales
Teacher: Kenneth Sando
Type of Work: Storytellers
11 years of experience
Awards: Never entered
Favorite Part of Work: Bringing joy to others by my work.
Signature: Wilma M Gachupin/W. Gachupin

JoAnne G. Gallegos
(F) Acoma
Born: 9/24/57
Parents: Elizabeth Garcia, Acoma
Teacher: My mother and Mary Lewis
Type of Work: Traditional and ceramic pots
15 years of experience
Awards: 1994 N.M. State Fair
Favorite Part of Work: Creating and desgning my handmade pottery.
Signature: JoAnne Garcia, Acoma

Amelia Galvan
(F) Jemez
Born: 5/10/40
Parents: Jemez Pueblo
Teacher: My mother
Type of Work: Traditional pottery
37 years of experience
Awards: None
Favorite Part of Work: I like just about everything about pottery making, except sanding.
Signature: A.G. Jemez N.M.

Beatrice Garcia, Page 13
(F) Acoma
Born: 1/16/53
Parents: Mr. and Mrs. Lorenzo P. Garcia
Teacher: My grandmother
Type of Work: Pottery
22 years of experience
Awards: None
Favorite Part of Work: Creating the pieces from the earth.
Signature: Beatrice Garcia

Beverly Vicctorino (Garcia), Page 13

Claudia Garcia
(F) Acoma
Born: 4/26/52
Parents: Ruth Garcia, Acoma N.M.
Teacher: My mother
Type of Work: Traditional and ceramic pottery
22 years of experience
Awards: None
Favorite Part of Work: Designing and painting are my favorite parts of my work.
Signature: Claudia Garcia, Acoma N.M.

Corrine Garcia
(F) Acoma
Born: 2/17/60
Parents: Fermin and Sarah Martinez
Teacher: My grandmother
Type of Work: Corrugated storybowls
20 years of experience
Awards: None
Favorite Part of Work: It depends on the day but usually I like to paint the most.
Signature: C. Garcia, Acoma N.M.

Cyres Garcia
(F) Acoma
Born: 12/17/55
Parents: Albert Garcia , Acoma
Teacher: My sisters
Type of Work: Pottery
5 years of experience
Awards: None
Favorite Part of Work: Creating the pottery.
Signature: Garcia, Acoma

Dolores L. Garcia
(F) Acoma
Born: 7/25/38
Parents: Lucy and Toribio Lewis
Teacher: Self-taught
Type of Work: Traditional Acoma pottery
47 years of experience
Awards: Many awards at shows all across the Southwest.
Favorite Part of Work: I like all steps of the potting process.
Signature: Dolores Lewis, Acoma N.M.

Effie Garcia, Page 57
Santa Clara Pueblo
Born: 9/13/53
Parents: Celestino and Victoia Gutierrez
Teacher: My parents and self-taught
Type of Work: Black carved pottery
30 years experience
Awards: Along with my husband, we've won Best of Division and Classification at Indian Market and Gallup Ceremonials. We've also won 1st, 2nd, and 3rd.
Favorite Part of Work: We like it when we finish a piece and it comes out wonderfully
Signature: Orville & Effie Garcia

Elliott Garcia, Page 14
(M) Acoma
Born: 7/24/47
Parents: Acoma
Teacher: My parents
Type of Work: Ceramic Pottery
22 years of experience
Awards: None
Favorite Part of Work: I like to come up with different designs.
Signature: A sunrise stamp

Fawn N. Garcia
(F) Hopi
Born: 3/25/59 (deceased)
Parents: Eunice Navasie, Hopi
Teacher: My mother
Type of Work: Traditional Hopi pottery
21 years of experience
Awards: I've won many awards at the Santa Fe Indian Market.
Favorite Part of Work: I think my favorite part would have to be painting.
Signature: Fawn w/doe prints

Greg Garcia, Page 52
(M) Santa Clara, San Juan
Born: 3/26/61
Parents: Santiago and Lydia Garcia
Teacher: My grandmother, Severa Tafoya
Type of Work: Black and red polished
22 years of experience
Awards: Best in Class two times at the Gallup Indian Ceremonial and a First and Second Place award at Santa Fe Indian Market.
Favorite Part of Work: Polishing the piece the best I can.
Signature: Greg Garcia

James Garcia (Nampeyo)
(M) Hopi/Laguna
Born: 2/11/58
Parents: Leah Nampeyo, Hopi
Teacher: Grandmother
Type of Work: Pottery
17 years of experience
Awards: Numerous awards. Heard Museum, N.M.State Fair , Gallup Indian Ceremonial.
Favorite Part of Work: Seeing the finished piece.
Signature: James G. Nampeyo

Janet Garcia
(F) Acoma
Born: 12/24/75
Parents: Elliot and Beatrice Garcia
Teacher: My parents
Type of Work: Ceramic fine line with lizards
4 years of experience
Awards: None yet
Favorite Part of Work: I really like to paint the fine line designs.
Signature: DJ Garcia, Acoma N.M.

Leslie M. Garcia
(F) Acoma
Born: 6/5/78
Parents: Loretta and Chris Garcia
Teacher: My mother and grandmother
Type of Work: Traditional Acoma pottery
3 years of experience
Awards: None yet
Favorite Part of Work: I like to paint the pottery.
Signature: L. Garcia

Loretta Garcia
(F) Acoma
Born: 1/7/56
Parents: Marie Torivio, Acoma
Teacher: Mother
Type of Work: Traditional pottery, ceramics
27 years of experience
Awards: Never entered
Favorite Part of Work: Creating the piece and painting
Signature: L. Garcia

Lorrie Garcia
(F) Acoma
Born: 5/27/57
Parents: Jessie Garcia, Acoma
Teacher: My mother
Type of Work: Traditional pottery
13 years of experience
Awards: None
Favorite Part of Work: Molding and painting.
Signature: Lori Garcia

Lynette Garcia
(F) Acoma
Born: 5/8/72
Parents: Beatrice and Elliot Garcia
Teacher: Mother
Type of Work: Pottery
7 years of experience
Awards: Never entered
Favorite Part of Work: Creating new designs
Signature: L. Garcia

Marty Garcia
(M) Acoma
Born: 9/3/61
Parents: Richard and Sally Garcia
Teacher: My friend
Type of Work: Ceramic and traditional pottery
8 years of experience
Awards: None yet
Favorite Part of Work: Creating the traditional pottery is my favorite part.
Signature: M. M. Garcia, Acoma N.M.

Mary J. Garcia
(F) Acoma
Born: 12/29/62
Parents: David and Hilda Antonio, Acoma
Teacher: My mother and grandmother
Type of Work: Traditional and ceramic pottery
17 years of experience
Awards: None
Favorite Part of Work: Molding the pieces and painting them.
Signature: M. A. G. Acoma N.M.

Sarah Garcia
(F) Acoma
Born: 12/6/28
Parents: Maria Trujillo, Laguna
Teacher: My grandmother from Laguna.
Type of Work: Traditional Acoma pottery
67 years of experience
Awards: Santa Fe Indian Market, Eight Northern Pueblo Show.
Favorite Part of Work: I like to make different sizes of pots and making unusual pots.
Signature: Sarah Garcia, Acoma N.M.

Shana Garcia, Page 14
(F) Acoma
Born: 12/31/69
Parents: Elliott Garcia
Teacher: My father and myself
Type of Work: Contemporary, traditional
8 years of experience
Awards: Third Place at the New Mexico State Fair, and also a Best of Show.
Favorite Part of Work: I like doing the painting and the selling but I really enjoy most of the processes.
Signature: S. Garcia, Acoma N.M.

Shelly R. Garcia
(F) Acoma
Born: 4/6/82
Parents: Marcus and Virginia Garcia
Teacher: Parents
Type of Work: Traditional
4 years of experience
Awards: Gallup Ceremonial, Arts and Crafts Best of Show; New Mexico State Fair.
Favorite Part of Work: Painting the turtle back designs.
Signature: Shelly Garcia w/ bearclaw

Tena Garcia
(F) Acoma
Born: 12/19/64
Parents: Rose Chino Garcia, Acoma N.M.
Teacher: My mother
Type of Work: Traditional and ceramic pottery
8 years of experience
Awards: I've won a few awards at different shows.
Favorite Part of Work: Painting is my favorite part of my work.
Signature: Tena Garcia, Acoma N.M.

Theresa R. Garcia
(F) Acoma
Born: 9/5/64
Parents: Mr and Mrs A. Garcia, Acoma
Teacher: Sister (Vivian Seymour—VIPS)
Type of Work: Traditional pottery
10 years of experience
Awards: Never entered
Favorite Part of Work: Adding color to a piece.
Signature: T. GARCIA ACOMA N.M.

Tina Garcia
(F) San Juan, Santa Clara
Born: 5/11/57
Parents: Santiago and Lydia Garcia
Teacher: My mother and grandmother
Type of Work: Traditional black and red
27 years of experience
Awards: Santa Fe Indian Market, Gallup Indian Ceremonial,
Heard Museum Show, N.M. State Fair
Favorite Part of Work: Building the pieces from the clay.
Signature: Tina Garcia San Juan , SC

Tina Garcia
(F) Acoma
Born: 3/29/50
Parents: Jessie Garcia
Teacher: My mother
Type of Work: Traditional pottery
32 years of experience
Awards: N.M. State Fair
Favorite Part of Work: I like painting the best.
Signature: Tina Garcia, Acoma, N.M.

Verna Garcia
(F) Acoma
Born: 3/24/67
Parents: Paulina Garcia Acoma
Teacher: My mother
Type of Work: Pottery
8 years of experience
Awards: None yet
Favorite Part of Work: Designing the pieces.
Signature: Verna Garcia, (year)

Veronica Garcia
(F) Laguna
Born: 12/31/63
Parents: Sally Garcia, Laguna
Teacher: My mother, Sally Garcia
Type of Work: Carved ceramics
8 years of experience
Awards: First Place ribbon, N.M. State Fair.
Favorite Part of Work: Carving the designs.
Signature: V. Garcia, Laguna

Virginia Garcia, Page 58
(F) Santa Clara, San Juan
Born: 10/30/63
Parents: Lydia and Santiago Garcia
Teacher: Sister and self
Type of Work: Traditional red and black
10 years of experience
Awards: I've won many awards at various art shows,
including Santa Fe Indian Market, Gallup Indian Ceremonial
and the Eight Northern Pueblo shows.
Favorite Part of Work: I like to make the piece and enjoy the
outcome.
Signature: Virginia Garcia, SC SJ\year

Virginia (Virgie) Garcia, Page 14
(F) Acoma
Born: 12/10/47
Parents: Rosita Stevens
Teacher: My grandmother
Type of Work: Traditional pottery
17 years of experience
Awards: N.M. State Fair
Favorite Part of Work: I like painting the most.
Signature: Virgie Garcia, Acoma N.M.

Wilfred Garcia, Page 15
(M) Acoma
Born: 3/30/54
Parents: Tony and Lucy Garcia, Acoma
Teacher: Self-taught and Stella Shutiva
Type of Work: Contemporary pottery
17 years of experience
Awards: Santa Fe Indian Market, Gallup Indian Ceremonial,
Heard Museum show, and the New Mexico State Fair.
Favorite Part of Work: I like to do the Mesa Verde Pots the
most.
Signature: WGarcia

JoAnne Garcia (Gallegos)
(F) Acoma
Born: 9/24/57
Parents: Mary Recus, Acoma
Teacher: My grandmother and uncle
Type of Work: Traditional pottery
15 years of experience
Awards: 1993 N.M. State Fair
Favorite Part of Work: Creating the pots and designing them.
Signature: JoAnne Garcia, Acoma N.M.

Gloria Goldenrod (Garcia), Page 58
(F) Santa Clara
Born: 12/1/46
Parents: Santa Clara
Teacher: Minnie Vigil
Type of Work: Traditional scraffitto
37 years of experience
Awards: Many awards have been won at places such as
Santa Fe Indian Market and the N.M. State Fair.
Favorite Part of Work: Creating designs is my favorite part.
Signature: GOLDENROD

Gabriel Gonzales, Page 37
(M) Jemez
Born: 5/6/71
Parents: George and Persingula Gonzales
Teacher: Parents, self, Nancy Youngblood
Type of Work: Carving designs and melons
10 years of experience
Awards: First, Second, Third—Indian Market, Eighth North-
ern, Grand Junction Colorado, Portland Oregon
Favorite Part of Work: Any kind of carving, especially on the
melons.
Signature: Gabriel Gonzales Jemez

Jeff Grandbois
(M) Turtle Mountain Chippewa
Born: 9/8/60
Parents: Chippewa
Teacher: Rollie Grandbois, my brother
Type of Work: Stone and bronze sculpture
12 years of experience
Awards: I did the 1992 Indy 500 trophy for Al Unser, Jr.
Favorite Part of Work: Finishing the stone to the best finish I
can get.
Signature: Jeff Grandbois (Year)

Rita Gurley
(F) Navajo
Born: 3/30/50
Parents: Navajo
Teacher: My family
Type of Work: Artifacts
5 years of experience
Awards: None
Favorite Part of Work: I like to do beading, and I also like to do the different types of artifacts such as Bows, Lances and Tomahawks.
Signature: Rita Gurley, Navajo

Denny Gutierrez, Page 58
(M) Santa Clara
Born: 1/12/42
Parents: Patrick and Kathy Gutierrez
Teacher: My mother
Type of Work: Contemporary red and black
14 years of experience
Awards: I've won awards at Gallup Indian Ceremonial, and Santa Fe Indian Market.
Favorite Part of Work: Shaping and polishing are my favorite parts of my work.
Signature: Denny Gutierrez, Santa Clara

Dorothy Gutierrez, Page 85
(F) Santa Clara
Born: 9/17/45
Parents: Apache and Bonnie Pinto
Teacher: Margaret Gutierrez
Type of Work: Figurines and mudheads
32 years of experience
Awards: My husband Paul and I have won many awards for our work and such shows as Eight Northern Pueblo Shows, Santa Fe Indian Market, N.M. State Fair and Gallup Indian Ceremonial.
Favorite Part of Work: I like to make my little figurines in all different shapes and then fire them.
Signature: Dorothy and Paul

Eugene Gutierrez
(M) Santa Clara
Born: 11/8/60
Parents: Celestino Gutierrez
Teacher: My parents
Type of Work: Sculptured pottery
22 years of experience
Awards: Santa Fe Indian Market, Gallup Indian Ceremonial and Eight Northern Pueblo Shows.
Favorite Part of Work: I enjoy all of my work.
Signature: E. Gutierrez, Santa Clara N.M.

Gary Gutierrez, Page 86
Santa Clara

Julie A. Gutierrez
(F) Santa Clara
Born: 5/18/65
Parents: Victoria and Celestino Gutierrez
Teacher: My mother
Type of Work: Black and red etched pottery
18 years of experience
Awards: I've never entered.
Favorite Part of Work: I like to shape the bowls and to etch.
Signature: J.A. Gutierrez

Lois Gutierrez, Page 50
Pojoaque

Margaret Gutierrez, Page 86
(F) Santa Clara
Born: 12/16/36
Parents: Lela and Van, Santa Clara
Teacher: My mother Lela
Type of Work: Polychrome traditional pottery
52 years of experience
Awards: I've won awards in at the Heard Museum Show in Pheonix, Santa Fe Indian Market Best of Division at N.M. State Fair, and Gallup Indian Ceremonial.
Favorite Part of Work: My favorite part is selling pieces for as much as I can get.
Signature: MARGARET

Paul Gutierrez
(M) Santa Clara
Born: 12/1/43
Parents: Luther and Lupita Gutierrez
Teacher: My father and grandmother
Type of Work: Figurines and mudheads
32 years of experience
Awards: My wife Dorothy and I have won many awards at all kinds of art shows such as Santa Fe Indian Market, Eight Northern Pueblo Show, N.M. State Fair and Gallup Indian Ceremonial.
Favorite Part of Work: I like sanding and polishing the most.
Signature: Dorothy and Paul

Teresa V. Gutierrez
(F) Santa Clara
Born: 6/3/33
Parents: Herman and Rosita Velarde
Teacher: My mother and mother-in-law
Type of Work: Traditonal deep carved
32 years of experience
Awards: Santa Fe Indian Market, Eight Northern Pueblo Shows, Tacoma Washington and also at a Minnesota Arts and Crafts Show.
Favorite Part of Work: I like molding and polishing but my favorite part is looking at the finished product.
Signature: Teresa Gutierrez, Santa Clara

Jimmie Harrison
(M) Navajo
Born: 2/4/52
Parents: Phil and Jessie Harrison
Teacher: Preston and Jessie Monogye
Type of Work: Contemporary inlay jewelry
15 years of experience
Awards: Best of Show, Northern Arizona Museum Show; Navajo Nation Fair, New Mexico State Fair and Santa Fe Indian Market.
Favorite Part of Work: I like to design the pattern and do the inlay.
Signature: Jim Harrison, Navajo

Derick L. Hayah
(M) Hopi
Born: 9/2/68
Parents: Carletta J. Hayah
Teacher: Uncles
Type of Work: Carving kachina dolls
16 years of experience
Awards: N.M. State Fair, Gallup Indian Ceremonial
Favorite Part of Work: Enjoys working with the wood and making the dolls
Signature: D. Hayah

Mervin Hayah
(M) Acoma-Hopi
Born: 6/8/67
Parents: Acoma-Hopi, Goldie Hayah
Teacher: My grandfather
Type of Work: Kachinas
8 years of experience
Awards: None
Favorite Part of Work: I like the basic carving of the raw wood.
Signature: Mervin Hayah, Acoma-Hopi

Goldie Hayah (Garcia), Page 15
(F) Acoma
Born: 7/18/56
Parents: Sarah Garcia, Acoma
Teacher: My mother
Type of Work: Traditional Acoma pottery
37 years of experience
Awards: I've won many awards at show such as Gallup Indian Ceremonial, and N.M. State Fair.
Favorite Part of Work: I like designing and painting in the colors.
Signature: Goldie Hayah, Acoma N.M.

John B. Hayah, Sr.
(M) Acoma
Born: 12/17/49
Parents: William and Esther Hayah
Teacher: My wife, Goldie Hayah
Type of Work: Ceramic Acoma
3 years of experience
Awards: None
Favorite Part of Work: I like painting the most.
Signature: John B. Hayah, Acoma N.M.

Juliet Haya, Page 15
Acoma
Born: 11/4/80
Parents: Goldie and John Haya
Teacher: My mother and grandmother
Type of Work: Traditional pottery
3 years experience
Awards: I haven't entered my work yet.
Favorite part of work: I like the process of making the pottery and painting.
Signature: Juliet Haya, Acoma

Marlin I. Hemlock
(M) Seneca Nation of Indians
Born: 1/12/54
Teacher: Billie, Dan and Lorrincita Tafoya
Type of Work: Santa Clara pottery, sculpture
12 years of experience
Awards: First, Second Place at State Fair; First Place in collector show, Sydney Australia
Favorite Part of Work: Combining elements of art in creating an eye appealing end result, reasearching pottery, and critiquing pottery.
Signature: Marlin and Phyllis Tafoya Hemlock

Phyllis F. Hemlock
(F) Santa Clara
Born: 7/25/59
Parents: Billie and Dan Tafoya
Teacher: Billie and Dan Tafoya
Type of Work: Santa Clara pottery
17 years of experience
Awards: First Place, State Fair
Favorite Part of Work: Creating pieces using the polish (traditional) method, in miniature and traditional forms.
Signature: Marlin and Phyllis Tafoya Hemlock

Helen T. Henderson
(F) Jemez
Born: 6/11/61
Parents: Vangie Tafoya Jemez
Teacher: Mother
Type of Work: Stone polish, scraffitto
12 years of experience
Awards: 4-First Place; 2-Second place; 1-Third Place at New Mexico State Fair, Gallup Indian Ceremonial .
Favorite Part of Work: Creating a pot and polishing it.
Signature: H. Tafoya Henderson

Cecilia Hepting
(F) Acoma
Born: 4/19/38
Parents: Lucita R. Vallo
Teacher: My mother Lucita
Type of Work: Ceramic and traditional
22 years of experience
Awards: None
Favorite Part of Work: Doing the traditional pots.
Signature: C.H. Acoma N.M.

Victoria Hepting
(F) Acoma
Born: 10/25/59
Parents: John and Cecilia Hepting
Teacher: My Mom and Grandmother
Type of Work: Ceramic Acoma pottery
24 years of experience
Awards: None
Favorite Part of Work: Designing is my favorite part of my work.
Signature: V.H. Acoma N.M.

Mary R. Herra, Page 86

Mavis B. Hererra
(F) Navajo, Married into Cochiti
Born: 6/19/41
Parents: Navajo
Teacher: My mother-in-law
Type of Work: Storytellers
10 years of experience
Awards: None yet
Favorite Part of Work: Making the flare skirts.
Signature: Mavis, Cochiti (year)

Edwin Herrera
(M) Cochiti
Born: 6/6/66
Parents: Mary Francis Herrera
Teacher: My mother
Type of Work: Pottery, fetishes, storytellers
7 years of experience
Awards: None yet
Favorite Part of Work: I like finishing each piece and watching each piece take shape.
Signature: EH Cochiti, N.M.

Irene Herrera
(F) Zia-Jemez
Born: 8/4/42
Parents: Andrea Tsosie, Jemez
Teacher: Andrea Tsosie
Type of Work: Pottery, storytellers
22 years of experience
Awards: Yes
Favorite Part of Work: Creating the pot and painting.
Signature: I. Herrera—Zia

Mary Herrera

(F) Cochiti
Born: 8/29/70
Parents: Mary Frances Herrera
Teacher: My mother
Type of Work: Storytellers
8 years of experience
Awards: None
Favorite Part of Work: I like painting my storytellers when they are finished being formed.
Signature: M. Herrera, Cochiti N.M.

Ronald E. Hinshaw, Sr.

(M) Laguna
Born: 9/7/49
Parents: Georgia Hinshaw
Teacher: Self-taught
Type of Work: Mini Hopi kachinas
12 years of experience
Awards: Never entered.
Favorite Part of Work: Carving the kachina dolls.
Signature: R Hinshaw

Eva Histia, Page 4, 16

(F) Acoma
Born: 5/4/14
Teacher: Mother
Type of Work: Handmade traditional designs
78 years of experience
Awards: N. M. State Fair
Favorite Part of Work: Creating new pieces.
Signature: E. Histia

Jaqueline (Jackie) Histia

(F) Acoma
Born: 8/12/61
Parents: Stella Shutiva, Acoma
Teacher: My mother
Type of Work: Traditional corrugated
15 years of experience
Awards: SWAIA, Eight Northern Pueblo Shows, Heard Museum Show, N.M. State Fair, Gallup Indian Ceremonial, Kansas Shows.
Favorite Part of Work: Making and experiencing new shapes.
Signature: J. Histia, Shutiva, Acoma N.M.

Marcus Homer

(M) Zuni
Born: 1/7/71
Parents: Bernard Homer, Jr.
Teacher: My grandmother
Type of Work: Traditional Zuni pottery
14 years of experience
Awards: I've won awards at the Gallup Intertribal Indian Ceremonial, The New Mexico State Fair, Heard Museum in Phoenix, and the Northern Arizona Indian Art show in Flagstaff.
Favorite Part of Work: I like to work with effigy pots, frogs, turtles, and water serpents, and I also like to do corn maid bowls.
Signature: Marcus Homer with bear paw

Robert A. Homer

(M) Zia and Hopi Pueblo
Born: 10/6/56
Parents: Marie Moquino, Zia Pueblo
Teacher: My Uncle, Corn Moquino
Type of Work: Traditional incised
14 years of experience
Awards: I won an honorable mention at the 1995 Heard Museum show in Pheonix.
Favorite Part of Work: I like the part of incising the pot to come up with the best design I can.
Signature: Robert Homer

Garret Honahnie

(M) Hopi
Born: 3/30/65
Parents: Moenkopi and Kykotsmovi
Teacher: Self-taught
Type of Work: Hopi Kachina carving
10 years of experience
Awards: None
Favorite Part of Work: All the parts of carving the doll.
Signature: Garret Honahni

Jimmie G. Honanie, Sr.

(M) Hopi
Born: 12/22/42
Parents: Clarence and Kathleen Honanie
Teacher: Loren Phillips
Type of Work: Hopi Kachina dolls
8 years of experience
Awards: Two Best of Show awards at museums.
Favorite Part of Work: Actually carving the dolls.
Signature: J.G. Honanie, Sr.

Wilson B. Hoski

(M) Navajo
Born: 8/17/42
Parents: Navajo
Teacher: Myself
Type of Work: Navajo Kachina dolls
18 years of experience
Awards: None.
Favorite Part of Work: Carving the wood.
Signature: Wilson Hoski, Navajo

Carmelita Ingersoll

(F) Jemez
Born: 10/1/43
Parents: Manuel and Marie Fragua
Teacher: My mother
Type of Work: Traditional pottery
27 years of experience
Awards: I won an award at the Winrock Arts and Crafts show.
Favorite Part of Work: Molding the pots is my favorite part.
Signature: C.I. Jemez N.M.

Pat Iule

(F) Acoma
Born: 3/10/56
Parents: Robert and Pauline Iule, Acoma
Teacher: Grandmother and mother-in-law
Type of Work: Traditional and ceramic
15 years of experience
Awards: None
Favorite Part of Work: Making the pottery, and painting it.
Signature: P. Iule, Acoma N.M.

Peter Ray James, Page 87
(M) Navajo
Born: 12/26/63
Parents: Fred and Rena James
Teacher: My parents and the Creator
Type of Work: Ceramic masks,anasazi dolls
10 years of experience
Awards: Inter-tribal Ceremonial—First, Second, Third; Indian Market—First, Second, Third; Totah Festival—Best of Show
Favorite Part of Work: Learning something spiritual through the process of art making.
Signature: Peter Ray James

Jacqueline W. Jarvison
(F) Navajo
Born: 7/21/65
Parents: Mary Jean Belon
Teacher: My grandmother
Type of Work: Navajo etched
7 years of experience
Awards: Best of Show, Navajo Nation Fair.
Favorite Part of Work: Working with different shapes and sizes.
Signature: J. Watson -Navajo

Diane (Cheyenne) Jim. Page 87
(F) Navajo
Born: 7/5/57
Parents: Navajo
Teacher: Self-taught
Type of Work: Mica-sculpture, storytellers
12 years of experience
Awards: N.M. State Fair and Gallup Indian Ceremonial
Favorite Part of Work: I like to make the male upright sculpture.
Signature: Cheyenne Jim

Loretta Joe, Page 16
(F) Acoma
Born: 9/17/58
Parents: Florence (Concho) Waconda
Teacher: Grandmother and mother
Type of Work: Handmade Acoma pottery
22 years of experience
Awards: New Mexico State Fair
Favorite Part of Work: Creating big pots, putting old designs on them.
Signature: L. Joe Acoma N.M.

Alta Johnson
(M) Navajo
Born: 5/2/60
Parents: Navajo
Teacher: My brother, Andrew
Type of Work: Navajo kachinas
6 years of experience
Awards: None
Favorite Part of Work: I like to dress the dolls the most.
Signature: A.J.

Carol Johnson
(F) Navajo
Born: 8/10/73
Parents: Evelyn Johnson, Navajo
Teacher: Dennis Charlie, Navajo
Type of Work: Navajo etched pottery
16 years of experience
Awards: None
Favorite Part of Work: I like to see what the colors do to the design.
Signature: Carol Johnson, Navajo

Cheryl B. Johnson
(F) Navajo
Born: 7/14/66
Parents: Nellie and Steven Bryant
Teacher: My mother
Type of Work: Sandpaintings
18 years of experience
Awards: I've won a few awards at Arts and Craft shows.
Favorite Part of Work: The fact that I learned from my parents in the old traditional ways and the fact that I'll be teaching my children in the same ways.
Signature: Bryan or Johnson

Dena Johnson, Page 46
(F) Navajo
Born: 7/14/72
Parents: Evelyn Johnson, Navajo
Teacher: My brother
Type of Work: Navajo etched pottery
16 years of experience
Awards: None
Favorite Part of Work: I enjoy etching the pottery and making different designs.
Signature: Dena Johnson, Navajo

Evelyn Johnson
(F) Navajo
Born: 9/1/36
Parents: Marie H. Dennison
Teacher: Dennis Charlie, Navajo
Type of Work: Navajo etched pottery
16 years of experience
Awards: None
Favorite Part of Work: I like all the parts of my work.
Signature: Evelyn Johnson, Navajo

Gary G. Johnson
(M) Navajo and Acoma
Born: 9/16/46
Parents: John Bahe and Josephine Hunt
Teacher: My father
Type of Work: Traditional Navajo jewelry
29 years of experience
Awards: I've won awards at the Gallup Indian Ceremonial and the New Mexico State Fair.
Favorite Part of Work: I like to create designs and see them come to reality in my jewelry.
Signature: GGJ .925

Harris Johnson
(M) Navajo
Born: 5/12/76
Teacher: Self-taught
Type of Work: Kachina dolls
6 years of experience
Awards: Never entered
Favorite Part of Work: Carving the figures.
Signature: Harris Johnson

Joann J. Johnson, Page 47
Navajo

Peterson Johnson
(M) Navajo
Born: 10/2/56
Parents: Wilson and Alice Johnson
Teacher: Self-taught
Type of Work: Traditional Navajo jewelry
20 years of experience
Awards: I've won many awards at various art shows all over the Southwest.
Favorite Part of Work: I like my work start to finish, but especially designing.
Signature: Peterson Johnson, Navajo

Harrison Jones
(M) Navajo
Born: 7/11/65
Parents: Eddie and Emma Jones
Teacher: Brother
Type of Work: Kachinas
14 years of experience
Awards: None yet
Favorite Part of Work: Painting and carving.
Signature: Harrison Jones

Patricia A. Jones
(F) Jemez
Born: 11/7/55
Parents: Reina L. Kohlmeyer (Waquiu)
Teacher: My mother
Type of Work: Ceramic pottery
30 years of experience
Awards: None
Favorite Part of Work: I like the stories that I associate with each piece of my pottery.
Signature: Patricia Jones, Jemez N.M.

Duane Jose
(M) Laguna
Born: 5/5/67
Parents: Laguna
Teacher: My cousin
Type of Work: Kachinas
12 years of experience
Awards: None
Favorite Part of Work: Carving a raw block of wood.
Signature: D. Jose

Ray Jose
(M) Laguna
Born: 12/22/64
Parents: Ray and Martha Jose Laguna
Teacher: Self-taught
Type of Work: Kachinas
10 years of experience
Awards: I've never entered my work, but I am working at it.
Favorite Part of Work: I like everything about it.
Signature: GAI-NAH-NE (Corn Dancer)

Andy Juanico
(M) Acoma
Born: 9/10/54
Parents: Lucy Juanico
Teacher: Self-taught
Type of Work: Kachinas, artifacts, pottery
25 years of experience
Awards: Never entered
Favorite Part of Work: Seeing a piece come into being from my mind.
Signature: A. Juanico

Marie Juanico
(F) Acoma
Born: 9/17/37
Parents: Acoma
Teacher: My mother
Type of Work: Traditional pottery
37 years of experience
Awards: I've won awards at the New Mexico State Fair, and the Gallup Indian Ceremonial.
Favorite Part of Work: Painting is my favorite part of my work.
Signature: M. Juanico, Acoma N.M.

Marietta P. Juanico
(F) Acoma
Born: 9/23/64
Parents: Isidore and Frances Concho
Teacher: My mother
Type of Work: Traditional Acoma pottery
26 years of experience
Awards: None yet
Favorite Part of Work: I like painting the pots the most—it gives me a very good feeling to look at my finished work.
Signature: M.P. Juanico, Acoma N.M.

Gloria Kahe
(F) Navajo
Born: 12/11/51
Parents: Elmer and Mary Jane Bizahaloni
Teacher: Marcella Kahe
Type of Work: Traditional Hopi pottery
12 years of experience
Awards: Best of Division, First, Second, Third Place—Santa Fe Market Museum or Northern Arizona Heard Museum.
Favorite Part of Work: Different Shapes.
Signature: G. Kahe

Wilmer Kaye
(M) Hopi
Born: 11/18/52
Parents: Hopi
Teacher: Self-taught
Type of Work: Hopi Kachina dolls
17 years of experience
Awards: First Places at Santa Fe Indian Market
Favorite Part of Work: Carving the body
Signature: Wilmer Kaye, Hopi

Samuel N. Kayquoptewa
(M) Hopi
Born: 8/11/64
Parents: Hotevilla
Teacher: My father
Type of Work: Hopi Kachina doll carving
15 years of experience
Awards: None
Favorite Part of Work: I like carving the fine details and trying different ways of doing the sashes and feathers, different poses, just working with raw wood, and the finished doll and painting.
Signature: S. Kayquoptewa

Bessie Kee
(F) Navajo
Born: 3/20/38
Parents: Navajo
Teacher: Self-taught
Type of Work: Navajo weaver dolls
52 years of experience
Awards: None
Favorite Part of Work: Making the money is my favorite part.
Signature: Bessie Kee, Navajo

Verra Kee
(F) Navajo
Born: 11/1/87
Parents: Navajo
Teacher: Self-taught
Type of Work: Kachinas
4 years of experience
Awards: None
Favorite Part of Work: Selling at the Palms.
Signature: V.K.

Alicia Kelsey
(F) Acoma
Born: 6/27/79
Parents: Darla Davis, Acoma
Teacher: My mother
Type of Work: Traditional and ceramic
5 years of experience
Awards: None
Favorite Part of Work: Painting is my favorite part of my work.
Signature: Alicia Kelsey, Acoma N.M.

Melville Kelsey
(F) Acoma
Born: 11/1/06
Parents: Darla Davis, Acoma
Teacher: My mother
Type of Work: Traditional and ceramic
16 years of experience
Awards: I've won awards at New Mexico State Fair and Gallup Indian Ceremonial.
Favorite Part of Work: I like the firing and the painting.
Signature: M.K. Acoma N.M.

William Kootswatewa
(M) Hopi
Born: 1/28/55
Parents: Wade and Pearl Kootswatewa
Teacher: My father
Type of Work: Hopi Kachina dolls
27 years of experience
Awards: None
Favorite Part of Work: I like to use my imagination from start to finish.
Signature: Wm. Koots

Wendell Kowemy
(M) Laguna
Born: 11/28/72
Parents: Kent and Wendy Kowemy
Teacher: Evelyn Cheromiah
Type of Work: Traditional pottery
6 years of experience
Awards: None
Favorite Part of Work: Making the pottery and the money are my favorite parts of my work.
Signature: W. Kowemy, Laguna N.M.

Emery Kyasyousie
(M) Hopi/Acoma
Born: 5/7/71
Parents: Lavern Kyasyousie
Teacher: Self-taught, Jocelyn Vote
Type of Work: Hopi Kachina dolls
14 years of experience
Awards: None yet
Favorite Part of Work: Painting after doing all the carving.
Signature: E. Kyasyousie

Harold Largo
(M) Navajo
Born: 6/2/60
Parents: Navajo
Teacher: My elders
Type of Work: Navajo kachinas
8 years of experience
Awards: Eastern Navajo Fair, Rug and Art Show
Favorite Part of Work: I like to design the dolls the most.
Signature: Just the name of the kachina

Sammie Largo
(M) Navajo
Born: 10/17/62
Parents: Dixie Largo, Navajo
Teacher: A vision thru traditional Herb
Type of Work: Ceramic etched
7 years of experience
Awards: First Place at a Arizona Ceramic Show.
Favorite Part of Work: I like the art and design of my work.
Signature: Sammie Largo, Navajo

Alan Lasiloo
(M) Zuni
Born: 3/31/69
Parents: Amaa and Marcus Lasiloo
Teacher: Santa Fe Institute of Indian Art
Type of Work: Traditional pottery
14 years of experience
Awards: None
Favorite Part of Work: Creating the old designs on my new pottery.
Signature: Alan Lasiloo, Zuni N.M

Alan Lasiloo
(M) Zuni
Born: 7/4/71
Parents: Angie Coochie
Teacher: Self-taught
Type of Work: Zuni Table fetishes
10 years of experience
Awards: Third Place at Flagstaff Art Show
Favorite Part of Work: I like to work with black jet the most.
Signature: Al Lasiloo

Joseph Latoma
(M) San Felipe
Born: 5/19/66
Parents: Joe Latoma
Teacher: My great-grandfather
Type of Work: Traditional artifacts
7 years of experience
Awards: Best of Show at the New Mexico State Fair, and the San Felipe Annual Art Show.
Favorite Part of Work: I like to reproduce the ancient tools of my ancestors.
Signature: With an arrow

Margaret Lee
(F) Navajo
Born: 4/16/52
Parents: Navajo
Teacher: My parents
Type of Work: Handmade silver beads
32 years of experience
Awards: I've won many awards for my work.
Favorite Part of Work: I like to sell my work, but I really love to make silver beads.
Signature: M.L.

Felipita (Phyllis) Leno
(F) Acoma
Born: 11/11/43
Parents: Tom and Juana Leno
Teacher: My mother
Type of Work: Traditional Acoma pottery
14 years of experience
Awards: None
Favorite Part of Work: Creating and designing the pottery.
Signature: P. Leno, Acoma, N.M.

Juana Leno
(F) Acoma
Born: 3/4/17
Parents: Acoma
Teacher: My grandmother, Eululia
Type of Work: Traditional Acoma pottery
62 years of experience
Awards: Santa Fe Indian Market, N.M. State Fair, Gallup
Indian Ceremonial, and at many shows in Oklahoma.
Favorite Part of Work: I like making my pots at the old village
because it's so quiet that I can concentrate on my pottery
and the designs. I love my grandkids but they drive me
crazy when I'm trying to work.
Signature: LENO, Acoma N.M.

Miranda Leno, Page 16
(F) Acoma
Born: 3/16/60
Parents: Mr. and Mrs. Lloyd Aragon
Teacher: Sister-in-law (Regina Shutiva)
Type of Work: Traditional Acoma pottery
6 years of experience
Awards: Never entered
Favorite Part of Work: Creating new pieces.
Signature: M Leno Acoma

Joyce Leno (Barreras)
(F) Acoma
Born: 10/17/52
Parents: Tom and Juana Leno
Teacher: My mother Juana Leno
Type of Work: Traditional Acoma pottery
37 years of experience
Awards: None
Favorite Part of Work: Making all kinds of different shapes
and then putting designs on them that come into my mind.
Signature: Joyce Leno, Acoma N.M.

Regina (Jeannie) Leno-Shutiva
(F) Acoma
Born: 9/7/55
Parents: Tom and Juana Leno, Acoma
Teacher: My mother, Juana
Type of Work: Traditional Acoma pottery
33 years of experience
Awards: None
Favorite Part of Work: Finding a place where there is peace
and quiet, where I can concentrate on my work.
Signature: RLS, Acoma N.M.

Adrian Leon
(M) Acoma, Hopi
Born: 7/15/60
Parents: Hopi and Acoma
Teacher: My friend
Type of Work: Miniature Kachina carving
18 years of experience
Awards: None yet
Favorite Part of Work: I like to paint the dolls.
Signature: AL

Andrew H. Lewis, Jr.
(M) Acoma
Born: 7/24/58
Parents: Theresa Walking Eagle/Andrew Lewis Sr.
Teacher: Father (Andrew H. Lewis)
Type of Work: Pottery, drawings
12 years of experience
Awards: Never entered
Favorite Part of Work: Keeping up with my father, also
working on the traditions my grandmother Lucy M. Lewis
started.
Signature: Andrew Haskaya Lewis, Jr.

Andrew H. Lewis, Sr.
(M) Acoma
Born: 12/8/27
Parents: Toribio H. and Lucy Martin Lewis
Teacher: Mother
Type of Work: Traditional Acoma
19 years of experience
Awards: Never entered
Favorite Part of Work: Shaping the pots.
Signature: Drew Lewis

Carmel Lewis (Haskaya)
(F) Acoma
Born: 9/5/47
Parents: Lucy M. Lewis, Toribio Haskaya
Teacher: My mother, Lucy
Type of Work: Traditional Acoma
47 years of experience
Awards: I've won awards for my work at Santa Fe Indian
Market, Heard Museum Shows, N.M. State Fair, and Gallup
Indian Ceremonial.
Favorite Part of Work: All aspects of my work are interesting
to me, from working with the clay to painting the designs
and firing the pieces.
Signature: Carmel Lewis, Acoma N.M.

Diane Lewis
(F) Acoma
Born: 5/26/59
Parents: Edward and Katherine Lewis
Teacher: Self-taught
Type of Work: Mimbres seedpots
14 years of experience
Awards: I've won many awards at Santa Fe Indian Market,
Gallup Indian Ceremonial, The Heard Museum Show and
The Wheelwright Museum.
Favorite Part of Work: Creating new designs and working
with different colors.
Signature: D. Lewis, Acoma N.M.

Joe Lewis
(M) Cochiti, Acoma
Born: 7/20/65
Parents: Ronald and Tomasita Lewis
Teacher: Self-taught
Type of Work: Kachina doll carving
12 years of experience
Awards: None
Favorite Part of Work: Creating art from the mind.
Signature: With a Bluejay

Judy Lewis
(F) Acoma
Parents: Katherine Lewis, Acoma
Teacher: My grandmother and sisters
Type of Work: Seed pots and storytellers
8 years of experience
Awards: I've won many First, Second and Third Place Ribbons for my work.
Favorite Part of Work: I like forming the pots and painting them.
Signature: Judy Lewis, Acoma N.M.

Katherine Lewis
(F) Acoma
Born: 9/28/32
Parents: Dolores Sanchez
Teacher: My mother
Type of Work: Traditional and ceramic
17 years of experience
Awards: None
Favorite Part of Work: I like to work with my daughters, and the painting is my favorite part.
Signature: K.L. Acoma N.M.

M. Lewis, Page 87
Acoma

Rose M. Lewis, Page 59
Santa Clara
Born: 4/9/52
Parents: Olaria Sisneros, Santa Clara
Teacher: Mother
Type of Work: Carved black pottery
20 years experience
Awards: I haven't entered my work yet.
Favorite part of work: I like to design and then carve.
Signature: Rose M. Lewis

Sharon Lewis. Page 16
(F) Acoma
Born: 8/19/59
Parents: Elizabeth Garcia
Teacher: Marilyn Ray, Rebecca Lucario
Type of Work: Traditional seedpots, jars
14 years of experience
Awards: First, second and Third Places at Santa Fe Indian Market.
Favorite Part of Work: I like to design and paint.
Signature: S. Lewis, Acoma N.M.

Tommie Lewis
(F) Cochiti
Born: 9/11/45
Parents: Cochiti
Teacher: Self-taught
Type of Work: Traditional storytellers
12 years of experience
Awards: None yet
Favorite Part of Work: I like to form the dolls.
Signature: Hummingbird

Dolores Lewis-Garcia
(F) Acoma
Born: 7/25/39
Parents: Lucy M. Lewis
Teacher: My mother
Type of Work: Traditional Acoma pottery
47 years of experience
Awards: I have won many awards from all different kinds of art shows, especially Santa Fe Indian Market.
Favorite Part of Work: I like all parts of my work, from start to finish.
Signature: Dolores Lewis, Acoma N.M.

Emma Lewis-Mitchell
(F) Acoma
Born: 10/4/31
Parents: Lucy M. Lewis
Teacher: My mother
Type of Work: Traditional Acoma pottery
47 years of experience
Awards: I've won many awards at various art shows, but probably the most from Santa Fe Indian Market.
Favorite Part of Work: I just like to make pottery, all kinds of shapes and designs.
Signature: Emma Lewis, Acoma N.M.

Albert Livingston
(M) Navajo
Born: 6/15/70
Parents: Ernest and Linda Livingston
Teacher: My mother, Linda
Type of Work: Fetish carving
12 years of experience
Awards: New Mexico Jewelers Designing Competition, First 1994
Favorite Part of Work: I like carving and detailing the most.
Signature: A.L.

Linda Livingston
(F) Navajo
Born: 10/24/48
Parents: Johnnie and Nesba Morgan
Teacher: Self-taught
Type of Work: Fetish carving
22 years of experience
Awards: None
Favorite Part of Work: I like buffing (polishing) the fetishes when I'm finished carving them.
Signature: L. Livingston

Gregory Lonewolf, Page 59
Santa Clara

Joseph Lonewolf, Page 59
(M) Santa Clara
Born: 1/26/32
Parents: Camilio and Agapita Tafoya
Teacher: Self-taught
Type of Work: Contemporary scraffito
57 years of experience
Awards: I have won all major awards at all major Indian Art shows around the world.
Favorite Part of Work: I take great pleasure in the finished product of my work.
Signature: Joseph Lonewolf, SCP

Thomas Long
(M) Navajo
Born: 5/12/41
Parents: Navajo
Teacher: Self-taught
Type of Work: Hopi style kachinas
17 years of experience
Awards: None
Favorite Part of Work: I like putting it together and painting.
Signature: T.L. Navajo

Angelina Lonjose
(F) Zuni
Born: 12/11/72
Parents: Rosie and Harold Gasper
Teacher: My grandmother and mother
Type of Work: Traditional pottery
4 years of experience
Awards: None yet
Favorite Part of Work: I like painting the most.
Signature: A. L. Zuni

Barbara M. Loretto, Page 37
(F) Jemez
Born: 6/28/52
Parents: Frank and Gevevieve Magdalena
Teacher: My mother
Type of Work: Traditional pottery
17 years of experience
Awards: none
Favorite Part of Work: Creating and shaping the bowls.
Signature: B.L. Jemez N.M.

Caroline Loretto
(F) Jemez
Born: 4/20/53
Parents: Cecilia A. Loretto
Teacher: Mother
Type of Work: Stone polished pottery
22 years of experience
Awards: Never entered
Favorite Part of Work: Polishing and design pieces.
Signature: C. G. Loretto

Deborah S. Loretto, Page 37, 88
(F) Jemez/Laguna
Born: 4/16/56
Parents: Kenneth and Caronne L. Seonia, Sr.
Teacher: Mother
Type of Work: Pottery, figurines
17 years of experience
Awards: Never entered
Favorite Part of Work: Sanding a piece to smoothness, and then painting.
Signature: DSL

Fannie Loretto, Page 88, 89
(F) Jemez
Born: 4/22/53
Parents: Louis and Carrie Loretto
Teacher: My mother
Type of Work: Masks and storytellers
22 years of experience
Awards: Heard Museum show and Eight Northern Pueblo shows.
Favorite Part of Work: I like making masks the best.
Signature: Fannie Loretto, Jemez

Felicia Loretto
(F) Jemez Pueblo
Born: 10/13/62
Parents: Jemez
Teacher: My mother
Type of Work: Traditional pottery
10 years of experience
Awards: I've won awards at Pueblo Grande, San Felipe, Santa Clara and California Art Shows.
Favorite Part of Work: I like to make the children on my friendship pots.
Signature: Felicia Loretto, Jemez N.M.

Julie Loretto
(F) Jemez
Born: 10/10/60
Parents: Jemez
Teacher: Self-taught
Type of Work: Storytellers
19 years of experience
Awards: I won an award at a Colorado Art Show.
Favorite Part of Work: Creating each piece is my favorite part of my work.
Signature: J. Loretto, Jemez N.M.

Mary H. Loretto, Page 37
(F) Jemez
Born: 6/25/55
Parents: Cecilia Loretto, Acoma
Teacher: Mother
Type of Work: Stone polished pots
17 years of experience
Awards: Never entered
Favorite Part of Work: Polishing the pots.
Signature: Mary H. Loretto

Nanette Loretto
(F) Jemez
Born: 9/17/71
Parents: Caroline Loretto, Jemez
Teacher: My mother and aunts
Type of Work: Stone polished pots
8 years of experience
Awards: None yet
Favorite Part of Work: Making and polishing.
Signature: N. Loretto, Jemez

Rachael I. Loretto
(F) Jemez
Born: 3/20/54
Parents: Napoleon and Andrea Loretto
Teacher: My mother and Clara Chosa
Type of Work: Traditional Jemez
11 years of experience
Awards: None
Favorite Part of Work: I like to paint the most.
Signature: R.L. Jemez

Gary Louis, Page 18
(M) Acoma
Born: 3/20/59
Parents: Acoma
Teacher: Self-taught
Type of Work: Horse hair pottery
32 years of experience
Awards: New Mexico State Fair
Favorite Part of Work: Incising and detailing anasazi designs.
Signature: Corrine and Gary Louis

Gerri Louis
(F) Acoma
Born: 2/12/57
Parents: Delma Vallo, Acoma
Teacher: My mother
Type of Work: Traditional and ceramic pots
17 years of experience
Awards: None
Favorite Part of Work: I love to do fine line work, especially the starburst patterns and the porcupine quill.
Signature: G. Louis, Acoma N.M.

Yvonne Louis
(F) Laguna, Navajo
Born: 6/23/54
Parents: Pauline Johnson
Teacher: Self-taught
Type of Work: Miniature kachinas
12 years of experience
Awards: I won a First Place at the New Mexico State Fair.
Favorite Part of Work: I like all the aspects of my work.
Signature: YL

Anna M. Lovato, Page 70
(F) Santo Domingo
Born: 11/8/54
Teacher: My grandmother
Type of Work: Traditional pots
22 years of experience
Awards: None
Favorite Part of Work: Creating my pieces.
Signature: Anna-Marie Lovato, AML

Pedro Lovato, Page 70
Santo Domingo

Arthur Lucario, Page 43, 44
(M) Laguna
Born: 6/23/42
Parents: Paul Lucario, Sr., Laguna N.M.
Teacher: Self-taught
Type of Work: Etched ceramic
12 years of experience
Awards: Eight blue ribbons, one Best of Show at the New Mexico State Fair
Favorite Part of Work: Being able to create the designs on the pottery at any time I want to. It's not a nine-to-five job.
Signature: A.V. (Arthur, Velma) Lucario, Laguna N.M.

Michael P. Lucario
(M) Laguna
Born: 12/17/75
Parents: Paul Lucario, Acoma
Teacher: My father
Type of Work: Traditional and ceramic pots
6 years of experience
Awards: None
Favorite Part of Work: I like the carving of my pottery and I also like learning more about traditional pottery.
Signature: M.P.L. Laguna N.M.

Ray Lucario
(M) Laguna-Acoma
Born: 12/27/71
Parents: Arthur Lucario, Laguna
Teacher: My friends
Type of Work: Kachina dolls
11 years of experience
Awards: None
Favorite Part of Work: Painting is my favorite part of my work.
Signature: R. Lucario

Rebecca Lucario, Page 17
(F) Acoma
Born: 4/18/51
Parents: Edward and Katherine Lewis
Teacher: Dolores S. Sanchez
Type of Work: Pottery
34 years of experience
Awards: Honorable mention, First, Second, and Third Places at Indian Market; Best of Show, Best of Division, Indian Market; Gallup Intertribal Ceremonial
Favorite Part of Work: Painting the pieces.
Signature: R. Lucario

Antonita (Toni) Lucero
(F) Cochiti
Born: 9/7/42
Parents: Eluterio and Berina Cordero
Teacher: Stephanie Rhoades
Type of Work: Storytellers and figurines
3 years of experience
Awards: None yet
Favorite Part of Work: Working with the traditional methods.
Signature: Antonita Lucero

Diane Lucero
(F) Jemez
Born: 10/1/66
Parents: Mary R. Lucero
Teacher: Joseph Fragua
Type of Work: Storytellers
5 years of experience
Awards: None
Favorite Part of Work: I like to see the expressions on the faces of the children when I finish.
Signature: D. Lucero, Jemez N.M.

Joyce Lucero, Page 88
(F) Jemez
Born: 9/18/68
Parents: Mary Lucero, Jemez
Teacher: My mother
Type of Work: Storytellers
14 years of experience
Awards: None
Favorite Part of Work: I like selling the most.
Signature: Joyce Lucero, Jemez, N.M.

Leonora (Lupe) L. Lucero, Page 89
(F) Jemez
Parents: Mr and Mrs Louis Loretto
Teacher: Sister—Dorothy Trujillo
Type of Work: Pottery, storytellers
20 years of experience
Awards: State Fair
Favorite Part of Work: Creating new pieces
Signature: L. Lupe Loretto Lucero

Nelda Lucero
(F) Acoma
Parents: Marie C. Torivio
Teacher: Mother
Type of Work: Traditional
42 years of experience
Awards: Never entered
Favorite Part of Work: Creating a new piece and painting it.
Signature: N. Lucero

Randy Lucio
(M) Zuni
Born: 2/5/73
Parents: Landy and Paula Lucio
Teacher: Family
Type of Work: Carving (fetishes and shalakos)
7 years of experience
Awards: Never entered
Favorite Part of Work: Starting and finishing a piece.
Signature: Randy Lucio

Geraldine Lujan
(F) Taos
Born: 1/18/55
Parents: Mr. and Mrs. Jim Lujan, Taos
Teacher: Grandmother and aunt
Type of Work: Taos Pueblo storytellers
12 years of experience
Awards: Art shows once or twice a year
Favorite Part of Work: The concentration and quietness.
Signature: GL Taos Pueblo

Charlene Lukee
(F) Acoma
Born: 5/23/70
Parents: Ramon and Shirley Lukee
Teacher: My mother
Type of Work: Traditional and negative
11 years of experience
Awards: None
Favorite Part of Work: Negative painting is my favorite part.
Signature: CLukee, Acoma N.M.

Lynette Lukee
(F) Acoma
Born: 3/1/75
Parents: Marvin and Teresa Lukee
Teacher: My mother
Type of Work: Ceramic fine line
5 years of experience
Awards: None yet
Favorite Part of Work: I like to paint the pottery.
Signature: L.L.Acoma N.M.

Terri Lukee, Page 18
(F) Acoma
Born: 9/9/37
Parents: Mr. and Mrs. Garcia Chino
Teacher: My mother, Juana Chino
Type of Work: Ceramic fine line
22 years of experience
Awards: None yet
Favorite Part of Work: I like to paint the pottery, especially the fine line.
Signature: T. Lukee, Acoma N.M.

Genevieve Madalena, Page 38
(F) Jemez
Born: 4/26/31
Parents: Jemez Pueblo
Teacher: Self-taught
Type of Work: Traditional pottery
40 years of experience
Awards: I've never entered my work.
Favorite Part of Work: I like the whole process in making it, and I like to sell it.
Signature: G.M.

Alma L. Maestas
(F) Jemez
Born: 10/9/41
Parents: Louis and Carrie Loretto
Teacher: Mother
Type of Work: Pottery and figures
37 years of experience
Awards: State Fair, Eight Northern, Indian market
Favorite Part of Work: Other people's enjoyment.
Signature: ALMA with water sign

Irma Maldonado
(F) Acoma
Born: 8/1/32
Parents: Santana Antonio, Acoma
Teacher: My mother
Type of Work: Traditional pottery
27 years of experience
Awards: Never entered.
Favorite Part of Work: The whole process that goes into making the pottery.
Signature: I.R.M.

Rita Malie, Page 18
(F) Acoma
Born: 9/25/46
Parents: John and Lupe Concho
Teacher: My mother
Type of Work: Traditional Acoma pottery
17 years of experience
Awards: None yet
Favorite Part of Work: Wedding vases and bowls of all kinds.
Signature: R. Malie or DandR Malie, Acoma

Robert L. Malott
(M) Laguna, Paguate Village
Born: 12/10/61
Parents: Suai and Alonso Romero
Teacher: Ted Francis, Sr.
Type of Work: Hopi Kachina dolls
12 years of experience
Awards: Second place at N.M. State Fair.
Favorite Part of Work: I like to imagine what the piece of wood will be and also painting the dolls. I also like to sing traditional Indian songs that relate to the spiritual concept of kachina dolls.
Signature: Robert Malott, Paguate

Nadine Mansfield, Page 18
(F) Acoma
Born: 2/21/68
Parents: Acoma
Teacher: My mother
Type of Work: Traditional Acoma pottery
13 years of experience
Awards: None
Favorite Part of Work: I like to make the lizard seedpots.
Signature: Louis Nadine Mansfield, Acoma

Betty Manygoats, Page 47
Navajo

Jon Marris, Page 44
(M) Laguna
Born: 9/11/60 (deceased)
Parents: Larose Saiz, Laguna
Teacher: Self-taught
Type of Work: Ceramic, fine line
14 years of experience
Awards: N.M. State Fair, 1994
Favorite Part of Work: Painting
Signature: J Marris, Laguna N.M.

Evan Martin
(M) Laguna
Born: 4/17/75
Parents: Laguna
Teacher: Robert Kasero, Sr.
Type of Work: Wood carving
3 years of experience
Awards: None yet
Favorite Part of Work: I like the wood burning the best.
Signature: E.J. Martin

Julia J. Martine
(F) Navajo
Born: 11/15/42
Parents: Jim and Mary Willeto, Navajo
Teacher: Husband, Ben N. Martine
Type of Work: Traditional Navajo jewelry
21 years of experience
Awards: I've won awards at the New Mexico State Fair.
Favorite Part of Work: I like to design, stamp, and to solder.
Signature: JJM - Sterling

Barbara Martinez
(F) Santa Clara
Born: 5/25/47
Parents: Ramon and Flora Naranjo
Teacher: My parents
Type of Work: Traditional Santa Clara
32 years of experience
Awards: None
Favorite Part of Work: I like to form the pots, carve them, polish, and paint them.
Signature: Barbara Martinez, Santa Clara

Gloracita Martinez
(F) Navajo
Born: 6/3/64
Parents: Betty Martinez, Navajo
Teacher: Self-taught
Type of Work: Navajo kachinas
6 years of experience
Awards: None
Favorite Part of Work: Dressing and painting the dolls are my favorite parts.
Signature: G.M. Navajo

Manuel Martinez, Page 18
(M) Acoma
Born: 12/20/63
Parents: Acoma
Teacher: Theresa Lukee
Type of Work: Ceramic Pottery
11 years of experience
Awards: None
Favorite Part of Work: I like fine line work the best.
Signature: M.M. Acoma N.M.

Maria Martinez, Page 51
San Ildefonso

Leland McConnell
(M) Crow
Born: 10/14/62
Parents: Crow
Teacher: Carmelita Gachupin
Type of Work: Jemez style ceramic
8 years of experience
Awards: None
Favorite Part of Work: Painting the different designs is my favorite part.
Signature: Leland McConnell, Jemez

Lucy L. McKelvey, Page 45
(F) Navajo
Born: 4/2/46
Parents: Minnie Barney
Teacher: Self-taught
Type of Work: Traditional Navajo pottery
24 years of experience
Awards: Many at Santa Fe Market and Heard Museum.
Favorite Part of Work: Creating and forming the different shapes.
Signature: Lucy Leuppe McKelvey, Navajo

Elizabeth Medina, Page 72
(F) Zia
Born: 11/30/56
Parents: Zia
Teacher: Sofia Medina
Type of Work: Traditional Zia Pottery
20 years of experience
Awards: Santa Fe Indian Market, Best Pottery. Eight Northern Pueblo Show, First, Second and Third Place. New Mexico State Fair, many other awards.
Favorite Part of Work: I like the painting the most.
Signature: Elizabeth Medina, Zia Pueblo

Kimberly H. Medina
(F) Zia
Born: 4/24/73
Parents: Elizabeth and Marcellus Medina
Teacher: Elizabeth Medina (mother)
Type of Work: Traditional pottery
12 years of experience
Awards: Colorado Indian Art Show—Honorable Mention
Favorite Part of Work: Painting the pottery
Signature: Kmberly Medina

Lois Medina
(F) Zia
Born: 12/9/59
Parents: Rafael and Sophia Medina
Teacher: My mother
Type of Work: Traditional Zia pottery
19 years of experience
Awards: I've won First Place awards at Santa Fe Indian Market, Gallup Indian Ceremonial, and the New Mexico State Fair.
Favorite Part of Work: I like to design my pottery before I paint it.
Signature: Lois Medina, Zia N.M.

Marcellus Medina, Page 73
(M) Zia
Born: 1/7/54
Parents: Rafael and Sophia Medina
Teacher: My father, Rafael
Type of Work: Pottery and paintings
21 years of experience
Awards: I've won Best of Show at many art shows such as N.M. State Fair, Santa Fe Indian Market and Gallup Indian Ceremonial.
Favorite Part of Work: I like to paint my pottery the best.
Signature: Marcellus Medina, Zia Pueblo

Maxine Medina
(F) Zia
Born: 11/7/67
Parents: Mr. and Mrs. Henry Shije, Zia
Teacher: Sophia Medina
Type of Work: Traditional pottery
5 years of experience
Awards: None
Favorite Part of Work: Painting.
Signature: Maxine Medina, Zia

Rachel Medina, Page 52
Tamaya-Santa Ana

Sophia Medina, Page 74
(F) Zia
Born: 2/9/32
Parents: Juanita and Andreas Pino
Teacher: Trinidad Medina
Type of Work: Traditional Zia pottery
32 years of experience
Awards: I've won too many awards to mention in this tiny space.
Favorite Part of Work: I like the part of building up my pottery from the ground up.
Signature: Sophia Medina, Zia N.M.

Keith Mike
(M) Navajo
Born: 1/8/62
Parents: Navajo
Teacher: Self-taught
Type of Work: Navajo kachinas
18 years of experience
Awards: I've never entered.
Favorite Part of Work: The whole process it takes, from start to finish.
Signature: Keith Mike

Patsy Mike
(F) Acoma
Born: 2/17/51
Parents: Acoma
Teacher: My grandmother
Type of Work: Traditional pottery
29 years of experience
Awards: None
Favorite Part of Work: I like to paint the pottery the most.
Signature: P. Mike, Acoma N.M.

Joanne Miller
(F) Navajo
Born: 7/14/58
Parents: Navajo
Teacher: My brother
Type of Work: Navajo kachinas
10 years of experience
Awards: none
Favorite Part of Work: Dressing and painting the dolls.
Signature: J. Miller, Navajo

Randy Miller
(M) 25% Cherokee
Born: 1/21/49
Teacher: Self-taught
Type of Work: Stone overlay on pottery
17 years of experience
Awards: I've won numerous ribbons for my work at several art shows across the country.
Favorite Part of Work: Seeing the finished pieces and the reaction I get from people admiring my work.
Signature: Randy

Aaron S. Mirabal
(M) Taos
Born: 9/21/66
Parents: Taos
Teacher: Self-taught
Type of Work: Pueblo drummer
3 years of experience
Awards: None yet
Favorite Part of Work: The time it takes to make my work perfect.
Signature: Aaron M. Taos

John Montoya
(M) Sandia
Born: 2/1/60
Parents: Berna Montoya
Teacher: My grandfather
Type of Work: Traditional Sandia pottery
12 years of experience
Awards: None yet
Favorite Part of Work: Seeing it when it's done. I want it to look good.
Signature: J. Montoya, Sandia Pueblo N.M.

Mary L. Montoya
(F) Jemez, Santa Ana
Born: 8/26/39
Parents: Jemez
Teacher: My mother
Type of Work: Traditional pottery
32 years of experience
Awards: None yet
Favorite Part of Work: I like to do the Santa Ana Pottery the most.
Signature: M.L. Montoya, Santa Ana, Jemez

Ada Morgan, Page 47
(F) Navajo
Born: 3/1/73
Parents: Navajo
Teacher: My sisters
Type of Work: Navajo Ceramic Etched
9 years of experience
Awards: None
Favorite Part of Work: Painting is my favorite part.
Signature: Ada Morgan, Navajo

Ella Morgan, Page 47
(F) Navajo
Born: 10/18/70
Parents: Mae Tom, Navajo
Teacher: Dena Johnson
Type of Work: Ceramic etched pottery
9 years of experience
Awards: None
Favorite Part of Work: I like to create unique designs and colors.
Signature: Ella Morgan, Navajo

Etta Morgan, Page 48
(F) Navajo
Born: 1/6/72
Parents: Mae Morgan, Navajo
Teacher: Ella Morgan
Type of Work: Navajo etched
9 years of experience
Awards: None
Favorite Part of Work: I like the painting and carving the most.
Signature: EM Dine

Burl Naha, Page 26
Hopi

Sylvia N. Naha
(F) Hopi/Tewa
Born: 2/20/51 (deceased)
Parents: Helen and Archie Naha
Teacher: Mother
Type of Work: White over grey, black on white
27 years of experience
Awards: Some from shows in Gallup, Albuquerque, Scottsdale, etc.
Favorite Part of Work: Painting the pieces.
Signature: A feather with an"S" on the side

Les Namingha
(M) Zuni
Born: 4/26/67
Parents: Irene Vicenti; Emerson Namingha
Teacher: Dextra Quotskuyva (aunt)
Type of Work: Pottery
8 years of experience
Awards: First, Hopi Pottery (bowls); Second, Hopi Pottery (jars) at 1994 Indian Market
Favorite Part of Work: Enjoys designing and painting pottery. Painting inside of bowls is one of my favorite things to do.
Signature: Les Namingha

Lillian Namingha
(F) Hopi
Born: 11/21/41
Parents: Hopi
Teacher: My parents
Type of Work: Traditional arts and crafts
4 years of experience
Awards: None
Favorite Part of Work: I like doing rattles the most.
Signature: Namingha, Hopi

Carla (Claw) Nampeyo
(F) Hopi/ Tewa
Born: 8/27/61
Parents: Thomas and Gertrude Polacca
Teacher: My father
Type of Work: Traditional Hopi pottery
12 years of experience
Awards: I've won First, Second and Third Place ribbons at several art shows, such as Sedona Hopi Show and Gallup Indian Ceremonial.
Favorite Part of Work: I like carving and designing the pieces.
Signature: CARLA CLAW NAMPEYO

Iris Y. Nampeyo, Page 28
(F) Hopi
Parents: Vinton and Fannie Polacca Nampeyo
Teacher: Self-taught
Type of Work: Pottery
32 years of experience
Awards: First, Gallup Indian ceremonial; Second, Santa Fe Indian Market; First, Flagstaff Hopi Show
Favorite Part of Work: Enjoys molding a piece and decorating it.
Signature: Iris Y. Nampeyo

James G. Nampeyo
(M) Tewa/Laguna
Born: 2/11/58
Parents: Leah Polacca (Hopi-Tewa)
Teacher: My mother and grandmother
Type of Work: Traditional Hopi pottery
18 years of experience
Awards: I've won awards at the Santa Fe Indian Market, Gallup Indian Ceremonial and the New Mexico State Fair.
Favorite Part of Work: I like the painting part of my work the most.
Signature: James G. Nampeyo

Nolan Y. Nampeyo
(M) Hopi
Born: 10/1/70
Parents: Iris and Wallace Youvella
Teacher: Parents
Type of Work: Contemporary pottery
8 years of experience
Awards: Never entered
Favorite Part of Work: Carving and molding pieces.
Signature: Nolan Youvella Nampeyo

Reva Nampeyo (Ami)
(F) Hopi-Tewa
Born: 1/14/64
Parents: Harold and Alice Polacca
Teacher: Self-taught
Type of Work: Traditional Hopi pottery
6 years of experience
Awards: None yet
Favorite Part of Work: Painting gives me most pleasure.
Signature: Reva Ami (Nampeyo)

Anna Naranjo
(F) Santa Clara
Born: 1/11/62
Parents: Gregorita Baca
Teacher: Christine Nieto and my mother
Type of Work: Black mellon bowls
3 years of experience
Awards: Never entered
Favorite Part of Work: Creating a new piece and polishing it.
Signature: A. Naranjo S.C.P.

Bernice A. Naranjo, Page 60
(F) Santa Clara, Taos
Parents: Taos
Teacher: Self-taught
Type of Work: Handmade pottery
16 years of experience
Awards: Many awards from all different kinds of shows.
Favorite Part of Work: Forming the pots.
Signature: (striped rock)

Dominic Naranjo
(M) Santa Clara
Born: 8/14/76
Parents: Jennifer and David Naranjo
Teacher: Jennifer Naranjo, my mom
Type of Work: Traditional black carved
7 years of experience
Awards: None yet
Favorite Part of Work: Forming and learning to polish.
Signature: Dominic Naranjo

Dusty Naranjo, Page 60
(M) Santa Clara
Born: 7/9/68
Parents: Tito and Bernice Naranjo
Teacher: Mother
Type of Work: Santa Clara pottery
7 years of experience
Awards: Never entered
Favorite Part of Work: Creating intricate designs in my scraffito style.
Signature: Dusty

Elizabeth Naranjo, Page 60
Santa Clara

Forrest Naranjo, Page 60, 61
(M) Santa Clara
Born: 11/11/63
Parents: Bernice Naranjo
Teacher: My mother and myself
Type of Work: Traditional Scraffito
9 years of experience
Awards: I've won awards at N.M. State Fair, The Heard Museum in Pheonix and the Gallup Indian Ceremonial.
Favorite Part of Work: Seeing what kinds of designs will fit well on the pottery, depending on the shape of the pot.
Signature: Forrest N. Santa Clara N.M.

Geri (Geraldine) Naranjo, Page 61
(F) Santa Clara
Born: 8/6/52
Parents: Alfred and Ursulitos Naranjo
Teacher: My mother
Type of Work: Traditional Polish/Scraffitto
26 years of experience
Awards: Santa Fe Indian Market, Best of Division; Gallup Indian Ceremonial, Best of Category; First Place at Eight Northern Pueblo Shows many times.
Favorite Part of Work: Designing and polishing.
Signature: Geri Naranjo, Santa Clara N.M.

Glenda Naranjo, Page 61
(F) Santa Clara
Born: 7/8/53
Parents: Ramon and Flora Naranjo
Teacher: Parents
Type of Work: Santa Clara, black and red
22 years of experience
Awards: State Fair, Indian Market, Eight Northern Pueblo
Favorite Part of Work: Seeing the finished piece, getting every piece out of the fire without breaking or cracking.
Signature: Glenda Naranjo

Gracie Naranjo
(F) Santa Clara, Navajo
Born: 6/13/38
Parents: Billy Briggs, Navajo
Teacher: Christina Naranjo
Type of Work: Traditional Santa Clara
16 years of experience
Awards: I've won awards at the Santa Fe Indian Market, and the Gallup Indian Ceremonial.
Favorite Part of Work: I like to make each pot in the form the clay gives my talent.
Signature: Gracie Naranjo, Santa Clara

Jennifer J. Naranjo, Page 61
(F) Santa Clara Pueblo
Born: 11/9/55
Parents: Pasqualita Montoya
Teacher: Reycita Naranjo
Type of Work: Traditional pottery
17 years of experience
Awards: I've won awards at the Eight Northern Pueblo Show and the Santa Fe Indian Market.
Favorite Part of Work: I like the part of polishing, and I think it shows in my work.
Signature: Jennifer Naranjo, Santa Clara

Karen Naranjo
(F) Santa Clara (Navajo)
Born: 5/28/67
Parents: Bernice Suazo Naranjo
Teacher: Forrest Naranjo
Type of Work: Polished and etched pottery
10 years of experience
Awards: I've won many awards at such shows as N.M. State Fair, Gallup Indian Ceremonial, and Santa Fe Indian Market.
Favorite Part of Work: Seeing the finished pieces and selling them.
Signature: Karen Naranjo

Kevin Naranjo, Page 62
(M) Santa Clara
Born: 6/28/72
Parents: Geri Naranjo and James Archuleta
Teacher: Grandma and Mom
Type of Work: Santa Clara Pueblo
12 years of experience
Awards: Indian Market—First, Second, Third Place
Favorite Part of Work: my favorite part in making my work is drawing.
Signature: Kevin Naranjo Santa Clara

Madeline E. Naranjo, Page 62
Santa Clara
Born: 11/17/71
Parents: Joseph and Madeline G. Naranjo
Teacher: Grandma, Madeline G. Naranjo
Type of Work: Black deep carved pots
10 years experience
Awards: I've won awards at the Santa Fe Indian Market, 3rd Place and Honorable Mention.
Favorite part of Work: Working from my home and being there for my children.
Signature: Madeline & Adrian Garcia SCP

Melissa Naranjo
(F) Santa Clara
Born: 4/19/75
Parents: Jennifer Naranjo
Teacher: Jennifer Naranjo
Type of Work: Traditional carved pottery
5 years of experience
Awards: None yet
Favorite Part of Work: I like forming and carving.
Signature: Melissa Naranjo, Santa Clara

Nicolasa Naranjo
(F) Santa Clara
Born: 7/17/07
Parents: Tomasita and Agapito Naranjo
Teacher: Christina Naranjo
Type of Work: Traditional Black on Black
52 years of experience
Awards: I've won many First and Second place ribbons at Santa Fe Indian Market.
Favorite Part of Work: Forming each piece is my favorite part of my work.
Signature: Nicolasa, Santa Clara N.M.

Paul Naranjo
(M) Santa Clara
Born: 8/17/56
Parents: Mr. and Mrs. Raymond Naranjo
Teacher: My relatives
Type of Work: Traditional Scraffito
17 years of experience
Awards: Best of Show, New Mexico State Fair; First at SWAIA; Best of Show, Casa Grande Arizona; and Awards at Gallup Indian Ceremonial.
Favorite Part of Work: I like to draw animals and dancers the best.
Signature: Paul Naranjo, Santa Clara N.M.

Reycita Naranjo
(F) Santa Clara
Born: 12/28/26
Parents: Jose and Pablita Chavarria
Teacher: Pablita Chavarria
Type of Work: Carved, polished, tradidional
63 years of experience
Awards: I've won many awards at The Santa Fe Indian Market and The Eight Northern Pueblo Shows.
Favorite Part of Work: I like everything I do on my pottery.
Signature: Reycita Naranjo, Santa Clara

Roberta Naranjo, Page 62
Santa Clara
Born: 9/20/46
Parents: Jose and Nicolasa Naranjo
Teacher: My mother
Type of Work: Black on black pottery
25 years experience
Favorite part of Work: I like to polish the best.
Signature: Roberta, Santa Clara

Sammy Naranjo, Page 62
(F) Santa Clara
Born: 2/22/72
Parents: Flora Naranjo
Teacher: Mother
Type of Work: Deep carve, etched
10 years of experience
Awards: Never entered
Favorite Part of Work: Coming up with original designs
Signature: Sammy and Adrianna Naranjo

Santiago (Sandy) Naranjo
(M) Santa Clara
Born: 7/7/41
Parents: Santa Clara
Teacher: Self-taught
Type of Work: Traditional black
8 years of experience
Awards: None
Favorite Part of Work: Forming and firing are my favorite parts.
Signature: Sandy Naranjo, Santa Clara N.M

Sharon Naranjo (Garcia), Page 63
(F) Santa Clara
Born: 2/10/51
Parents: Raised by Christina Naranjo
Teacher: Christina Naranjo
Type of Work: Traditional carved and matte
22 years of experience
Awards: First Place at New Mexico State Fair, Third Place at Santa Fe Indian Market, and a few awards at Eight Northern Pueblo Shows.
Favorite Part of Work: Forming the vessels is my favorite part of my work.
Signature: Sharon Naranjo Garcia

Stephanie Naranjo
(F) Santa Clara
Born: 8/4/60
Parents: Margaret and Luther Gutierrez
Teacher: My mother and grandparents
Type of Work: Traditional polychrome
22 years of experience
Awards: I've won awards at many art shows, including Santa Fe Indian Market, N.M. State Fair, Heard Museum Show and Eight Northern Pueblo Shows.
Favorite Part of Work: Painting and giving the figurines expressions are my favorite things to do.
Signature: Stephanie Naranjo, Santa Clara

Teresita Naranjo, Page 53, 64
Santa Clara

Tracy Naranjo
(F) Santa Clara, Navajo
Born: 11/19/66
Parents: Navajo, Santa Clara
Teacher: My mom, Gracie Naranjo
Type of Work: Traditional Santa Clara
2 years of experience
Awards: None yet
Favorite Part of Work: I like to construct the pottery and I also like to fire it.
Signature: 12

Charmae Natseway
(F) Acoma
Born: 8/1/58
Parents: Ethel Shields
Teacher: Ethel Shields, Delores Sanchez
Type of Work: Traditional pottery, contemporary shapes
21 years of experience
Awards: I've won various awards at Santa Fe Indian Market, Heard Museum, New Mexico State Fair, Old Town Award, and at Gallup Ceremonials.
Favorite Part of Work: I like painting the best.
Signature: Charmae Shields Natesway

Thomas G. Natseway
(M) Acoma
Born: 4/19/53
Parents: Pete and Beth Natseway
Teacher: My wife and mother-in-law
Type of Work: Miniature pottery
18 years of experience
Awards: I've won awards every year at Santa Fe Indian Market, Gallup Indian Ceremonial and N.M. State Fair.
Favorite Part of Work: I like to think up new shapes and designs.
Signature: "B" for bear clan

Dawn Navasie
(F) Hopi
Born: 7/1/61
Parents: Eunice Navasie, Hopi
Teacher: My mother
Type of Work: Traditional Hopi pottery
17 years of experience
Awards: Museum of Northern Arizona, First Place and Best of Division.
Favorite Part of Work: Painting the designs on my work is my favorite part.
Signature: Dawn Navasie

Donna Navasie (Robertson)
(F) Hopi/ Tewa
Born: 7/24/72
Parents: Marianne Navasie, Hopi
Teacher: My mother and grandmother
Type of Work: Traditional Hopi pottery
16 years of experience
Awards: None yet
Favorite Part of Work: I like the painting because it is the most beautiful part of my work, but I enjoy the polishing also.
Signature: With a frog, a tadpole and initial

Grace Navasie (Lomahquahua), Page 29
(F) Hopi
Born: 9/16/53
Parents: Joy and Perry Navasie
Teacher: My mother, Frog Woman
Type of Work: Traditional Hopi pottery
27 years of experience
Awards: I've won awards at the Gallup Indian Ceremonial and the Sedona, Arizona Art Show.
Favorite Part of Work: I like the part of molding the pottery in interesting shapes.
Signature: With a frog

Joy Navasie, Page 29
(F) Tewa/Hopi
Born: 1/3/16
Parents: Mary and Albert Naha
Teacher: Mother
Type of Work: Pottery
63 years of experience
Awards: Various awards—Santa Fe, Arizona, Gallup, Eight Northern Pueblo
Favorite Part of Work: I love molding a piece, painting it, firing it, and selling it
Signature: [frog] before 1940[flower]

Marianne Navasie
(F) Hopi
Born: 11/8/57
Parents: Perry and Joy Navasie
Teacher: My mother, Joy
Type of Work: White polychrome pottery
22 years of experience
Awards: I've won awards at Santa Fe Indian Market and the Gallup Indian Ceremonial.
Favorite Part of Work: I like to do all the moulding and painting.
Signature: Frog, tadpole and Name

Wally Navasie
(M) Hopi
Born: 1/5/67
Parents: Doug and JoAnn Navasie
Teacher: My father
Type of Work: Hopi kachina dolls
12 years of experience
Awards: None yet
Favorite Part of Work: Making sure the pieces turn out nice.
Signature: Wally Navasie

Paulina Nez
(F) Navajo
Born: 2/1/42
Parents: Navajo
Teacher: My sister and family
Type of Work: Ceramic pottery
7 years of experience
Awards: None
Favorite Part of Work: I like to paint the designs the best.
Signature: P. Nez, Navajo

Phyllis Nez, Page 90
(F) Navajo
Born: 11/2/58
Parents: Cochiti Pueblo N.M.
Teacher: Felicita Erstace, Cochiti
Type of Work: Traditional storytellers
12 years of experience
Awards: Never entered
Favorite Part of Work: I enjoy working with the clay, I really enjoy it.
Signature: P. Nez Cochiti N.M.

Robert Nichols
(M) Santa Clara
Born: 4/10/61
Parents: Santa Clara
Teacher: My grandmother, Severa Tafoya
Type of Work: Traditional carved
12 years of experience
Awards: I have not won any awards yet.
Favorite Part of Work: I like the deep-carving style.
Signature: Robert Nichols, Tall Mountain

Christine Nieto, Page 64
(F) Santa Clara
Parents: Benerita Naranjo (Bluecloud)
Teacher: Self-taught
Type of Work: Bowls—brown etched flowers
9 years of experience
Awards: Never entered
Favorite Part of Work: Watching a piece go from start to finish.
Signature: Christine Nieto S.C.P

Wilfred Noble
(M) Navajo
Born: 7/17/65
Parents: Berlyn and Elizabeth Noble
Teacher: Self-taught
Type of Work: Traditional
12 years of experience
Awards: Never entered
Favorite Part of Work: Creating new designs.
Signature: WOLF

Julia Norton
(F) Navajo
Born: 8/20/40
Parents: Jimmy and Bessie Spencer
Teacher: Stan Beartoe and myself
Type of Work: Handmade fetishes
20 years of experience
Awards: None
Favorite Part of Work: I like to make sitting bears, horned toads, lizards, and owls.
Signature: J.N.

Earl Numkena
(M) Hopi
Born: 5/8/54
Parents: Second Mesa
Teacher: Self-taught
Type of Work: Sculptured Hopi kachinas
27 years of experience
Awards: None
Favorite Part of Work: Coming up with different designs.
Signature: Earl Numkena, Hopi

Ken Nunez
(M) Laguna
Born: 7/8/66
Parents: Mr. and Mrs. Armando Nunez
Teacher: Sterling Francis
Type of Work: Sculpture kachinas
3 years of experience
Awards: None
Favorite Part of Work: Seeing my work improve.
Signature: Ken Nunez

Gilbert Olivas
(M) San Juan, Santa Clara, Spanish
Born: 11/7/58
Parents: Spanish
Teacher: Self-taught
Type of Work: Traditional Santa Clara style
10 years of experience
Awards: We've won awards at the Los Alamos National Labs Art show and had our work featured in Guest Life 1996.
Favorite Part of Work: I like the parts of coil building and then polishing.
Signature: Olivas Pottery, Gil and Gina

Gina R. Olivas
(F) Taos, Santo Domingo, Hispanic
Born: 3/13/60
Parents: Taos, Santo Domingo, Hispanic
Teacher: Barbara Gonzales
Type of Work: Traditional red and black polish
10 years of experience
Awards: Smithsonian Museum, National Geographic Society, and New Mexico State Fair.
Favorite Part of Work: Polishing is my favorite part, but I also like to carve the pieces.
Signature: Gil and Gina Olivas Pottery

Donna Ortiz, Page 38
(F) Jemez
Born: 9/2/53
Parents: Juan R. Tafoya, Jemez
Teacher: My mother
Type of Work: Traditional pottery
37 years of experience
Awards: None
Favorite Part of Work: Making the pots and selling them at the Palms.
Signature: D.O. Jemez N.M.

Anthony Otero
(M) Navajo
Born: 5/14/67
Parents: Rose Otero
Teacher: Self-taught
Type of Work: Artifacts, kachinas
10 years of experience
Awards: I've won some awards at various art shows.
Favorite Part of Work: I like painting the most, but overall I like all aspects of my work.
Signature: A. Otero

Gerry Oueletto
(M) Montagnais, N.E. Canada
Born: 3/30/39
Parents: Montagnais
Teacher: Hollis Littlecreek
Type of Work: Flutes
5 years of experience
Awards: None
Favorite Part of Work: Making flutes that not only look good, but sound good also.
Signature: o O o

Paulita Pacheco, Page 70
(F) Santo Domingo
Born: 12/10/43
Teacher: Self-taught
Type of Work: Traditional Pottery
29 years of experience
Awards: Eight-Northern Pueblo Show, Santa Fe Indian Market. I also have some pieces on display at the Smithsonian Institution in Washington D.C.
Favorite Part of Work: Shaping the pots and then painting them.
Signature: Paulita Pacheco, Santo Domingo

Roger A. Pacheco
(M) Santo Domingo, Hopi
Born: 2/4/70
Parents: Randall Sahme Nampeyo
Teacher: Self-taught
Type of Work: Fetishes and jewelry
3 years of experience
Awards: None yet
Favorite Part of Work: I like the sculpting part of my work the most.
Signature: RP

Reyes Panana, Page 89
(F) Jemez
Born: 2/26/61
Parents: Stella Panana, Jemez
Teacher: Self-taught
Type of Work: Koshare figurines
13 years of experience
Awards: I've won awards at the Gallup Indian Ceremonial, New Mexico State Fair, and The Eight Northern Pueblo Shows.
Favorite Part of Work: I like to mix the clay and to paint the figurines.
Signature: R. Panana, Jemez N.M.

Raymond Parkett
(M) Navajo
Born: 9/12/48
Parents: Grant and Mary S. Parkett
Teacher: Self-taught
Type of Work: Navajo kachinas
26 years of experience
Awards: None
Favorite Part of Work: Selling, I like the money.
Signature: Raymond Parkett, Navajo

Tony Parkett

(M) Navajo
Born: 10/6/49
Parents: Grant and Mary Parkett
Teacher: My parents
Type of Work: Navajo Kachina dolls
22 years of experience
Awards: I've won many First, Second and Third Place ribbons.
Favorite Part of Work: I like carving and painting my dolls.
Signature: Tony Parkett, Navajo

Alton Pashano

(M) Hopi-Tewa
Born: 3/31/60
Parents: Thomas Pashano
Teacher: Self-taught
Type of Work: Hopi Kachina doll carving
12 years of experience
Awards: None
Favorite Part of Work: I like selling the most.
Signature: Alton Pashano

Darrin Pasquale, Page 19

(M) Acoma
Born: 2/14/65
Parents: Harold and Becky Pasquale
Teacher: Paul Lucario, Jr.
Type of Work: Etched ceramic pottery
8 years of experience
Awards: I've won two First Place ribbons at the New Mexico State Fair.
Favorite Part of Work: I like carving out the designs.
Signature: D. M. Pasquale, Laguna Acoma

Michelle Pasquale, Page 19

(F) Laguna
Born: 5/16/69
Parents: Paul and Karen Lucario
Teacher: My father
Type of Work: Etched ceramic pottery
8 years of experience
Awards: Two First Place ribbons at the New Mexico State Fair.
Favorite Part of Work: Etching out the design work.
Signature: D.M. Pasquale, Laguna Acoma

Adrian Ann Patricio

(F) Acoma
Born: 7/28/61
Parents: Rafalita Antonio, Acoma
Teacher: Sister
Type of Work: Painting and etching pottery
12 years of experience
Awards: I've never entered.
Favorite Part of Work: To see how the design is going to come out when it is finished.
Signature: Adrian Ann Patricio, Acoma

Darrell Patricio

(M) Acoma
Born: 1/7/64
Parents: Mike and Delma Vallo
Teacher: My mother
Type of Work: Fine line pottery
16 years of experience
Awards: I've won First and Third Place ribbons at the New Mexico State Fair.
Favorite Part of Work: Painting the finest lines I can is my favorite part of my work.
Signature: Darrell Patricio, Acoma N.M.

Leo Patricio

(M) Acoma
Born: 8/27/57
Parents: Elsie Routzen, Acoma
Teacher: My mother
Type of Work: Traditional and ceramic
24 years of experience
Awards: None
Favorite Part of Work: I like selling the most, seeing how much I can get for my work.
Signature: Patricio, Acoma N.M.

Lillie Patricio

(F) Acoma
Born: 4/8/70
Parents: Mike Patricio, Sr.
Teacher: My sister
Type of Work: Fine line design
7 years of experience
Awards: I've never entered any of my work.
Favorite Part of Work: I like to paint with a touch of orange because it shows its beauty.
Signature: Lillie Patricio

Michael Patricio, Jr.

(M) Acoma
Born: 1/17/68
Parents:
Teacher: Mother
Type of Work: Traditional bowls and vases
16 years of experience
Awards: Never entered
Favorite Part of Work: The finished pot (lightning designs).
Signature: Michael Patricio, Jr.

Norbert L. Patricio

(M) Acoma
Born: 9/23/70
Parents: Isidore and Frances Concho
Teacher: My parents
Type of Work: Traditional and ceramic pottery
20 years of experience
Awards: None yet
Favorite Part of Work: I like forming and painting the pottery.
Signature: N. Patricio, Acoma N.M.

Sandrea Patricio

(F) Acoma
Born: 10/8/67
Parents: Acoma
Teacher: My father
Type of Work: Traditional Acoma fine line
12 years of experience
Awards: None
Favorite Part of Work: I like working on my fine line and taking pride in my work.
Signature: S.B. Patricio, Acoma N.M.

Stephanie M. Patricio Nez

(F) Acoma
Born: 9/3/70
Parents: Doris and Parick Patricio
Teacher: Mom and Grandma
Type of Work: Traditional pottery
17 years of experience
Awards: Never entered.
Favorite Part of Work: Everything, from start to finish.
Signature: S. Patricio Nez

Reginald K. Patrick
(M) Navajo/Ojibwa
Born: 1/15/66
Parents: Virginia Benton
Teacher: James Clah
Type of Work: Navajo Kachina dolls
12 years of experience
Awards: None
Favorite Part of Work: Carving in solitude is my favorite part.
Signature: R. Patrick

Irwin Pecos
(M) Jemez
Born: 12/16/53
Parents: Jose and Carol Pecos
Teacher: Self-taught
Type of Work: Figurative pottery
18 years of experience
Awards: I won a Third Place ribbon at the SWAIA show in 1990.
Favorite Part of Work: I like to create the pottery, and I really like to sell!
Signature: I. Pecos, Jemez N.M.

Rose Pecos - Sun Rhodes
(F) Jemez , Pecos
Born: 5/23/56
Parents: Carol Pecos
Teacher: My mother
Type of Work: Navajo Storytellers
27 years of experience
Awards: Santa Fe Indian Market, Dallas Indian Market, Inter-tribal Arts Experience, Dayton, Ohio
Favorite Part of Work: My work is a spiritual part of me bringing myself and the earth together as one.
Signature: Rose Pecos, Jemez N.M.

Sherrel Pedro
(F) Laguna
Born: 4/1/52
Parents: Ruth Kajond, Laguna
Teacher: Self-taught
Type of Work: Ceramic pottery
7 years of experience
Awards: None
Favorite Part of Work: Painting good clean lines.
Signature: S. Pedro, Laguna

Josephine Pedro
(F) Acoma
Born: 7/25/30
Parents: Acoma
Teacher: Looking at other potters
Type of Work: Traditional and ceramic
57 years of experience
Awards: None
Favorite Part of Work: The designs that I do have been passed on from the past, and I try to stay with it.
Signature: Josephine Pedro, Acoma N.M.

Travis Penketewa
(M) Zuni
Born: 4/7/72
Parents: Zuni
Teacher: Family members
Type of Work: Traditional Zuni pottery
7 years of experience
Awards: None yet
Favorite Part of Work: I like to paint the most.
Signature: Travis Penketewa

Freddie Peterson
(M) Navajo
Born: 12/4/62
Parents: Leo and Ruth Peterson
Teacher: My Brother, Franklin Peterson
Type of Work: Fetish carving
4 years of experience
Awards: None
Favorite Part of Work: Carving and then selling at Palms.
Signature: F.P. Navajo

Agnes Peynetsa, Page 75
(F) Zuni
Born: 11/11/62
Parents: Charles Peynetsa, Zuni
Teacher: My sister, Pricilla
Type of Work: Traditional Zuni
12 years of experience
Awards: I've won awards at the Santa Fe Indian Market and the Flagstaff Indian Art Show.
Favorite Part of Work: I like to make the pottery and paint it.
Signature: Agnes Peynetsa, Zuni N.M. (year)

Anderson Peynetsa, Page 76
Zuni

Pricilla Peynetsa, Page 76
(F) Zuni
Born: 5/27/61
Parents: Charles and Wilma Peynetsa
Teacher: Lenny Lacte, Zuni
Type of Work: Traditional Zuni pottery
19 years of experience
Awards: I've won awards at the Flagstaff Art Show and the Heard Museum Show in Pheonix.
Favorite Part of Work: Since I lost my arm, it's difficult to have a favorite part, because all of it is hard for me to do and it takes a lot longer, but I guess my favorite part is painting and putting the finishing touches on the pottery.
Signature: P. Peynetsa, Zuni N.M. (year)

Santana Phillips, Page 19
(F) Acoma
Born: 1/11/50
Parents: Acoma Pueblo N.M.
Teacher: My mother
Type of Work: Traditional Acoma pottery
48 years of experience
Awards: I really haven't entered any art shows, but if I had, I know I would have won some ribbons.
Favorite Part of Work: I like to paint fine line designs the most on my pots.
Signature: Santana Phillips, Acoma N.M.

Bernadette Pino
(F) Zia
Born: 1/27/60
Parents: Rudy Waquiu, Jemez
Teacher: My mother-in-law (Zia)
Type of Work: Traditional Zia pottery
17 years of experience
Awards: None
Favorite Part of Work: Polishing and firing.
Signature: B.W. Pino, Zia

Erlinda Pino, Page 74
Zia

Minnie Platero
(F) Navajo
Born: 12/28/41
Parents: Frances Willeto, (Mother)
Teacher: David Zachary, (Trader)
Type of Work: Traditional Navajo jewelry
29 years of experience
Awards: None yet
Favorite Part of Work: I like to design the pieces of jewelry.
Signature: P-Sterling

Patricia Platero
(F) Navajo
Born: 11/23/65
Parents: Fannie Platero
Teacher: My mother
Type of Work: Traditional Navajo jewelry
10 years of experience
Awards: None
Favorite Part of Work: I like to put the designs on the jewelry.
Signature: P. or PP.

Robert Platero
(M) Navajo
Born: 8/31/74
Parents: Jennie Platero (mother)
Teacher: Myself
Type of Work: Kachinas
10 years of experience
Awards: I've never entered.
Favorite Part of Work: I like to sand the most.
Signature: Robert Platero and name of doll

Clinton Polacca (Nampeyo), Page 29
(M) Apache/Tewa
Born: 5/24/58
Parents: Harold and Alice Polacca
Teacher: Grandmother
Type of Work: Pottery
14 years of experience
Awards: Never entered
Favorite Part of Work: Painting, molding, firing, sanding, and polishing a piece.
Signature: Clinton Polacca Nampeyo

George E. Polley
(M) Hopi
Born: 3/2/51
Parents: Emil and Clara Pooley, Hopi
Teacher: My father
Type of Work: Kachinas
35 years of experience
Awards: I've won awards at Santa Fe Indian Market, the Heard Museum, and Eight Northern.
Favorite Part of Work: Believe it or not, I like to gather the wood the best.
Signature: G. or Geo. Pooley—Hopi

Monica Poma, Page 19

Aggie (Christine) Poncho
(F) Acoma
Born: 8/6/73
Parents: Christine and Ted Martinez
Teacher: Marilyn Henderson
Type of Work: Storytellers
8 years of experience
Awards: None yet
Favorite Part of Work: Creating the storytellers, watching them take shape.
Signature: "Aggie" Acoma, N.M.

Rose Poncho
(F) Acoma
Born: 11/21/21
Parents: Santana Pino, Acoma
Teacher: My mother
Type of Work: Ceramic and Traditional Pottery
62 years of experience
Awards: None
Favorite Part of Work: Forming the pots and painting them are my favorite parts of my work.
Signature: R. Poncho, Acoma N.M.

Louise W. Ponchuella
(F) Zuni
Born: 1/5/73
Parents: Zuni
Teacher: Self-taught
Type of Work: Zuni table fetishes
5 years of experience
Awards: I won three awards at various art shows.
Favorite Part of Work: I like the fun parts, like selling.
Signature: Louise Wallace, Zuni

Ted Poola
(M) Hopi-Tewa
Born: 8/14/58
Parents: Polacca
Teacher: Self-taught
Type of Work: Hopi Kachina doll carving
6 years of experience
Awards: None
Favorite Part of Work: The favorite part of my work is when I am finished with a piece.
Signature: Ted Poola, First Mesa Village

Abby Quam
(F) Zuni
Born: 5/18/64
Parents: Zuni
Teacher: My family members
Type of Work: Traditional fetishes
12 years of experience
Awards: Best of Show, Honorable Mention, and many First, Second, and Third Place ribbons
Favorite Part of Work: Creating new designs all the time.
Signature: A.Q., Zuni

Sylvia Quam
(F) Zuni
Born: 11/6/57
Parents: Zuni
Teacher: My family
Type of Work: Traditional Zuni fetishes
10 years of experience
Awards: None
Favorite Part of Work: Buffing and creating are my favorite parts of my work.
Signature: S. Quam, Zuni

Bryce Quamahonynewa
(M) Hopi
Born: 11/14/66
Parents: Radford Quamahonynewa
Teacher: Self-taught
Type of Work: Kachina doll carving
12 years of experience
Awards: None
Favorite Part of Work: Starting the dolls and also finding new ideas for the dolls.
Signature: B !!Quamahonynewa!!

Angel Quintana
(F) Cochiti
Born: 8/12/36
Parents: Felipa Trujillo, Cochiti
Teacher: My mother
Type of Work: Traditional ornaments
27 years of experience
Awards: None
Favorite Part of Work: Creating the little figurines.
Signature: A.Q.

Irene Quintana
(F) Cochiti
Born: 1/30/29
Parents: Cochiti
Teacher: My Mother
Type of Work: Storytellers and leatherwork
57 years of experience
Awards: None
Favorite Part of Work: I like to make my storytellers the most.
Signature: Irene, Cochiti N.M.

Margaret Quintana
(F) Cheyenne
Born: 7/4/48
Parents: Harry and Daisy Behan
Teacher: My mother-in-law
Type of Work: Storytellers, figurines
17 years of experience
Awards: Gallup Indian Ceremonial, Santa Fe Indian Market, and the New Mexico State Fair.
Favorite Part of Work: I like to paint my dolls because it's like putting clothes on them.
Signature: Margaret Quintana, Cochiti N.M.

Mary E. Quintana (Baca), Page 90
(F) Cochiti
Born: 12/21/44
Parents: Margaret and Geronimo Quintana
Teacher: My mother
Type of Work: Storytellers
17 years of experience
Awards: I've won awards at the Eight Northern Pueblo Show and N.M. State Fair.
Favorite Part of Work: I like all the parts of my work, from start to finish.
Signature: Mary E. Quintana, Cochiti N.M.

Pablo B. Quintana, Page 90
(M) Cochiti
Born: 7/17/47
Parents: Jerry and Margaret Quintana
Teacher: Self-taught
Type of Work: Clay storytellers
13 years of experience
Awards: SWIA-Indian market 1991, Outstanding Cochiti traditional Storyteller Art; John Bott Memorial Award, First Place in Category.
Favorite Part of Work: Actual sculpting and painting
Signature: Pablo Quintana

Pamela E. Quintana
(F) Cochiti
Born: 6/17/74
Parents: Margaret and Pablo Quintana
Teacher: Both my parents
Type of Work: Storytellers
10 years of experience
Awards: None yet
Favorite Part of Work: Painting is my favorite part.
Signature: Pamela E. Quintana, Cochiti

Dextra Quotskuyva
(F) Tewa/Hopi
Parents: Emerson and Rachel Namingha
Teacher: Mother
Type of Work: Pottery
21 years of experience
Awards: Best of Show, Santa Fe; Living Treasure Award
Favorite Part of Work: Painting the piece and seeing it come alive.
Signature: Dextra with corn

Sam Rahona
(M) Hopi
Born: 12/24/59
Parents: Upper Polacca, now Moencopi
Teacher: Self-taught
Type of Work: Hopi Kachina dolls
17 years of experience
Awards: None
Favorite Part of Work: I like the thrill of surprising myself with the finished doll.
Signature: S. Rahona (in cursive)

Marilyn Ray, Page 20, 90
(F) Acoma
Born: 8/14/54
Parents: Edward and Katherine Lewis
Teacher: Self-taught
Type of Work: Storytellers and figurines
15 years of experience
Awards: Many First, Second and Third Place Ribbons at Eight Northern Pueblo Shows, Santa Fe Indian Market, and N.M. State Fair.
Favorite Part of Work: I like to paint the children on my work the most
Signature: M. Ray, Acoma N.M.with lizard

Dean Reano, Page 20
(M) Acoma, Santo Domingo, Sioux
Born: 12/22/56
Parents: Acoma
Teacher: Divine, through her mother.
Type of Work: Miniature pottery
18 years of experience
Awards: None
Favorite Part of Work: I like painting the most.
Signature: D. Reano, Acoma N.M.

Divine Reano, Page 20
(F) Acoma
Born: 2/13/59
Parents: James and Mae Routzen, Acoma
Teacher: Self-taught
Type of Work: Traditional plates
16 years of experience
Awards: None
Favorite Part of Work: I like the finished product and the dollars.
Signature: D. Reano, Acoma N.M.

Richard A. Reano
(M) Laguna
Born: 4/26/69
Parents: Mary Reano, Laguna
Teacher: Self-taught
Type of Work: Ceramic pottery
4 years of experience
Awards: None
Favorite Part of Work: Selling my work for a profit.
Signature: R.R. Laguna N.M.

Norman Red Star, Page 6

(M) Sioux
Born: 9/4/55
Parents: Lillian and Mark Thunder, Sioux
Teacher: Red Star and myself
Type of Work: Carving on traditional pottery
20 years of experience
Awards: I've won Best of Show and First Place awards at various shows.
Favorite Part of Work: I like to design and to look at the finished work and know that I did my best.
Signature: Red Star with personal logo

Jimmy Redbird

(M) Kiowa
Born: 2/28/69
Parents: Carol Redbird
Teacher: Robert Redbird
Type of Work: Southwest art
10 years of experience
Awards: None yet
Favorite Part of Work: I like air brushing the most.
Signature: Jimmy Redbird, Kiowa

Snowflake (Stephanie) Rhoades

(F) Cochiti
Born: 12/26/31
Parents: Eleterin and Berina Cordero
Teacher: Mary Martin
Type of Work: Storytellers and figurines
21 years of experience
Awards: John Botts Memorial in Memory of Helen Cordero, First Place for my nativity scene.
Favorite Part of Work: Designing and firing.
Signature: Snowflake with flower

Donna Robertson

(F) Hopi
Born: 7/24/72
Parents: Marianne Navasie, Hopi, Tewa
Teacher: My mother
Type of Work: Traditional Hopi pottery
15 years of experience
Awards: None yet
Favorite Part of Work: Molding each piece is what I like to do most.
Signature: With a tadpole only.

David A. Rogge

(M) Hopi
Born: 2/8/67
Parents: Mary Rogge
Teacher: My mother and my brothers.
Type of Work: Small kachina dolls
3 years of experience
Awards: None
Favorite Part of Work: Painting the dolls.
Signature: D.A.R.

Mary Rogge

(F) Hopi
Born: 12/16/38
Parents: Wille and Pauline Cain, Hopi
Teacher: My father and my brothers.
Type of Work: Kachina dolls and ornaments.
8 years of experience
Awards: None.
Favorite Part of Work: To be able to be at home and still earn an income. I also enjoy meeting people at craft shows.
Signature: M.R.

Annette Romero

(F) Cochiti
Born: 2/4/44
Parents: Cochiti
Teacher: My cousin and my mother
Type of Work: Storytellers and figurines
37 years of experience
Awards: None
Favorite Part of Work: Molding each piece into something special.
Signature: Annette Romero, Cochiti N.M.

Gertrude Romero

(F) Acoma
Born: 3/30/42
Parents: Mr. and Mrs. Phillip Concho
Teacher: My grandmother
Type of Work: Ceramic Acoma Pottery
37 years of experience
Awards: None
Favorite Part of Work: Painting my pottery is the best part of my work.
Signature: A.R. , Jemez N.M.

Gregory Romero, Page 20

(M) Acoma
Born: 6/29/61
Parents: Ann Romero, Acoma N.M.
Teacher: My mother
Type of Work: Ceramic Acoma pottery
20 years of experience
Awards: None
Favorite Part of Work: I like the colors and the designs of the pottery.
Signature: G.P.R. Acoma N.M.

Marie G. Romero, Page 38

(F) Jemez
Born: 7/27/27
Parents: Persingula M. Gachupin, Jemez
Teacher: My mother
Type of Work: Traditional pottery
62 years of experience
Awards: Santa Fe Indian Market, Heard Museum Show, Eight Northern Pueblo Show, and Gallup Indian Ceremonial.
Favorite Part of Work: I like all the ten steps I use in my pottery.
Signature: Marie G. Romero, Jemez N.M.

Michael Romero, Page 20

(M) Acoma
Born: 10/5/64
Parents: Gertrude Romero
Teacher: My mother
Type of Work: Ceramic etched pottery
11 years of experience
Awards: None
Favorite Part of Work: The Kachina pots and realistic animal figures in black and white.
Signature: M.R. Romero, Acoma N.M.

Pauline (Anita) Romero, Page 38

(F) Jemez
Born: 9/25/62
Parents: Persingula R. Tosa
Teacher: My mother
Type of Work: Traditional polished vases
18 years of experience
Awards: Gallup Indian Ceremonial
Favorite Part of Work: I like to polish the pieces.
Signature: Pauline Romero, Jemez N.M.

Robyn Romero, Page 20
(F) Acoma
Born: 3/21/68
Parents: Angelina Aragon
Teacher: My mother
Type of Work: Acoma etched pottery
11 years of experience
Awards: None
Favorite Part of Work: Kachina pots and realistic animal figures.
Signature: R.M. Romero Acoma Sky City

David Roy
(M) Hopi
Born: 3/16/55
Parents: Moenkopi village
Teacher: Self-taught
Type of Work: Hopi Kachina dolls
22 years of experience
Awards: I've won a Best of Show award.
Favorite Part of Work: Carving all the different kinds of dolls.
Signature: David Roy, Yok-ua

Michael Runningwolf
(M) MICMAC
Born: 6/25/53
Parents: Old Man Hawk, Micmac
Teacher: My father and grandfather
Type of Work: Traditional artifacts
22 years of experience
Awards: None
Favorite Part of Work: I like to make skull crackers and fishing sticks.
Signature: Michael Runningwolf

Rebecca Russell
(F) Santa Ana
Born: 12/1/57
Parents: Rose Armijo, grandmother
Teacher: Grandmother
Type of Work: Ceramics
12 years of experience
Awards: Never entered
Favorite Part of Work: Painting the pieces with traditional designs.
Signature: SRI-TZEE-YAA

Patrick Rustin, Page 14
Acoma

Kathleen Sabaquie
(F) Jemez
Born: 10/1/66
Parents: Rosita Sabaquie, Jemez
Teacher: My mother
Type of Work: Traditional Jemez pottery
7 years of experience
Awards: None
Favorite Part of Work: Painting is the best part of my work.
Signature: K. Sabaquie

Jean Sahmie, Page 30
(F) Hopi
Born: 9/5/41
Parents: Priscilla Nampeyo
Teacher: My mother and grandmother
Type of Work: Traditional Hopi pottery
18 years of experience
Awards: I've won Best of Show at many art competitions throughout the Southwest.
Favorite Part of Work: I like painting and firing the most.
Signature: J. with a corn stalk.

Jeanette Sahu, Page 30
(F) Hopi
Parents: Emogene Lomakema, Hopi
Teacher: Mother
Type of Work: Pottery
42 years of experience
Awards: Many First, Second and Third Place ribbons at various shows.
Favorite Part of Work: Seeing how many shapes I can come up with.
Signature: Jeanette Sahu

Jett Saint Michael
(M) Chocta
Born: 6/5/70
Parents: Ron David
Teacher: Ron Sunsinger, Choctaw
Type of Work: Traditional ceremonial art
6 years of experience
Awards: None
Favorite Part of Work: I like all aspects of my work.
Signature: Jett Saint Michael

Michael Sakestewa
(M) Hopi-Navajo
Born: 5/27/64
Parents: Theodore Francis Laguna, Hopi
Teacher: My stepfather
Type of Work: Sculpture kachinas
8 years of experience
Awards: None
Favorite Part of Work: I like my action dolls, eagle dancers, and other action dolls.
Signature: M.V. Sakestewa, Sr.

Francescia V. Salas
(F) Zia
Born: 9/1/62
Parents: Juanico and Teresita Galvan
Teacher: Lois Medina
Type of Work: Traditional pottery
1 years of experience
Awards: I've never entered my work.
Favorite Part of Work: I like to build the pot.
Signature: Frances Salas

Angela Salazar
(F) Santa Clara
Born: 7/2/70
Parents: Frances Salazar, Santa Clara
Teacher: Mother
Type of Work: Black carved
9 years of experience
Awards: Never entered
Favorite Part of Work: Watching the pottery take shape.
Signature: Angela Salazar, Santa Clara

Elaine Salazar, Page 64
Santa Clara

Frances Salazar
(F) Santa Clara
Born: 9/13/36
Parents: Flora Naranjo
Teacher: My mother
Type of Work: Black carved and red pottery
57 years of experience
Awards: I've won some awards at the Eight Northern Pueblo Show.
Favorite Part of Work: I like to form the pots and put the best polish I can on them.
Signature: Frances Naranjo Salazar

Fred Salazar
(M) Hopi/Tewa
Teacher: Father
Type of Work: Kachinas
16 years of experience
Awards: Never entered
Favorite Part of Work: All facets of working with wood.
Signature: Fred Chapeila

Pauline Salazar
(F) Santa Clara
Born: 10/19/55
Parents: Felicita Naranjo, Santa Clara
Teacher: My nephew
Type of Work: Black deep carved
14 years of experience
Awards: None
Favorite Part of Work: I like to make the designs and carve them.
Signature: Pauline Salazar, Santa Clara

George A. Salvador
(M) Acoma
Born: 2/7/52
Parents: Mr. and Mrs. Grace Salvador
Teacher: Self-taught
Type of Work: All traditional
15 years of experience
Awards: 80 Most Traditional Award, Yuma, Arizona Museum
Favorite Part of Work: Beginning and the finished piece.
Signature: G.A. Salvador Acoma, N.M.

Peggy (Etsitty) Sam, Page 46
(F) Navajo
Born: 3/5/65
Parents: Mae Tom, Navajo
Teacher: Davis and Dena Willie
Type of Work: Navajo etched pottery
6 years of experience
Awards: Never entered
Favorite Part of Work: Painting and etching the pots.
Signature: P.S Dine (year)

Dannielle Sanchez
(M) Laguna
Born: 7/13/73
Parents: Yvonne R Louis, Laguna
Teacher: Mother
Type of Work: Kachinas
4 years of experience
Awards: Never entered
Favorite Part of Work: Dressing the kachinas
Signature: DS

Debbie Sandia
(F) Jemez
Born: 12/3/69
Parents: Wilbert and Geraldine Sandia
Teacher: My parents
Type of Work: Stone polished pottery
10 years of experience
Awards: I've never entered.
Favorite Part of Work: I like to paint the most.
Signature: D. Sandia

Dory Sandia
(M) Jemez
Born: 5/21/68
Parents: Sharon Sandia, Jemez
Teacher: My mother
Type of Work: Traditional polished Jemez
10 years of experience
Awards: None yet
Favorite Part of Work: Polishing and painting are my favorite parts of my work.
Signature: D. Sandia, Jemez N.M.

Geraldine Sandia
(F) Jemez
Born: 1/2/50
Parents: Cecilia and Aurthur Loretto
Teacher: My grandmother
Type of Work: Stone-polished Jemez designs
27 years of experience
Awards: Santa Fe Indian Market, Heard Museun Show, Gallup Indian Ceremonial and more from other shows and competitions.
Favorite Part of Work: I like all of my work, espcially selling it for high prices.
Signature: G. Sandia, Jemez

Marsha Sandia
(F) Jemez
Born: 9/25/68
Parents: Mary Ann Sandia
Teacher: Mother
Type of Work: Pottery
7 years of experience
Awards: Never entered
Favorite Part of Work: Painting the pots.
Signature: M. Sandia

Mary Ann Sandia
(F) Jemez
Born: 4/28/55
Parents: Jemez
Teacher: Self-taught
Type of Work: Traditional
9 years of experience
Awards: None
Favorite Part of Work: Selling at Palms.
Signature: M. Sandia, Jemez

Natalie Sandia
(F) Jemez
Born: 4/2/66
Parents: Wibert and Geraldine Sandia
Teacher: Self-taught
Type of Work: Stone-polished Jemez
7 years of experience
Awards: None
Favorite Part of Work: Polishing and painting.
Signature: N. Sandia Jemez

Caroline Sando, Page 39, 91
(F) Jemez
Born: 12/14/63
Parents: Andrea Tsosie
Teacher: My grandmother
Type of Work: Traditional pottery and storytellers
17 years of experience
Awards: I've won First, Second, and Third Place awards at the Santa Fe Indian Market.
Favorite Part of Work: I like to work with the clay and to see what form comes from it.
Signature: Caroline Sando, Jemez N.M.

Diane Sando
(F) Jemez
Born: 5/13/59
Parents: Mr.and Mrs. Barnabe Romero
Teacher: Cecilia Romero, my mother
Type of Work: Storytellers
23 years of experience
Awards: None yet
Favorite Part of Work: Making storytellers, then selling them.
Signature: D.S. Jemez N.M.

Kenneth J. Sando, Page 39, 91
(M) Jemez
Born: 12/22/63
Parents: Juanita Sandia, Jemez
Teacher: My grandmother
Type of Work: Traditional storytellers
15 years of experience
Awards: I've won awards at N.M. State Fair and Gallup Indian Ceremonial.
Favorite Part of Work: I like to sell and meet people.
Signature: K.J. Sando, Jemez N.M.

Roberta Sando
(F) Jemez
Born: 7/30/52
Parents: Mr. and Mrs. Barnabe Romero
Teacher: My mother, Cecilia
Type of Work: Traditional pottery
23 years of experience
Awards: None
Favorite Part of Work: Creating, painting, and selling.
Signature: R. Sando

Veronica Sando, Page 39
(F) Jemez
Born: 8/12/42
Teacher: My grandmother
Type of Work: Traditional Jemez pottery
11 years of experience
Awards: I've never entered.
Favorite Part of Work: Making wedding vases and painting them.
Signature: Veronica Sando, Jemez N.M.

Marie R. Sandoval, Page 50
(F) San Felipe
Born: 1/4/37
Parents: Bridgett Esquibel, San Felipe
Teacher: My mother-in-law
Type of Work: Traditional pottery
52 years of experience
Awards: None
Favorite Part of Work: Painting is my favorite part of my work.
Signature: Marie R. Sandoval, San Felipe

Clara Santiago, Page 21
(F) Acoma
Born: 11/13/51
Parents: Rose Poncho, Acoma
Teacher: Self-taught
Type of Work: Handmade and ceramic pottery
17 years of experience
Awards: Art shows in Kansas City, Houston, and Denver
Favorite Part of Work: Creating new designs.
Signature: Kuutimaits'a (means "mountain")

Anna Sarracino
(F) Zuni
Born: 3/19/59
Parents: Kathlutah and Lonita Telese
Teacher: My mother Lonita
Type of Work: Bead work
10 years of experience
Awards: New Mexico State Fair
Favorite Part of Work: Being creative.

Edwin L. Sarracino
(M) Acoma
Born: 3/8/51
Parents: Marie A. Vallo, Acoma
Teacher: My mother
Type of Work: Traditional pottery
12 years of experience
Awards: None yet
Favorite Part of Work: Working with the clay, the coiling process.
Signature: E. and Ml. Sarracino, Acoma N.M.

Myron Sarracino, Page 44
(M) Laguna
Born: 1/8/67
Parents: Joan and Mike Sarracino, Laguna
Teacher: Grandparents, various others
Type of Work: Traditional Laguna pottery
10 years of experience
Awards: Best of Show, Best in Traditional 1994 Eight Northern Indian Artist and Craftman show
Favorite Part of Work: Creating pots with clay, working on old designs.
Signature: Myron Sarracino Laguna Pueblo

Sharon Sarracino
(F) Jemez , Laguna
Parents: Mr. Francisco Sarracino
Teacher: I learned on my own.
Type of Work: Handmade pottery
27 years of experience
Awards: I won Best of Show one time.
Favorite Part of Work: Making new shapes and painting new designs on them.
Signature: Sharon Sarracino

Dorothy Secatero
(F) Navajo
Born: 2/9/42
Parents: Marie and Jim Thompson
Teacher: My grandfather and school
Type of Work: Traditional Navajo jewelry
34 years of experience
Awards: None yet
Favorite Part of Work: I like soldering and coming up with new ideas.
Signature: DS

Randy Secatero
(M) Navajo
Born: 10/11/63
Parents: Dorothy and Ray Secatero
Teacher: My mother
Type of Work: Contemporary and Traditional Jewelry
11 years of experience
Awards: None yet
Favorite Part of Work: I like to design jewelry.
Signature: RS

Caroline Seonia
(F) Jemez
Born: 3/30/28
Parents: Jose and Persingula Loretto
Teacher: Self-taught
Type of Work: Traditional figurines
40 years of experience
Awards: None
Favorite Part of Work: Painting cute faces on my figurines.
Signature: CLS, Jemez N.M.

Marian K. Seonia
(F) Jemez
Born: 1/4/73
Parents: Mr. and Mrs. Kenneth Seonia Jr
Teacher: My mother
Type of Work: Traditional pottery
5 years of experience
Awards: None
Favorite Part of Work: Painting
Signature: Seonia, Jemez N.M.

Santana M. Seonia
(F) Jemez
Born: 7/21/47
Parents: Juanita Toledo , Jemez
Teacher: My mother
Type of Work: Storytellers, pots, figurines.
17 years of experience
Awards: N.M. State Fair, San Felipe Shows.
Favorite Part of Work: Creating the pots, painting them, and selling them.
Signature: S.T.S. or Santana Seonia

Cynthia R. Sequi
(F) Hopi
Born: 9/30/54
Parents: Hugh and Roberta Sequi
Teacher: Helen Naha and Sylvia Naha
Type of Work: Natural Hopi pots
12 years of experience
Awards: Never entered
Favorite Part of Work: Using my hands to mold the pot and then painting it.
Signature: C.R. Sequi

Gwen Setalla
(F) Hopi
Parents: Pauline Setalla, Hopi
Teacher: Mother
Type of Work: Traditional Hopi
12 years of experience
Favorite Part of Work: Making intricate designs.
Signature: G. Setalla with bear paw

Stetson Setalla, Page 30
Hopi

Vivian Seymour
(F) Acoma
Born: 8/26/60
Parents: Mr and Mrs Albert Garcia, Acoma
Teacher: Grandma and mother-in-law
Type of Work: Hand-coiled pottery
24 years of experience
Awards: Never entered.
Favorite Part of Work: Painting and shaping the piece.
Signature: V. Seymour or L. and V. Seymour

Ashiki Shash
(M) Navajo
Born: 9/29/54
Parents: Navajo
Teacher: Self-taught
Type of Work: Flutes
17 years of experience
Awards: None
Favorite Part of Work: I like to get the tone just right; it's not a flute if it doesn't play.
Signature: Ashikii Shash

Jaqueline Shendo
(F) Jemez
Born: 7/12/61
Parents: Rosita Sabaque, Jemez
Teacher: My mother and her friend
Type of Work: Storytellers and bowls
13 years of experience
Awards: None
Favorite Part of Work: Creating each piece—the way they're made.
Signature: J.S. Shendo, Jemez N.M.

Juanita Shendo
(F) Jemez
Born: 6/15/57
Parents:
Teacher: Mother
Type of Work: Pottery
14 years of experience
Awards: Never entered
Favorite Part of Work: All phases of pottery making.
Signature: J. Shendo

Roberta Shendo, Page 40
Jemez
Born: 8/4/59
Parents: Jemez Pueblo
Teacher: My mother
Type of Work: Traditional, Stone polish
20 years eperience
Awards: I've never entered my work
Favorite part of work: I like painting the most.
Signature: Roberta Shendo, Walatowa

Ethel Shields
(F) Acoma
Born: 9/17/26
Parents: Toribio and Delores Sanchez
Teacher: Mother
Type of Work: Traditional pots, effigies
52 years of experience
Awards: I've won awards in Santa Fe, Arizona, and Colorado.
Favorite Part of Work: Coming up with different designs that work with my style.
Signature: ETHEL ACOMA N.M.

Judy Shields
(F) Acoma
Born: 4/4/62
Parents: Elmer and Edna Chino, Acoma
Teacher: My grandmother, Lita Garcia
Type of Work: Miniature storytellers
17 years of experience
Awards: I've won awards at the Santa Fe Indian Market and at many shows in Arizona.
Favorite Part of Work: I like to paint and detail my work.
Signature: Judy Shields, Acoma N.M.

Michelle Shields, Page 21
(F) Acoma
Born: 9/23/72
Parents: Ethel Shields
Teacher: Ethel Shields, Charmae Natseway
Type of Work: Traditional pots
9 years of experience
Awards: None.
Favorite Part of Work: Making different creations from clay.
Signature: M. Shields

Donovan Shroulote
(M) Acoma
Born: 7/25/72
Parents: Acoma
Teacher: Ted Francis, Jr.
Type of Work: Kachinas
7 years of experience
Awards: None
Favorite Part of Work: Trying to improve my work with each doll I carve.
Signature: D. Shroulote

Manuel L. Shroulote
(M) Acoma
Born: 10/14/62
Parents: John and Ruby Shroulote, Acoma
Teacher: self taught
Type of Work: Traditional Acoma Pottery
9 years of experience
Awards: Never entered
Favorite Part of Work: The final painting of a piece.
Signature: MLS

Antoinette E. Silas
(F) Hopi, Tewa, Laguna
Born: 12/31/59
Parents: Roberta M. Silas
Teacher: My mother
Type of Work: Traditional Hopi pottery
20 years of experience
Awards: I've won a Second Place and an Honorable Mention at the Gallup Indian Ceremonial.
Favorite Part of Work: I like the molding process to the finished work.
Signature: Anotinette Silas, Hopi

Roberta Silas
(F) Laguna, Tewa
Born: 4/28/39
Parents: Pauline and Roy Youvella
Teacher: Self-taught
Type of Work: Tradtional Hopi
3 years of experience
Awards: I've won many blue ribbons at various art shows.
Favorite Part of Work: I like to make the Hopi pottery— I just like the style.
Signature: Roberta Youvella Silas, Hopi

Venora Silas, Page 30
(F) Hopi/Tewa
Born: 10/29/67
Parents: Ruden and Roberta Silas
Teacher: Mother
Type of Work: Pottery
22 years of experience
Awards: Never entered
Favorite Part of Work: Molding, scraping, polishing and painting the pieces.
Signature: Venora Silas

Amalia Silk
(F) Jemez
Born: 11/10/58
Parents: Leandro and Josephine Sando
Teacher: My mother
Type of Work: Traditional polished, etched
16 years of experience
Awards: None yet
Favorite Part of Work: I like sculpting with the clay
Signature: Amalia Silk, Jemez N.M.

Gloria Silver
(F) Navajo
Born: 6/5/64
Parents: Matilda Wilson, Chee
Teacher: My father
Type of Work: Silver Earrings
22 years of experience
Awards: None
Favorite Part of Work: I like to make new styles.
Signature: DJS, for Duphen Silver Jewelry

Melody Simpson
(F) Acoma
Born: 3/26/60
Parents: Acoma
Teacher: Self-taught
Type of Work: Etched ceramic pottery
10 years of experience
Awards: I've won two awards for my work.
Favorite Part of Work: I like the stories and designs.
Signature: MS/G Acoma, N.M.

Davin G. Singer
(M) Navajo
Born: 8/6/71
Parents: David and Louise Singer
Teacher: My mother
Type of Work: Fetishes
8 years of experience
Awards: I won an award at the N.M. State Fair.
Favorite Part of Work: My favorite part is making the fetishes look like they are alive.
Signature: In cryptic initials

Mary Small, Page 40
(F) Jemez
Born: 7/12/40
Parents: Jemez
Teacher: My mother
Type of Work: Traditional pottery
50 years of experience
Awards: I've won many awards at such shows as Santa Fe Indian Market, Gallup Indian Ceremonial, The Heard Museum Show in Pheonix and The New Mexico State Fair.
Favorite Part of Work: Creating my own unique style of pottery and seeing the people enjoy my work.
Signature: Mary Small

Sheila Smith
(F) Jemez
Born: 6/24/71
Parents: Celina Chavez, Jemez
Teacher: My mother
Type of Work: Traditional pottery
7 years of experience
Awards: None
Favorite Part of Work: I like to paint the pottery the most.
Signature: S. C. Jemez N.M.

Terry Smith
(F) Navajo
Born: 11/13/70
Parents: Freddie and Rose Smith, Navajo
Teacher: Victoria Tsosie, my sister
Type of Work: Ceramic carved
8 years of experience
Awards: None yet
Favorite Part of Work: I like carving the pottery after I design it.
Signature: Terry Smith (Shiprock)

Tim "Coyote" Smith
(M) Hopi/Laguna
Born: 11/4/54
Parents: Dennis and Katherine Smith
Teacher: My grandmother
Type of Work: Traditional pottery
22 years of experience
Awards: None yet
Favorite Part of Work: I like painting and firing and to see the pottery finished.
Signature: Coyote

Cynthia Starflower
(F) San Ildefonso, Tewa
Born: 6/21/59
Parents: Carmelita Dunlap
Teacher: My mother
Type of Work: Traditional pottery
29 years of experience
Awards: I've won awards at the Santa Monica Indian Art Show and at the Heard Museum in Scottsdale, Arizona.
Favorite Part of Work: I like contsructing the pots by hand the way my mother taught me.
Signature: Cynthia Starflower with flower

Marilyn Stark
(F) Kiowa, Nebraska
Born: 8/7/42
Parents: From Weeping Water, NB
Teacher: Self-taught
Type of Work: Handpainted kachina rocks
15 years of experience
Awards: None
Favorite Part of Work: Collecting rocks and painting different kachinas on them.
Signature: M. Stark

Red Starr
(M) Sioux, Pine Ridge,South Dakota
Born: 11/20/37
Parents: Wounded Knee, South Dakota
Teacher: Self-taught
Type of Work: Etched pottery
23 years of experience
Awards: Santa Fe Indian Market, Eight Northern Pueblo Show, N.M. State Fair, Heard Museum Show
Favorite Part of Work: I like to carve the feather designs the most.
Signature: Red Starr, Sioux

Manuel Stevens
(M) Acoma
Born: 6/16/57
Parents: James and Rosita Stevens
Teacher: My mother
Type of Work: Traditional Acoma pottery
15 years of experience
Awards: None
Favorite Part of Work: Building larger pots because not many people make them.
Signature: STEVENS

Sharon Stevens, Page 21
(F) Acoma
Born: 9/24/60
Parents: Rose Stevens, Acoma
Teacher: Mother
Type of Work: Pottery
17 years of experience
Awards: Never entered
Favorite Part of Work: Molding large pieces.
Signature: S. Stevens

Ron Suazo, Page 65
(M) Santa Clara
Born: 3/6/54
Parents: Clara C. Suazo, Santa Clara
Teacher: Clara C. Suazo
Type of Work: Contemporary polished pottery
19 years of experience
Awards: Honorable mention, Heard Museum; First Place, Eight Northern Pueblo Show.
Favorite Part of Work: Designing the pottery.
Signature: Ron Suazo, Santa Clara N.M.

Clara C. Suazo
(F) Santa Clara
Born: 4/13/12 (deceased)
Parents: Geranino and Gregoria Chavarria
Teacher: Candelaria Suazo
Type of Work: Traditional black on black
70 years of experience
Awards: I've won blue ribbons at Eight Northern Pueblo Shows.
Favorite Part of Work: I like to polish my own work and make it as beautiful as I can.
Signature: Clara Suazo, Santa Clara N.M.

Ada Suina
(F) Cochiti
Born: 5/20/30
Parents: Berina and Eluterio Cordero
Teacher: Self-taught
Type of Work: Traditional storytellers
22 years of experience
Awards: Several First Place awards and Santa Fe Indian Market, Gallup Indian Ceremonial, and N.M. State Fair.
Favorite Part of Work: Creating the figures and putting the slip on them.
Signature: Ada Suina, Cochiti N.M.

Dena M. Suina
(F) Cochiti
Born: 9/12/61
Parents: Joe and Juana Trancosa
Teacher: My mother-in-law
Type of Work: Traditional Storytellers
10 years of experience
Awards: I've won awards at the Gallup Indian Ceremonial and the New Mexico State Fair.
Favorite Part of Work: I like to paint my storytellers the most.
Signature: Dena M. Suina, Cochiti N.M.

Joseph and Esther Suina
(M) Cochiti
Born: 4/1/43
Parents: Cochiti, Apache, Hopi
Teacher: Self-taught
Type of Work: Traditional storytellers
17 years of experience
Awards: We have won many awards at various art shows, such as New Mexico State Fair, Gallup Indian Ceremonial, and the world famous Santa Fe Indian Market.
Favorite Part of Work: I like the sculpting and painting part of my work.
Signature: Blooming flower, EK Suina.

Judith A. Suina
(F) Cochiti
Born: 4/14/60
Parents: Dorothy and Onofre Trujillo
Teacher: Mother, Dorothy Trujillo
Type of Work: Storyteller figures
17 years of experience
Awards: Never entered
Favorite Part of Work: Working with wet clay, then opening the tin pan at the firing to see the finished figures and making sure they all came out good.
Signature: J. Suina

Mary "Vangie" Suina
(F) Cochiti
Born: 4/25/59
Parents: Ernest and Louise Suina
Teacher: Mother
Type of Work: Pottery, storytellers, nativity
19 years of experience
Awards: I've placed First, Second, and Third at Santa Fe Indian Market for the past 17 years; Best of Show, Cristofs and Heard Museum.
Favorite Part of Work: Painting—bringing them to life.
Signature: Vangie Suina AWS

Norma A. Suina, Page 91
(F) Hopi and Cochiti
Born: 3/30/44
Parents: Mr. and Mrs. Ellis Fredericks
Teacher: Dorothy Trujillo
Type of Work: Storytellers and mudheads
22 years of experience
Awards: None
Favorite Part of Work: I like to make storytellers the best.
Signature: N.S. Cochiti N.M.

Pete Sumatzkuku
(M) Hopi
Born: 3/23/57
Parents: Hopi
Teacher: Self-taught
Type of Work: Paintings, Pottery, Sculptures
32 years of experience
Awards: I've won several First and Second Place ribbons.
Favorite Part of Work: Getting paid and getting awards.
Signature: P. Sumatzkuku, Hopi

Andrea Tafoya, Page 40
Jemez

Brenda Tafoya
(F) Jemez
Born: 5/3/63
Parents: Vangie and David Tafoya
Teacher: My mother, Vangie
Type of Work: Traditional polished
17 years of experience
Awards: I've won an award at N.M. State Fair.
Favorite Part of Work: Drawing and carving.
Signature: Brenda Tafoya, Jemez N.M.

Celes Tafoya, Page 65
(F) Santa Clara
Born: 11/27/31
Parents: Pasqual and Logoria Tafoya
Teacher: My mother
Type of Work: Traditional Polished, Carved
47 years of experience
Awards: Santa Fe Indian Market, First, Second and Third; N.M. State Fair, First, Second, and Third.
Favorite Part of Work: I like to form my pottery the best.
Signature: Celes and Evelyn, Santa Clara

Douglas Tafoya, Page 65
(M) Santa Clara
Born: 9/14/42
Parents: Mary Cain
Teacher: My mother
Type of Work: Carved red and black
10 years of experience
Awards: N.M.State Fair, Gallup Indian Ceremonial
Favorite Part of Work: Firing, then seeing how well the pieces came out.
Signature: Doug Tafoya, Santa Clara

Emily Tafoya, Page 65
(F) Kiowa/Santa Clara
Born: 4/25/59
Parents: Alfred and Lela Suazo
Teacher: Grandmother, Clara Suazo
Type of Work: Incised pottery
23 years of experience
Awards: Never entered
Favorite Part of Work: Polishing pieces; designing.
Signature: Emily Tafoya with SCP

Eric Tafoya, Page 66
(M) Santa Clara
Born: 12/21/69
Parents: Wanda Tafoya, Santa Clara
Teacher: My aunt, Gwen Tafoya
Type of Work: Incised red on black
10 years of experience
Awards: I've won Second and Third Place at the New Mexico State Fair, Eight Northern.
Favorite Part of Work: I like to look at the pieces when they are finished.
Signature: Eric Tafoya

Gwen Tafoya, Page 66
(F) Santa Clara
Born: 4/18/65
Parents: Mary Agnes Tafoya
Teacher: Mother
Type of Work: Traditional carved and etched
15 years of experience
Awards: Best of Show, First, and Second at Gallup Ceremonials, N.M. State Fair, Eight Northern Pueblo Show.
Favorite Part of Work: I like to etch as well as polish.
Signature: Gwen Tafoya S.C.P.

Judy Tafoya
(F) Santa Clara
Born: 1/12/62
Parents: Christina Naranjo
Teacher: My grandmother and aunt
Type of Work: Traditional pottery
14 years of experience
Awards: I've won awards at the New Mexico State Fair and Art shows in Houston, Texas.
Favorite Part of Work: I like to make the pot, carve the designs, and work with the clay.
Signature: Judy and Lincoln Tafoya

Madeline Tafoya
(F) Santa Clara
Born: 12/22/12
Parents: Santa Clara Pueblo
Teacher: My grandmother and my aunt
Type of Work: Traditional black and red
52 years of experience
Awards: Santa Fe Indian Market and the N.M. State Fair.
Favorite Part of Work: Creating each piece from the shapes in my mind.
Signature: Madeline Tafoya, Santa Clara

Mida Tafoya, Page 66
Santa Clara
Born: 11/20/31
Parents: Christina Naranjo
Treacher: My mother
Type of Work: Black and red carved
60 years experience
Awards: I've won 1st and 2nd Place at the Chicago Fair, Denver Fair, and Eight Northern.
Favorite Part of Work: I pretty much like the whole process. I like making the pottery, polishing it, and then carving.
Signature: Mida Tafoya

Phyllis Tafoya
(F) Santa Clara
Parents: Mida and Avelino Tafoya
Teacher: Grandmother
Type of Work: Carved traditional black
31 years of experience
Awards: 1971 N.M. State Fair
Favorite Part of Work: Polishing pieces and teaching others.
Signature: Phyllis Tafoya

Sally Tafoya
(F) Santa Clara
Born: 6/16/58
Parents: Victoria Velarde
Teacher: My mother
Type of Work: Traditional polished
22 years of experience
Awards: Santa Fe Indian Market, First, Second and Third Place awards; Gallup Indian Ceremonial, First and Second Places.
Favorite Part of Work: I like to carve my pieces the most.
Signature: Sally Tafoya, Santa Clara N.M.

Starr Tafoya, Page 58
(F) Santa Clara
Born: 8/6/51
Parents: Henry and Jane Baca
Teacher: My mother and myself
Type of Work: Traditional pottery
22 years of experience
Awards: I've won First, Second and Third Place ribbons at Santa Fe Indian Market and Eight Northern Pueblo Shows.
Favorite Part of Work: Carving the pottery is my favorite part of my work.
Signature: Starr, or Jane and Starr

Vangie Tafoya, Page 40
(F) Jemez, San Ildefonso
Born: 8/4/44
Parents: Jemez
Teacher: My grandmother
Type of Work: Traditional scraffitto
17 years of experience
Awards: Best of Show, N.M. State Fair; many ribbons at the Santa Fe Indian Market, Gallup Indian Ceremonial and the Heard Museum Show in Pheonix.
Favorite Part of Work: I like shaping the pottery into a masterpiece.
Signature: Vangie Tafoya, Jemez N.M.

Marlin and Phyllis Tafoya-Hemlock, Page 67
Santa Clara

Linda Tafoya-Oyenque, Page 67
(F) Santa Clara
Born: 9/19/62
Parents: Lee and Betty Tafoya
Teacher: My parents
Type of Work: Traditional Santa Clara
14 years of experience
Awards: Ive won many awards at many Indian art shows, such as the Santa Fe Indian Market, and the Eight Northern Pueblo Show.
Favorite Part of Work: I like to carve my pots the most.
Signature: Linda Tafoya-Oyenque

Mark Tahbo
(M) Tewa-Hopi
Born: 4/13/58
Parents: Ramon and Mary Tahbo
Teacher: Great-grandmother
Type of Work: Pottery
25 years of experience
Awards: Honorable Mention '94 SW Association on Indian Affairs; Best of Division, First, Third, Honorable Mention '93 Southwest Association on Indian Affairs; Third, '92 Southwest Association on Indian Affairs; Best of Class, Best of Division, '92 Indian Fair and Market; Best of Division, First Place
Favorite Part of Work: Traveling to show work, meeting people, teaching and demonstrating pottery techniques.
Signature: M. Tahbo

Roy Tanner
(M) San Juan
Born: 5/10/57
Parents: Stella Talachy, San Juan
Teacher: My great-grandfather
Type of Work: Traditional scraffito
2 years of experience
Awards: First, Second and Third Place awards at Santa Fe Indian Market, First Place awards at Heard Museum and The New Mexico State Fair.
Favorite Part of Work: I like to design hummingbirds and do the embroidery on the kachinas on my pottery.
Signature: Tsigowa-Kwa Povi, San Juan

Mae Tapia
(F) Santa Clara
Born: 5/1/52
Parents: Santanita Suazo
Teacher: My mother
Type of Work: Traditional carved pottery
26 years of experience
Awards: I've won some awards at Santa Fe Indian Market.
Favorite Part of Work: I like to design my pottery the most.
Signature: MAE TAPIA, Santa Clara N.M.

Sue Tapia
(F) Laguna
Born: 5/11/46
Parents: Laguna
Teacher: My mother
Type of Work: Traditional black
12 years of experience
Awards: N.M. State Fair and Gallup Indian Ceremonial
Favorite Part of Work: Polishing is my favorite part of my work.
Signature: Sue Tapia

Tom Tapia
(M) San Juan
Born: 7/4/45
Parents: Jose and Leonidas Tapia
Teacher: My mother
Type of Work: Black and red traditional
27 years of experience
Awards: N.M. State Fair, Eight Northern Pueblo Show, Gallup Indian Ceremonial.
Favorite Part of Work: I like to make the carved pieces the most.
Signature: Tom Tapia, San Juan

Alisa J. Taptto
(F) Acoma
Born: 11/30/70
Parents: David and Monica Taptto
Teacher: My mother and in-laws
Type of Work: Traditional seedpots
8 years of experience
Awards: I've won First Place and Best of Show at the Anadarko Indian Fair.
Favorite Part of Work: I like to put rain dancers on all my pottery.
Signature: Alisa Taptto, Acoma N.M.

Chris Teller, Page 92
(F) Isleta
Born: 1/10/56
Parents: Stella and Louis Teller
Teacher: My mother, Stella
Type of Work: Storytellers, Figuines
16 years of experience
Awards: First and Second Place at the New Mexico State Fair.
Favorite Part of Work: I like to build the pots and storytellers.
Signature: C. Teller, Isleta N.M.

Lynette Teller
(F) Isleta
Born: 8/21/63
Parents: Stella Teller, Isleta
Teacher: My mother
Type of Work: Pottery and storytellers
15 years of experience
Awards: I've won awards at the Gallup Indian Ceremonial and the New Mexico State Fair.
Favorite Part of Work: I like building the pottery the most.
Signature: Lynette Teller, Isleta N.M.

Mona Teller, Page 92
(F) Isleta
Born: 10/15/60
Parents: Stella Teller
Teacher: My mother
Type of Work: Storytellers, nativity sets
27 years of experience
Awards: N.M. State Fair, Gallup Indian Ceremonial, Santa Fe Indian Market.
Favorite Part of Work: Varying the types of figures she creates with the clay.
Signature: Mona Teller, Isleta

Nicol B. Teller
(F) Isleta
Born: 4/6/78
Parents: Romona Blythe Teller
Teacher: My grandmother and mother
Type of Work: Traditional figurines
5 years of experience
Awards: None yet
Favorite Part of Work: I like all stages of my work.
Signature: Nicole Teller

Robin Teller
(F) Isleta
Born: 3/7/54
Parents: Stella Teller, Isleta
Teacher: Myself and my mother
Type of Work: Storytellers and figurines
11 years of experience
Awards: SWAIA, Eight Northern and the Heard Museum show.
Favorite Part of Work: Creating each individual piece.
Signature: Robin Teller, Isleta

Stella Teller, Page 92
(F) Isleta Pueblo
Born: 2/10/29
Parents: Rudy and Felicita Jojola
Teacher: Self-taught
Type of Work: Traditional storytellers
38 years of experience
Awards: I have won more awards than I can remember, but the most prestigious was at the Santa Fe Indian Market.
Favorite Part of Work: I like all phases of my work. I recieve complete fulfillment in doing my work.
Signature: Stella Teller

Leslie Teller (Velardez)
(F) Isleta
Born: 6/14/73
Parents: Ray and Marie Velardez
Teacher: My grandmother, Stella
Type of Work: Storytellers and nativities
9 years of experience
Awards: None yet
Favorite Part of Work: I like painting the figures the most.
Signature: Leslie Teller Velarde, Isleta

Doris Tenorio
(F) Santa Clara
Born: 11/27/52
Parents: Tony and Teresa Gutierrez
Teacher: My grandmother and mother
Type of Work: Traditional deep carved pottery
42 years of experience
Awards: Eight Northern Pueblo Shows, Totahi Show in Farmington N.M., Santa Fe Indian Market—First, Second and Third Place ribbons.
Favorite Part of Work: I like my work from start to finish.
Signature: Doris Tenorio, Santa Clara N.M

Gary Tenorio, Sr., Page 93
Santo Domingo
Born: 9/29/57
Parents: Victor and Ramona Tenorio
Teacher: Self-taught
Type of Work: Pottery and Storytellers
20 years experience
Awards: I've won various awards at Indian Market and show on the East Coast.
Favorite part of Work: I like the whole process because it is a great stress relief to me.
Signature: G. Tenorio, Santo Domingo

Marlene Tenorio
(F) Santa Ana
Born: 2/27/63
Parents: Ruth and Bernardino Tenorio
Teacher: Self-taught
Type of Work: Etched ceramics with kokopelli
8 years of experience
Awards: 1993 State Fair
Favorite Part of Work: Creating unique designs; having people admire my unique work.
Signature: M. Tenorio

Robert Tenorio, Page 69, 71
(M) Santo Domingo
Born: 12/29/50
Parents: Juanita Calabaza
Teacher: My grandmother, Andrea Ortiz
Type of Work: Traditional polychrome
27 years of experience
Awards: Santa Fe Indian Market, Eight Northern Pueblo shows, N.M. State Fair, Governor's Award.
Favorite Part of Work: Creating the old designs on my pottery, working with materials my people used hundreds of years ago, and educating my customers.
Signature: Robert Tenorio, Santo Domingo

Thomas Tenorio, Page 71
(M) Santo Domingo
Born: 6/15/63
Parents: Trinidad and Anacita Tenorio
Teacher: Self-taught
Type of Work: Traditional earthware
13 years of experience
Awards: I've won awards at many art shows, such as N.M. State Fair, Gallup Indian Ceremonial, and awards at art shows in Colorado, Niagra Falls, Ohio, Pennsylvania, and Texas.
Favorite Part of Work: I like to paint and design my pottery the most.
Signature: Thomas Tenorio, Santo Domingo

Dion G. Terrazas
(M) Zuni
Born: 10/3/67
Parents: Geri and Ricardo, Zuni
Teacher: My friend
Type of Work: Table fetishes
6 years of experience
Awards: None yet
Favorite Part of Work: The satisfaction of producing quality work.
Signature: DT

Diana Thomas
(F) Navajo
Born: 6/8/72
Parents: Navajo
Teacher: My relatives
Type of Work: Navajo kachinas
4 years of experience
Awards: None
Favorite Part of Work: I like to paint the dolls the most.

Signature: dft

Bernie Todacheeny
(M) Navajo
Born: 3/16/66
Parents: Navajo
Teacher: Self-taught at age 12
Type of Work: Cedar carvings
20 years of experience
Awards: I won a Third Place ribbon at the N.M. State Fair in 1996.
Favorite Part of Work: I like to figure out what would look good on the rough wood as the finished product.
Signature: Bernie Todacheeny

Clemente F. Toledo
(M) Jemez
Born: 10/4/58
Parents: Joe and Esther Toledo
Teacher: Self-taught
Type of Work: Traditional pottery
18 years of experience
Awards: I've won three awards at Santa Fe Indian Market.
Favorite Part of Work: I like to make my turtles the most.
Signature: Clemente Toledo, Jemez N.M.

Lorraine Toledo
(F) Jemez
Born: 8/31/59
Parents: Margaret Toya, Jemez
Teacher: My mother
Type of Work: Natural pottery
10 years of experience
Awards: None
Favorite Part of Work: Shaping the pots and then painting them.
Signature: Toledo, Jemez

Mary Margaret Toledo
(F) Jemez
Born: 3/16/36
Parents: Mr. and Mrs. Lucas Toledo
Teacher: My mother
Type of Work: Traditional Jemez
42 years of experience
Awards: None
Favorite Part of Work: I like to make bowls and wedding vases.
Signature: Mary Margaret Toledo, Jemez

Verda Toledo, Page 40
(F) Jemez
Born: 6/30/41
Parents: Jemez
Teacher: Tom Tenorio
Type of Work: Traditional pottery
4 years of experience
Awards: None
Favorite Part of Work: I like painting the most.
Signature: V.T. Jemez N.M.

Theresa Tom
(F) Navajo
Born: 3/16/71
Parents: Mae Tom (aunt, Navajo)
Teacher: Peggy Sam
Type of Work: Navajo etched pottery
5 years of experience
Awards: Never entered
Favorite Part of Work: Etching the design.
Signature: T. Tom Dine (year)

Dorothy Torivio, Page 22
(F) Acoma
Born: 8/19/46
Parents: Mary Valley, Acoma
Teacher: Self-taught
Type of Work: Acoma seed pots
22 years of experience
Awards: First Place Gallup Ceremonial, First Place Santa Fe Indian Market, First Place Heard Museum show, all won several times.
Favorite Part of Work: Making the pots and creating different designs.
Signature: Dorothy Torivio, Acoma N.M.

Lavine Torivio
(F) Acoma
Born: 1/2/55
Parents: Ida Ortiz, Acoma
Teacher: My Grandmother, Eva Histia
Type of Work: Vases and wedding vases
12 years of experience
Awards: None
Favorite Part of Work: Creating the individuality of each piece.
Signature: LT, Acoma N.M.

Mary Torivio
(F) Acoma
Born: 1/6/45
Parents: Marie C. Torivio, Acoma
Teacher: My mother
Type of Work: Traditional pottery
14 years of experience
Awards: None yet
Favorite Part of Work: I like the part of painting the most.
Signature: M. Torivio, Acoma N.M.

James Torivio, Jr.
(M) Acoma
Born: 2/12/56
Parents: Rosinda and Jimmy Torivio
Teacher: Self-taught
Type of Work: Traditional pottery
27 years of experience
Awards: None
Favorite Part of Work: I like working with the clay to mold clay into something people can have at home.
Signature: J. Torivio, Acoma N.M.

Christina Tosa
(F) Jemez
Born: 2/19/50
Parents: Anacita Chinana, Jemez
Teacher: Self-taught
Type of Work: Traditional pottery
24 years of experience
Awards: None
Favorite Part of Work: I like the painting, polishing and selling.
Signature: C. Tosa, Jemez

Timothy M. Tosa
(M) Jemez
Born: 6/19/65
Parents: Marie Tosa, Jemez
Teacher: My mother
Type of Work: Traditional storytellers
17 years of experience
Awards: None
Favorite Part of Work: I like to paint my dolls with bright colors.
Signature: T. Tosa Jemez N.M.

Benjamin Toya
(M) Jemez
Born: 2/29/64
Parents: Margaret Toya
Teacher: Mother
Type of Work: Pottery
12 years of experience
Awards: State Fair, Belluah Colorado
Favorite Part of Work: Developing and painting new pottery.
Signature: J.B. Toya

Damian Toya, Page 41
(M) Jemez
Born: 11/6/71
Parents: Maxine Toya
Teacher: Marie and Maxine Toya, Laura Gachupin
Type of Work: Pottery
22 years of experience
Awards: First, Second, Third at Santa Fe Indian Market, Eight Northern Indian Pueblo Show.
Favorite Part of Work: Experiencing and creating new work.
Signature: Damian Toya

Dannette Toya
(F) Jemez
Born: 10/22/74
Parents: Clemente and Lorraine Toledo
Teacher: My grandmother and aunt
Type of Work: Natural pottery
8 years of experience
Awards: None yet
Favorite Part of Work: Painting
Signature: D.Toya Jemez

Frances S. Toya
(F) Jemez
Born: 9/14/46
Parents: Mabel and Frank Sando, Jemez
Teacher: My mother
Type of Work: Pottery,Traditional
35 years of experience
Awards: None
Favorite Part of Work: I like making pottery and sewing.
Signature: F. Toya, Jemez

Geraldine Toya
(F) Jemez
Born: 10/26/66
Parents: Pauline Sarracino
Teacher: Mother
Type of Work: Pottery
12 years of experience
Awards: State Fair
Favorite Part of Work: Painting the pottery.
Signature: JB Toya, Jemez

Jacqueline R. Toya
(F) Jemez
Born: 1/22/75
Parents: Mr and Mrs Joseph Toya, Sr.
Teacher: My mother
Type of Work: Traditional pottery
12 years of experience
Awards: None
Favorite Part of Work: Painting and selling at the Palms.
Signature: J. Toya Jemez

Judy Toya, Page 31, 93
(F) Jemez
Born: 9/19/53
Parents: Mary E. and Casimiro Toya, Jemez
Teacher: Mother
Type of Work: Storytellers
27 years of experience
Awards: First, Second, and Third Place ribbons from various art shows.
Favorite Part of Work: Designing the children, then selling the pieces; meeting all other types of artists and people all over the world.
Signature: Judy Toya

Lawrence Toya
(M) Jemez
Born: 6/28/61
Parents: Martha Toya, Jemez
Teacher: Mother
Type of Work: Pottery
17 years of experience
Awards: Never entered.
Favorite Part of Work: All areas of pottery making.
Signature: L. Toya and R N Toya

Lyda M. Toya
(F) Jemez
Born: 4/6/54
Parents: Jemez
Teacher: My sister and mother
Type of Work: Pottery and storytellers
24 years of experience
Awards: None
Favorite Part of Work: Creating and painting them.
Signature: Lyda M. Toya, Jemez

Margaret Toya
(F) Jemez
Born: 9/17/35
Parents: Juan and Reyes Toya
Teacher: My mother-in-law
Type of Work: Handmade Jemez pottery
42 years of experience
Awards: None
Favorite Part of Work: Making wedding vases.
Signature: Toya, Jemez

Marie R. Toya, Page 41, 93
(F) Jemez
Born: 7/6/56
Parents: Casimiro and Mary E. Toya
Teacher: My mother
Type of Work: Storytellers and nativities
19 years of experience
Awards: None
Favorite Part of Work: My favorite time is when I am making them; it makes me think of what to give each child and what the grandfather or grandmother is telling them.
Signature: Marie R. Toya, Jemez N.M.

Mary Ellen Toya, Page 78
(F) Jemez
Born: 3/28/55
Parents: Casimiro and Mary E. Toya
Teacher: My mother
Type of Work: Storytellers
17 years of experience
Awards: Santa Fe Indian Market, N.M. State Fair
Favorite Part of Work: Creating each piece.
Signature: Mary Ellen Toya, Jemez N.M.

Mary Rose Toya, Page 41
Jemez
Born: 4/25/36
Parents: Elcira Madelena, Jemez and Zia
Teacher: My mom and grandma from Zia
Type of Work: Traditional and Cermaic Pottery
40 years experience
Awards: I've won awards from Santa Fe Indian Market, Totah Festival, Mesa Verde, and Eight Northern.
Favorite Part of Work: I like doing all different kinds of pottery. As long as I'm doing pottery, I am happy.
Signature: Mary Rose Toya, Jemez Pueblo

Phyllis Toya
(F) Jemez
Born: 9/21/61
Parents: Ruby C. Waquie Jemez
Teacher: Mary S. Toya, mother-in-law
Type of Work: Handmade pottery
15 years of experience
Awards: None
Favorite Part of Work: Making and painting.
Signature: P. Toya, Jemez

Rosalie Toya
(F) Jemez
Born: 9/23/62
Parents: Frank and Margaret Toya
Teacher: Self-taught
Type of Work: Storytellers and pots
30 years of experience
Awards: Eight Northern Pueblo Show
Favorite Part of Work: Making my storytellers and my wedding vase figurines.
Signature: Toya, Jemez

Rosanna Toya
(F) Jemez
Born: 3/8/81
Parents: Rosalie Toya, Jemez
Teacher: My mother
Type of Work: Traditional Jemez pottery
4 years of experience
Awards: None
Favorite Part of Work: Firing the pieces and seeing them come out OK.
Signature: Toya, Jemez N.M.

Ruby Toya
(F) Jemez
Born: 9/7/57
Parents:
Teacher: Mother
Type of Work: Pottery
17 years of experience
Awards: Never entered
Favorite Part of Work: Creating new pieces.
Signature: L. Toya and R N Toya

Yolanda Toya, Page 94
(F) Jemez
Born: 4/21/67
Parents: Mary E. Toya, Casimiro Toya
Teacher: My mother
Type of Work: Traditional storytellers
22 years of experience
Awards: None
Favorite Part of Work: I like the whole process of what I do.
Signature: Yolanda Toya, Jemez N.M.

Bernadette Track
(F) Taos
Born: 11/4/47
Parents: Jerri Suazo Track, Taos
Teacher: My grandmother
Type of Work: Traditional Taos pottery
17 years of experience
Awards: I won an award at Picuris Pueblo in 1994.
Favorite Part of Work: I like to dig my own clay.
Signature: B. Track

Geri Track
(F) Taos
Born: 9/27/17
Parents: Mr. and Mrs. Elisio Suazo
Teacher: Self-taught
Type of Work: Miniature Pueblos
42 years of experience
Awards: I won an award at the Gallup Indian Ceremonial.
Favorite Part of Work: I like to work with anything that has to do with the clay.
Signature: Geri T., Taos N.M.

Kevin Trancosa
(M) San Felipe
Born: 4/6/68 (deceased)
Parents: San Felipe
Teacher: Hubert Candelaria
Type of Work: Traditional micacious
3 years of experience
Awards: None
Favorite Part of Work: Painting the pottery.
Signature: Kevin Trancosa, San Felipe

Katie Tree
(F) Navajo
Born: 1/24/55
Parents: Navajo
Teacher: My mother, Leta Kieth
Type of Work: Navajo rug weaving
17 years of experience
Awards: None
Favorite Part of Work: Carrying on the traditions of my people.

Carolyn S. Trujillo
(F) Cochiti
Born: 9/16/49
Parents: Eufracio and Katherine Suina
Teacher: My mother
Type of Work: Storytellers and figurines
3 years of experience
Awards: None yet
Favorite Part of Work: I like the idea of creating something where there was nothing before, doing my work in the traditional way.
Signature: C. S. Trujillo, Cochiti N.M.

Cecilia V. Trujillo, Page 94
(F) Cochiti
Born: 10/12/54
Parents: Onofre and Dorothy Trujillo
Teacher: My mother
Type of Work: Storytellers and nativity sets
22 years of experience
Awards: I've won awards at N.M. State Fair, Santa Fe Indian Market, and the Santo Domingo Art Show.
Favorite Part of Work: I like shaping and getting into the clay.
Signature: C.V. Trujillo, Cochiti N.M.

Dorothy Trujillo, Page 78, 94
(F) Cochiti
Born: 4/26/32 (deceased)
Parents: Carrie and Louis Loretto
Teacher: My grandmother, Guadalupe
Type of Work: Storytellers
52 years of experience
Awards: I've won many awards, N.M. State Fair, Santa Fe Indian Market, and the Heard Museum Show in Pheonix.
Favorite Part of Work: Dressing the the storytellers.
Signature: D. Trujillo, Cochiti, N.M.

Mary T. Trujillo, Page 95
(F) Cochiti, San Juan
Born: 5/26/37
Parents: Jose and Leonida Cata
Teacher: Helen Cordero, Ada Suina
Type of Work: Traditional storytellers
16 years of experience
Awards: I've won many awards in my career, including First Place awards at all major art shows such as Santa Fe Indian Market, Gallup Indian Ceremonial and Eight Northern Pueblo Shows.
Favorite Part of Work: I like to paint my storytellers the most.
Signature: Mary Trujillo, Cochiti N.M.

Patrick S. Trujillo
(M) Cochiti
Born: 3/5/54
Parents: Marie Laweka, Cochiti
Teacher: Domacia Cordero, Cochiti
Type of Work: Storytellers and figurines
7 years of experience
Awards: None yet
Favorite Part of Work: I like the idea of making the storytellers the way my grandmother taught me, it makes me think of her and that makes me feel good.
Signature: Tsi-na-tyi, (Rainclouds)

Roberta H. Trujillo
(F) Acoma
Born: 5/23/51
Parents: Ventura Howeya, Acoma
Teacher: My mom and grandmother
Type of Work: Ceramic pottery
12 years of experience
Awards: None
Favorite Part of Work: I like to paint the fine line.
Signature: Roberta H. Trujillo, Acoma N.M

Yolanda P. Trujillo, Page 22
(F) Acoma
Born: 2/7/63
Parents: Harold and Rebecca Pasquale
Teacher: My mother and grandmother
Type of Work: Traditional Acoma pottery
14 years of experience
Awards: None
Favorite Part of Work: Changing and going with the new times.
Signature: Yolanda Trujillo, Acoma N.M.

Robin Tsawatewa
(M) Hopi
Born: 5/23/74
Parents: Hopi
Teacher: Self-taught
Type of Work: Hopi Kachina dolls
6 years of experience
Awards: None yet
Favorite Part of Work: I like to see what will come of a piece of wood that I transform into a kachina doll.
Signature: Robin Tsawatewa, Hopi

Dora Tse Pe, Page 51
(F) San Ildefonso
Born: 1/17/39
Parents: Candelaria Gachupin, Zia
Teacher: C. Gachupin; Rose Gonzales
Type of Work: Black and sienna carved inlaid pottery
30 years of experience
Awards: Many at SWAIA, ENIPC, and others—First and Best of Shows.
Favorite Part of Work: Forming the pottery.
Signature: Dora of San Ildefonso

Irene Tse Pe
(F) San Ildefonso
Born: 12/18/61
Parents: Tse Pe and Dora Tse Pe
Teacher: Parents and grandparents
Type of Work: Black and red carved pottery
25 years of experience
Awards: I've won several awards at the Santa Fe Indian Market, and SWAIA.
Favorite Part of Work: I like working in family tradition, working with family and developing new designs.
Signature: Irene Tse Pe

Tse-Pe
(M) San Ildefonso
Born: 3/26/40
Parents: Rose Gonzales
Teacher: My mother
Type of Work: Black and red carved
30 years of experience
Awards: I've won many awards at Santa Fe Indian Market, Gallup Ceremonial, New Mexico State Fair, Heard Museum.
Favorite Part of Work: I love everything start to finish. I put everything I have into making each pot.
Signature: T P

Jennifer N. Tse-Pe (Sisneros)
(F) Santa Clara/San Juan
Born: 12/2/60
Parents: Juan and Dominquita Sisneros
Teacher: Parents, friends, self
Type of Work: Pottery
12 years of experience
Awards: I have won at the Santa Fe Indian Market.
Favorite Part of Work: I like to polish and to cut the design.
Signature: TS

Andrea Tsosie
(F) Jemez
Born: 6/4/22
Parents: Juan Celo, Jemez
Teacher: Self-taught
Type of Work: Pottery
22 years of experience
Awards: Never entered
Favorite Part of Work: Making wedding vases.
Signature: A Tsosie—Jemez

D. Tsosie, Page 95
Jemez

Eddie Tsosie
(M) Navajo
Born: 1/15/48
Parents: Navajo
Teacher: Self-taught
Type of Work: Painting in different mediums.
27 years of experience
Awards: I've won the best watercolor award at the Navajo Nation Fair and I've won awards at the Heard Museum in Pheonix.
Favorite Part of Work: I like every part of my work, it all gives me pleasure.
Signature: Eddie Tsosie

Emily F. Tsosie, Page 95
(F) Jemez
Born: 6/4/51
Parents: Felix and Grace Fragua, Jemez
Teacher: Mother and grandmother
Type of Work: Mostly figurines
22 years of experience
Awards: Indian Market, Gallup Ceremonials, Scottsdale shows; Eight Northern Pueblos
Favorite Part of Work: Hollowing out figurines.
Signature: E. Fragua Tsosie

James Tsosie
(M) Navajo
Born: 8/26/63
Parents: Navajo
Teacher: My father
Type of Work: Sculptured Kachina dolls
5 years of experience
Awards: None
Favorite Part of Work: I like the wood burning the best.
Signature: J. Tsosie

Leonard Tsosie, Page 80
(M) Jemez
Born: 6/10/41
Parents: Hubert and Andrea Tsosie
Teacher: Mother and wife
Type of Work: Pottery; storytellers
8 years of experience
Awards: Eight Northern show; Indian market
Favorite Part of Work: Adding the color to a piece.
Signature: Corn Hill and Leonard Tsosie

Victoria Tsosie
(F) Navajo
Born: 9/6/61
Parents: Rose and Freddie Smith
Teacher: Self-taught in 1982
Type of Work: Ceramic etched Navajo pottery
18 years of experience
Awards: I've won many awards for my work at many art shows.
Favorite Part of Work: I like to mix my colors, especially turquoise and gold.
Signature: Victoria Tsosie, with Shiprock

Duwayne Turpen
(M) Navajo
Born: 9/29/60
Parents: Eve Upshaw
Teacher: My uncle
Type of Work: Fetish carvings
22 years of experience
Awards: N.M. State Fair, Best of Show and Snake Carving Recognition.
Favorite Part of Work: Selling the finished product.
Signature: D.T.

Mary Turtle
(F) Ute, Cheyenne, Navajo
Born: 12/25/43
Parents: Vincent and Edith Morgan
Teacher: Self-taught
Type of Work: Cradleboards, moccasins
28 years of experience
Awards: I've won awards in both Arizona and New Mexico.
Favorite Part of Work: I like to make cradleboards the most.
Signature: Mary Turtle

Burton Uqualla
(M) Hopi
Born: 8/4/63
Parents: Mishongwovi
Teacher: Self-taught
Type of Work: Hopi Kachina doll carving
17 years of experience
Awards: None
Favorite Part of Work: I like to see the finished product.
Signature: Burton Uqualla

Geraldine Vail
(F) Navajo
Born: 1/16/60
Parents: Navajo
Teacher: My husband, William
Type of Work: Etched, painted, and horsehair pots
14 years of experience
Awards: I've won two awards for my work.
Favorite Part of Work: I like to design the Flute Man and Bear Claws.
Signature: Geri Vail, or Skeeter and Geri

Pearl Valdo
(F) Acoma
Born: 5/15/40
Parents: Acoma
Teacher: My mother
Type of Work: Traditional Acoma pottery
32 years of experience
Awards: I've won awards at a few art shows, mostly Second and Third Places.
Favorite Part of Work: I like to make pots in the old traditional way and I really like to paint fine line.
Signature: P. Valdo, Acoma N.M.

Patricia Valencia
(F) Jemez
Born: 2/21/56
Parents: Mary Celo, Jemez
Teacher: My mother
Type of Work: Handmade wedding vases
32 years of experience
Awards: None so far, but I hope I win some soon.
Favorite Part of Work: Building the pottery
Signature: P.V. Jemez

Leroy and Rena Valentine
(M) Navajo, Hopi
Born: 2/1/64
Parents: Navajo
Teacher: Self-taught
Type of Work: Hopi Kachina sculptures
10 years of experience
Awards: None yet
Favorite Part of Work: Carving and detailing the dolls.
Signature: L. Valentine

Mary Ann Valley
(F) Acoma
Born: 9/1/61
Parents: Mr. and Mrs. Pasqual Concho
Teacher: My grandmother
Type of Work: Traditional fine line
17 years of experience
Awards: None
Favorite Part of Work: I like to put the designs on the pottery.
Signature: MA Valley, Acoma N.M.

Adrian Vallo, Page 22
(M) Acoma
Born: 2/6/64
Parents: Dennis and Loretta Vallo
Teacher: Santana Cerno
Type of Work: Traditional and ceramic pots
12 years of experience
Awards: None yet
Favorite Part of Work: I like to form the pots into the shapes I see in my mind. I also enjoy the time I spend painting each piece.
Signature: A. Vallo, Acoma N.M.

Darlene Vallo
(F) Navajo
Born: 1/16/62
Parents: Ben and Bessie Lee
Teacher: My brother
Type of Work: Storytellers
7 years of experience
Awards: None
Favorite Part of Work: Painting the storytellers and the children.
Signature: Darlene Lee Vallo

Delma Vallo, Page 22
(F) Acoma
Born: 4/14/35
Parents: Acoma
Teacher: My aunt
Type of Work: Traditional fine line pottery
27 years of experience
Awards: I've won many awards at several shows, including Best of Show, and many First Places.
Favorite Part of Work: Painting the best fine line I can is what excites me the most.
Signature: Delma Vallo, Acoma N.M.

Ergil F. Vallo, Sr., Page 23
(M) Acoma/Hopi
Born: 12/1/59
Parents: Harold and Laura Chino, Acoma
Teacher: Self-taught
Type of Work: Carved pottery
18 years of experience
Awards: Many N.M. State Fair Ribbons.
Favorite Part of Work: Creating pottery with unique designs.
Signature: Dalawepi, Acoma N.M.

Jeannette (Jay) Vallo. Page 23
(F) Acoma
Born: 1/1/59
Parents: Elmer and Edna Chino
Teacher: My Grandmother, Lita Garcia
Type of Work: Fine line pottery
18 years of experience
Awards: I've won many New Mexico State Fair Ribbons in several different years.
Favorite Part of Work: I like to paint the pottery and think of new designs to put on the pots.
Signature: Jay Vallo, Acoma N.M.

Laura Vallo (Chino)
(F) Acoma
Born: 12/29/42
Parents: Mr. and Mrs. Tony Vallo
Teacher: Eva Histia, my aunt.
Type of Work: Traditonal Acoma pottery
22 years of experience
Awards: None yet
Favorite Part of Work: Painting the pottery is my favorite part.
Signature: LgV, Acoma N.M.

Leland R. Vallo, Page 23
(M) Acoma
Born: 10/18/69
Parents: Simon and Marie Vallo
Teacher: Self-taught
Type of Work: Traditional and ceramic
7 years of experience
Awards: First Place, N.M. State Fair 1995, several more second and Third Place awards at the N.M. State Fair.
Favorite Part of Work: I like to make the actual pot.
Signature: L. Vallo, Acoma N.M.

Marie Vallo
(F) Acoma
Born: 4/21/49 (deceased)
Parents: Lorenzo and Gladys Garcia
Teacher: My grandmother
Type of Work: Traditional and ceramic pots
38 years of experience
Awards: I've won a few ribbons at the New Mexico State Fair in Albuquerque.
Favorite Part of Work: Creating each piece in my own style.
Signature: M. Vallo, Acoma N.M.

Nathaniel J. Vallo
(M) Acoma
Born: 11/25/65
Parents: Florina and Earl Vallo
Teacher: Self-taught
Type of Work: Etched ceramics with Kokopelli
8 years of experience
Awards: New Mexico State Fair 1994.
Favorite Part of Work: People's admiration; creating new designs; adding very fine detail.
Signature: N. Vallo Acoma, N.M.

Simon Vallo, Page 23
Acoma
Born: 4/15/48
Parents: Henry L. Vallo, Acoma
Teacher: My mother
Type of Work: Traditional pottery
16 years experience
Awards: I've never entered my work.
Favorite part of work: I like painting the most.
Signature: Vallo

Gordon Van Wert
(M) Redlake Chippewa
Born: 3/21/52
Parents: Katherine VanWert
Teacher: Allen Houser, Doug Hyde
Type of Work: Sculpture
29 years of experience
Awards: Many First, second and Third Place awards at Santa Fe Indian Market, Heard Museum, and Gallup Indian Ceremonial.
Favorite Part of Work: I like to rough out the stone after I figure out what the sculpture is going to be.
Signature: GVW

Faith Vargas
(F) Acoma
Born: 11/6/64
Parents: Elliott Sanchez
Teacher: My grandmother
Type of Work: Ceramic pottery
7 years of experience
Awards: None
Favorite Part of Work: Painting the fine line artwork on my pots is my favorite part of my work.
Signature: F. Vargas, Acoma N.M.

Clara Vasquez
(F) Navajo
Born: 4/5/59
Parents: Hoskie and Vernie Nez
Teacher: Self-taught
Type of Work: Artifacts of all kinds
7 years of experience
Awards: None yet
Favorite Part of Work: I like to sell my work.
Signature: Name Engraved

Carol Velarde (Brewer), Page 67. 68
(F) Santa Clara
Born: 1/25/49
Parents: Teresa V. Gutierrez
Teacher: My grandmother and aunts
Type of Work: Carved black and red
32 years of experience
Awards: First and Second Place awards at Santa Fe Indian Market and First and Second Places at ENIPC.
Favorite Part of Work: Molding and polishing are my favorite parts.
Signature: Carol Velarde, Santa Clara N.M

Tricia Velarde, Page 68
(F) Santa Clara
Born: 4/12/72
Parents: Sophie Cata, Santa Clara
Teacher: Mother, grandmother
Type of Work: Pottery
9 years of experience
Awards: Never entered
Favorite Part of Work: Coming up with a new design for the pottery.
Signature: Tricia Velarde

Dale Vicente
(M) Acoma
Born: 9/26/54
Parents: Mr. and Mrs. Willie Vicente
Teacher: My mother
Type of Work: Traditional and ceramic
15 years of experience
Awards: None yet
Favorite Part of Work: I like to do the fine line work the most.
Signature: V. Acoma N.M.

Charlene Victorino
(F) Cochiti
Born: 4/11/80
Parents: Monroe and Beverly Victorino
Teacher: Both my parents
Type of Work: Traditional and ceramic pots
6 years of experience
Awards: None
Favorite Part of Work: Filling in the lines after we design the pottery.
Signature: C. Victorino Acoma

Dylene Victorino, Page 24
(F) Acoma
Born: 2/3/79
Parents: Beverly Victorino
Teacher: My mother
Type of Work: Ceramic pottery
6 years of experience
Awards: None, for now.
Favorite Part of Work: Selling my pots at the Palms.
Signature: D. Victorino

Greg P. Victorino
(M) Acoma
Born: 2/27/60
Parents: Paul and Virginia Victorino
Teacher: Myself
Type of Work: pottery, canvas paintings
12 years of experience
Awards: I've never entered a competition.
Favorite Part of Work: Designing the pots and canvases.
Signature: G. V. Acoma

Monroe F. Victorino
(M) Acoma
Born: 5/18/40
Teacher: Self-taught
Type of Work: Traditional and ceramic
22 years of experience
Awards: None
Favorite Part of Work: Doing fine line work.
Signature: Victorino Acoma N.M.

Sandra Victorino, Page 24
(F) Acoma
Born: 2/10/58
Parents: Acoma
Teacher: Grandma and Dorothy Torivio
Type of Work: Traditional eye dazzler
12 years of experience
Awards: Many awards from Santa Fe Indian Market, Eight Northern Show, Heard Museum, and Gallup Indian Ceremonial.
Favorite Part of Work: Finishing the pottery.
Signature: Sandra Victorino, Acoma N.M.

Virginia Victorino
(F) Acoma
Born: 11/26/33
Parents: Lita Garcia, Acoma
Teacher: My mother
Type of Work: Traditional pottery
57 years of experience
Awards: None
Favorite Part of Work: Creating each piece from scratch.
Signature: Garcia, Acoma N.M.

Beverly Victorino (Garcia)
(F) Acoma
Born: 1/14/55
Parents: Florence Waconda, Acoma
Teacher: My grandmother, Lupe Concho
Type of Work: Traditional and ceramic pots
37 years of experience
Awards: None
Favorite Part of Work: I like to paint all different kinds of designs.
Signature: B. Victorino or Garcia, Acoma

Albert and Josephine Vigil
(F) San Ildefonso
Born: 5/12/27
Parents: San Ildefonso
Teacher: My aunt, Maria Martinez
Type of Work: Cream on red and black
37 years of experience
Awards: All sorts of ribbons, 11 First Place and many second and thirds.
Favorite Part of Work: I like the start, forming the pottery.
Signature: Albert and Josephine Vigil

Bruce Vigil
(M) San Ildefonso
Parents: Albert and Josephine Vigil
Teacher: My parents
Type of Work: Red polished, animals
7 years of experience
Awards: None yet.
Favorite Part of Work: Making animals.
Signature: Bruce Vigil

Carol D. Vigil, Page 41
(F) Jemez
Born: 3/18/60
Parents: Cerelia Baca, Jemez
Teacher: My grandmother
Type of Work: Red polished and etched
14 years of experience
Awards: Santa Fe Indian Market, N.M. State Fair, Gallup Indian Ceremonial, Eight Northern Pueblo Shows—First, Second, Third and some Best of Show ribbons.
Favorite Part of Work: I like to carve the daisy pattern with an eagle or butterfly.
Signature: Carol Vigil, Jemez N.M.

Minnie Vigil. Page 68
(F) Santa Clara
Born: 2/8/31
Parents: Juan and Petra Gutierrez
Teacher: My grandmother
Type of Work: Traditional pottery
22 years of experience
Awards: Santa Fe Indian Market.
Favorite Part of Work: I like to shape the pots.
Signature: Minnie

Jocelyn Vote (Honani)
(F) Hopi/Laguna/Jemez
Born: 10/27/62
Parents: Mom, Hopi; Dad, Laguna
Teacher: Self-taught
Type of Work: Hopi Kachina carvings
14 years of experience
Awards: N.M. State Fair, Gallup Indian Ceremonial
Favorite Part of Work: Meeting collectors, private collectors, so I don't have to argue over price too much. (Ha Ha Ha!)
Signature: Kocha Hon Mana

Donna Waconda
(F) Laguna/ Hopi
Type of Work: Hopi kachinas
7 years of experience
Awards: None
Favorite Part of Work: All of it.
Signature: D. Waconda

Adrian Wall
(M) Jemez
Born: 9/2/70
Parents: Fannie Loretto, Jemez
Teacher: My father, Steve Wall
Type of Work: Stone sculpture
8 years of experience
Awards: Dallas Indian Market, N.M. State Fair.
Favorite Part of Work: I like to see the stone come alive.
Signature: Adrian Wall, Jemez N.M.

Kathleen Wall, Page 96
(F) Jemez
Born: 9/29/72
Parents: Fannie Loretto, Jemez
Teacher: Steve Wall and Fannie Loretto
Type of Work: Traditional masks and clowns
9 years of experience
Awards: I've won awards at the Eight Northern Pueblo Show, New Mexico State Fair, and the Dallas Arts and Crafts Show, and Sant Fe Indian Market.
Favorite Part of Work: I like to paint and mold the clay.
Signature: KATHLEEN WALL, Jemez N.M.

Angela Waquie, Page 42
(F) Jemez
Born: 11/1/46
Parents: Jemez
Teacher: My grandmother
Type of Work: Handmade pottery
12 years of experience
Awards: None yet
Favorite Part of Work: Building the pots, then painting them.
Signature: A.W. Jemez

Joseph A. Waquie, Page 42
(M) Jemez
Born: 5/6/56
Parents: Felipita Waquie
Teacher: My mother
Type of Work: Traditional Jemez
14 years of experience
Awards: None
Favorite Part of Work: I like painting the most.
Signature: JAW, Jemez, N.M.

Troy H. Watson
(M) Navajo
Born: 3/2/72
Parents: Della Watson
Teacher: Darryl Brown, Navajo
Type of Work: Table fetishes
7 years of experience
Awards: None
Favorite Part of Work: Carving is my favorite part.
Signature: T.W.

Eloise Westika
(F) Zuni
Born: 1/1/13
Parents: Amy Westika
Teacher: My grandmother
Type of Work: Pottery and beadwork
72 years of experience
Awards: None
Favorite Part of Work: Creating the pottery, and also intricate beadwork.
Signature: E.W. Zuni N.M.

Irene White, Page 48
(F) Navajo
Born: 6/10/55
Parents: Navajo
Teacher: Self-taught
Type of Work: Traditional Navajo pottery
14 years of experience
Awards: None
Favorite Part of Work: Creating the designs.
Signature: I. White Navajo

Kenneth White
(M) Navajo
Born: 4/13/55
Parents: Navajo
Teacher: Self-taught
Type of Work: Traditional Navajo
18 years of experience
Awards: None
Favorite Part of Work: I like to see my different shapes form.
Signature: K. W. Navajo

Velma White
(F) Navajo, Hopi
Born: 4/19/65
Parents: Navajo, Hopi
Teacher: My sister
Type of Work: Kachina trees
8 years of experience
Awards: None
Favorite Part of Work: I like all of my work.
Signature: V. White

Shyatesa White Dove
(F) Acoma
Born: 7/7/56
Parents: Margaret and James Garcia
Teacher: Connie O. Cerno (grandmother)
Type of Work: Traditional Acoma pottery
14 years of experience
Awards: N. M. State Fair, First Place
Favorite Part of Work: Working, meeting people, and sales.
Signature: Shyatesa White Dove

Craig White Eagle, Page 48
(M) Navajo
Born: 8/23/68
Parents: Adopted from Navajo Reservation
Teacher: Self-taught
Type of Work: Ceramics, handmade pottery
12 years of experience
Awards: Many First Place (especially N.M. State Fair)
Favorite Part of Work: People's appreciation and complements.
Signature: Navajo, Craig White Eagle

Dolly J. White Swan Joe
(F) Hopi
Born: 7/9/64
Parents: Fawn Navasie, Hopi
Teacher: My grandmother and mother
Type of Work: Traditional Hopi pottery
18 years of experience
Awards: I've won Best of Show, First Place, and many other ribbons at juried art shows such as Santa Fe Indian Market, Gallup Indian Ceremonial and the New Mexico State Fair in Albuquerque.
Favorite Part of Work: I like shaping and designing my pottery.
Signature: White Swan

Everson Whitegoat
(M) Navajo
Born: 3/29/63
Parents: Margaret and Eli Whitegoat
Teacher: Dennis Charlie, Navajo
Type of Work: Ceramic etched pottery
12 years of experience
Awards: None
Favorite Part of Work: I like the selling the most.
Signature: Everson Whitegoat, Navajo

Ferguson Whitegoat
(M) Navajo
Born: 1/3/68
Parents: Navajo
Teacher: Self-taught
Type of Work: Ceramic etched pottery
6 years of experience
Awards: None
Favorite Part of Work: Etching and selling.
Signature: Ferguson Whitegoat, Navajo

Hilda Whitegoat, Page 49
(F) Navajo
Born: 7/28/67
Parents: Navajo
Teacher: Susie Charlie, Navajo
Type of Work: Ceramic etched pottery
9 years of experience
Awards: None
Favorite Part of Work: Doing Navajo pottery, selling, and trading.
Signature: Hilda Whitegoat, Navajo

Ernie Whitman
(M) Navajo
Born: 5/14/62
Parents: Pauline Sandoval
Teacher: Self-taught
Type of Work: Navajo kachinas
3 years of experience
Awards: None yet
Favorite Part of Work: I like to make the body of the kachina the most.
Signature: E. Whitman, Navajo

Wesley Whitman
(M) Navajo
Born: 8/6/63
Parents: Tim and Elizabeth Whitman
Teacher: My mother
Type of Work: Silver miniature pots and vases
8 years of experience
Awards: First Place, Denver Trade Fair, and an Honorable Mention at the North Dakota Art Show.
Favorite Part of Work: I really enjoy looking at my finished pieces.
Signature: E.M.W. Sterling

Lonnie Wille
(M) Navajo
Born: 4/9/58
Parents: Andy and Mae Wille
Teacher: Albuquerque Indian School
Type of Work: All types of jewelry and gold
25 years of experience
Awards: Best of Show at 1985 Colorado Indian Market.
Favorite Part of Work: I like the new designs.
Signature: L.W. or Lonnie Willie

Lorraine Williams, Page 49
Navajo

Michelle Williams, Page 49
Navajo

Carol Willie
(F) Navajo
Born: 8/10/73
Parents: Evelyn Johnson
Teacher: Self-taught
Type of Work: Navajo etched pottery
4 years of experience
Awards: None
Favorite Part of Work: Creating the designs.
Signature: David and Carol Willie, Navajo

David Willie
(M) Navajo
Born: 9/6/71
Parents: David and Evelyn Johnson
Teacher: Self-taught
Type of Work: Ceramic etched pottery
4 years of experience
Awards: None
Favorite Part of Work: Creating the design, then watching everything fall into place.
Signature: David and Carol Willie, Navajo

Elsie Willie
(F) Navajo
Born: 6/30/64
Parents: Navajo
Teacher: My friends
Type of Work: Navajo kachinas with removable masks
7 years of experience
Awards: I've never entered a show.
Favorite Part of Work: Painting the pieces.
Signature: E. Willie

Lonnie Willie
(M) Navajo
Born: 4/9/58
Parents: Andy and Mae Willie
Teacher: Albuquerque Indian School
Type of Work: Contemporary and traditional Navajo jewelry
24 years of experience
Awards: I have won a Best of Show award at the Colorado Indian Art Market, 1985.
Favorite Part of Work: I like to develop new designs.
Signature: LW

Louise Willie
(F) Acoma
Born: 11/3/46
Parents: Lorenzo and Frances Abeita
Teacher: Grandmother, Delores Stern
Type of Work: Traditional pottery, using Zuni design
39 years of experience
Awards: Never entered
Favorite Part of Work: Working with the clay to form interesting peices.
Signature: Louise Amos

McConnell Wood
(M) Navajo
Born: 7/26/57
Parents: Navajo
Teacher: Self-taught
Type of Work: Clown kachinas
5 years of experience
Awards: None
Favorite Part of Work: I like the money part the best.
Signature: Mc. Wood

Anna J. Woodie
(F) Navajo
Born: 5/24/60
Parents: John and Martha Cleveland
Teacher: My parents
Type of Work: Navajo Kachina dolls
22 years of experience
Awards: New Mexico State Fair
Favorite Part of Work: I like to dress the dolls, and paint them.
Signature: AW, Navajo

Jaqueline Woody
(F) Navajo
Born: 3/20/68
Parents: Kee and Alice Platero
Teacher: Self-taught
Type of Work: Wood carving and painting
6 years of experience
Awards: None
Favorite Part of Work: I like the painting and the dressing of each doll.
Signature: J. or F. Woody, Navajo

P.K. Work
(F) Choctow, Cherokee
Born: 9/30/47
Parents: Frances Hudaon
Teacher: Tully Kee, Navajo
Type of Work: Navajo and Choctow jewelry
29 years of experience
Awards: Gallery of Plains Indians, Oklahoma
Favorite Part of Work: I like to design. I also like to put the pieces of the puzzle together.
Signature: PKW

Cheryl Yazza
(F) Navajo
Born: 1/29/62
Parents: Navajo
Teacher: Self-taught
Type of Work: Indian porcelain dolls
8 years of experience
Awards: I've won a Best in Division.
Favorite Part of Work: I love the faces.
Signature: CY (under the left ear)

Albert Yazzie
(M) Navajo
Born: 5/20/54
Parents: Mary and Charlie Yazzie
Teacher: Self-taught
Type of Work: Traditional and Contemporary jewelry
32 years of experience
Awards: I've won First Place ribbons at the New Mexico State Fair, The Denver Indian Art Show and at a show in San Diego.
Favorite Part of Work: I like to design jewelry.
Signature: AY-Sterling

David J. Yazzie
(M) Navajo
Born: 4/28/61
Parents: Willie and Helen Yazzie
Teacher: My father-in-law
Type of Work: Table fetishes
6 years of experience
Awards: None
Favorite Part of Work: I like to carve buffalos, eagles, skunks, and raccoons.
Signature: D.J.Y.

Mena Yazzie
(F) Navajo
Born: 3/3/59
Parents: Willie and Grace Yazzie
Teacher: My in-laws
Type of Work: Porcelain dolls
14 years of experience
Awards: None
Favorite Part of Work: I like painting the most.
Signature: M.Y.

Nora Yazzie, Page 96
(F) Navajo
Born: 10/16/54
Parents: Daniel and Minnie Yazzie
Teacher: My mother
Type of Work: Clay sculpture
13 years of experience
Awards: 1989 and 1990 Totah Festival; First and Second Place in the Sculpture Division.
Favorite Part of Work: Painting and building are the favorite parts of my work.
Signature: Nanzebah

Timmy E. Yazzie
(M) San Felipe, Navajo, S.D.
Born: 6/22/68
Parents: Andy and Dora Yazzie
Teacher: Chalmers Day, Jimmy Harrison
Type of Work: Overlay and inlay
9 years of experience
Awards: None yet
Favorite Part of Work: I like all aspects of my work.
Signature: Tim Yazzie

Alvin Yellowhorse
(M) Navajo
Born: 4/14/68
Parents: Navajo
Teacher: Ray Tracey
Type of Work: Navajo inlay jewelry
11 years of experience
Awards: I've won many awards at all kinds of art shows all over the United States.
Favorite Part of Work: I like goldsmithing and inlaying the most.
Signature: Alvin Yellowhorse, with a horse

Alvina Yepa
(F) Jemez
Born: 8/4/54
Parents: Nick and Felipita Yepa
Teacher: Mother
Type of Work: Stone polished pottery
17 years of experience
Awards: Indian Market, Gallup Ceremonial, and Heard Muesum.
Favorite Part of Work: The whole process, from start to finish.
Signature: Alvina Yepa

Ida Yepa, Page 42
Jemez

Juanita Yepa

(F) Jemez
Born: 6/7/37
Parents: Mr. and Mrs. John Fragua
Teacher: My mother
Type of Work: Pottery and jewelry
42 years of experience
Awards: I've won many awards.
Favorite Part of Work: I like all aspects of my work.
Signature: J. Yepa. Jemez

Lawrence Yepa, Page 42

(M) Jemez
Born: 10/15/48
Parents: Feliita Yepa, Jemez
Teacher: My mother
Type of Work: Encised stone polished pottery
20 years of experience
Awards: I've won Second Place at Santa Fe Indian Market.
Favorite Part of Work: I like to polish.
Signature: L. Yepa Jemez Pue.

Paul M. Yepa

(M) Jemez
Born: 11/27/56
Parents: Paul M. Yepa
Teacher: Self-taught
Type of Work: Pottery
12 years of experience
Awards: Never entered
Favorite Part of Work: Painting the pots.
Signature: Juanita Shendo-Paul Yepa

Wallace Youvella

(M) Hopi
Born: 7/28/47
Parents: Susie and Charles Youvella
Teacher: Self-taught
Type of Work: All types
22 years of experience
Awards: Museum Northern Arizona, Best of Show (miniatures)
Favorite Part of Work: Making up new designs.
Signature: Wallace Youvella

Everette R. Youyetewa

(M) Hopi-Tewa/Navajo
Born: 12/3/75
Parents: Jerry H. Youyetewa, Sr.
Teacher: Uncle
Type of Work: Kachinas
3 years of experience
Awards: Never entered
Favorite Part of Work: Carving the wood.
Signature: Everette Ray Youyetewa

Mary Zuni

(F) Laguna
Born: 6/2/56
Parents: Diego and Mary Abieta
Teacher: Myself and friends
Type of Work: Pottery
3 years of experience
Awards: None
Favorite Part of Work: When I see the finished work.
Signature: M. Zuni, Laguna

NOTES